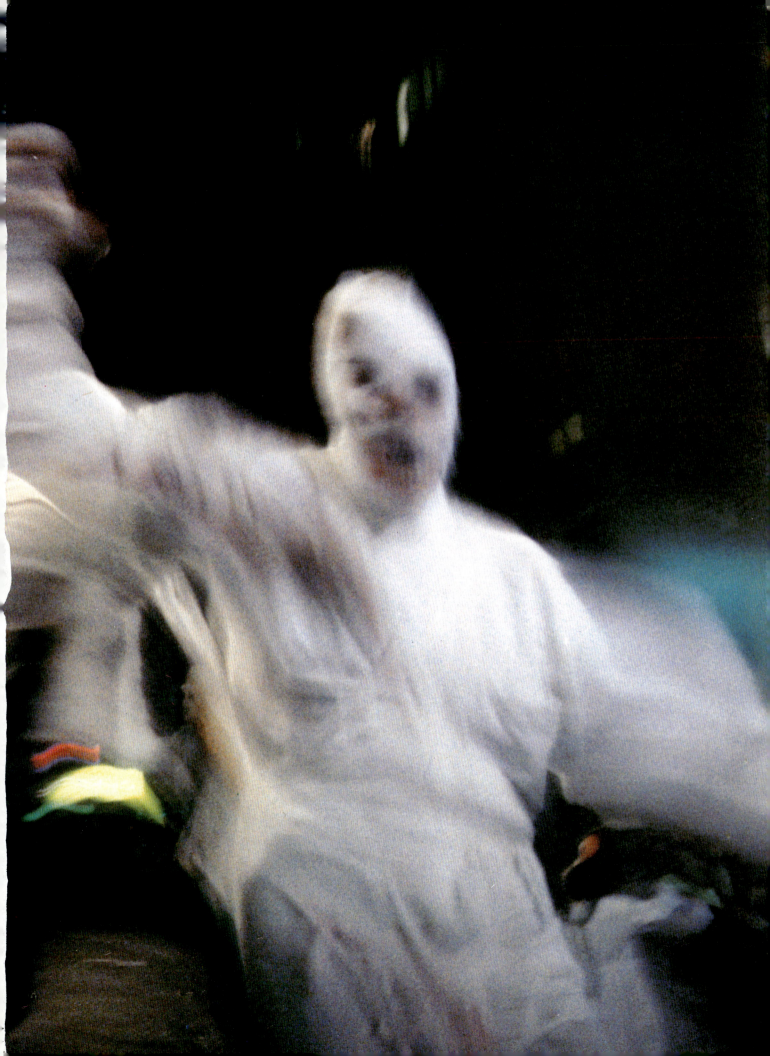

DO YOU HAVE ANYTHING THE EXECUTIONER MIGHT

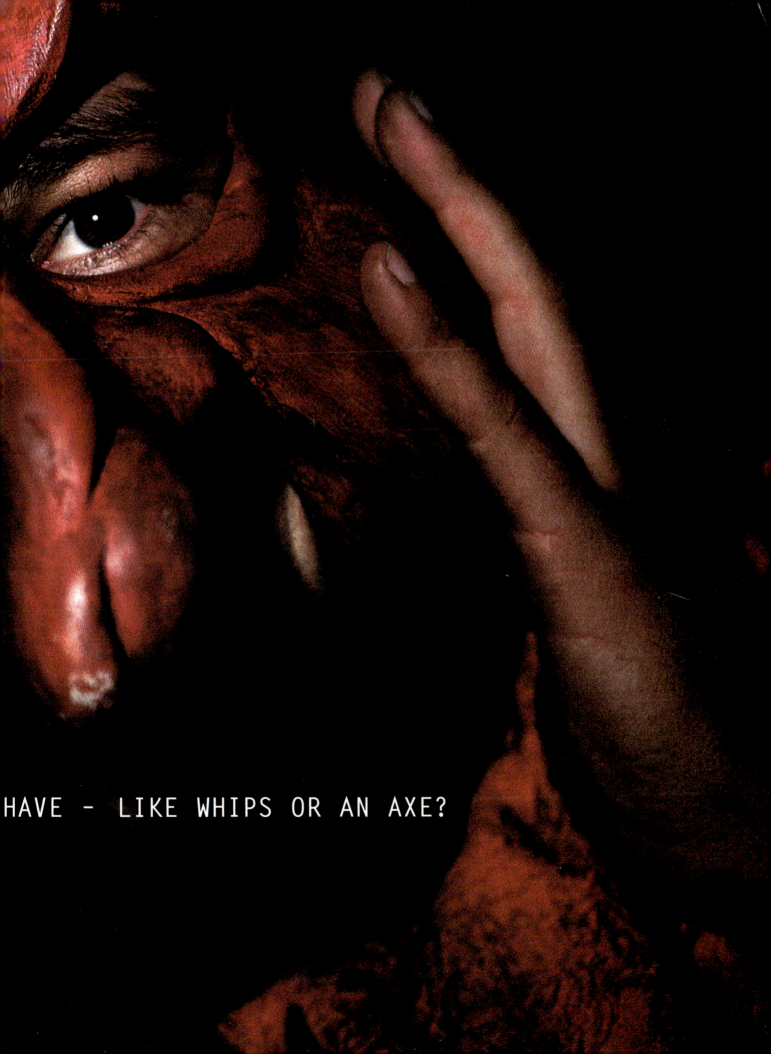

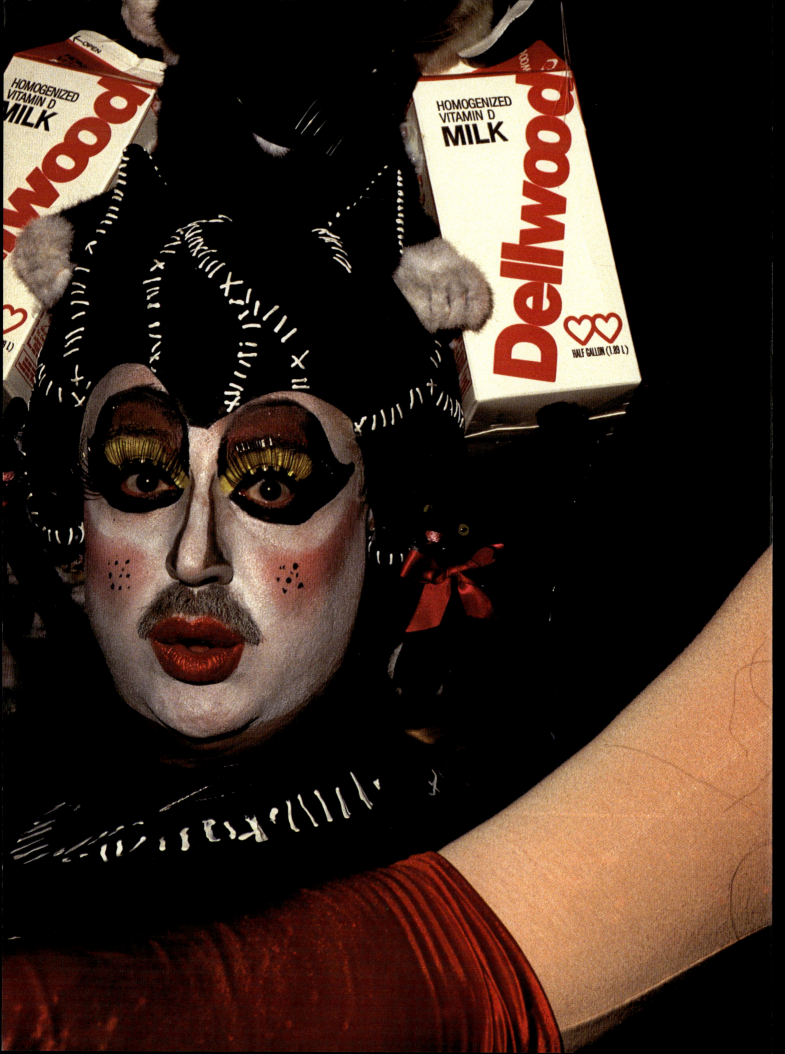

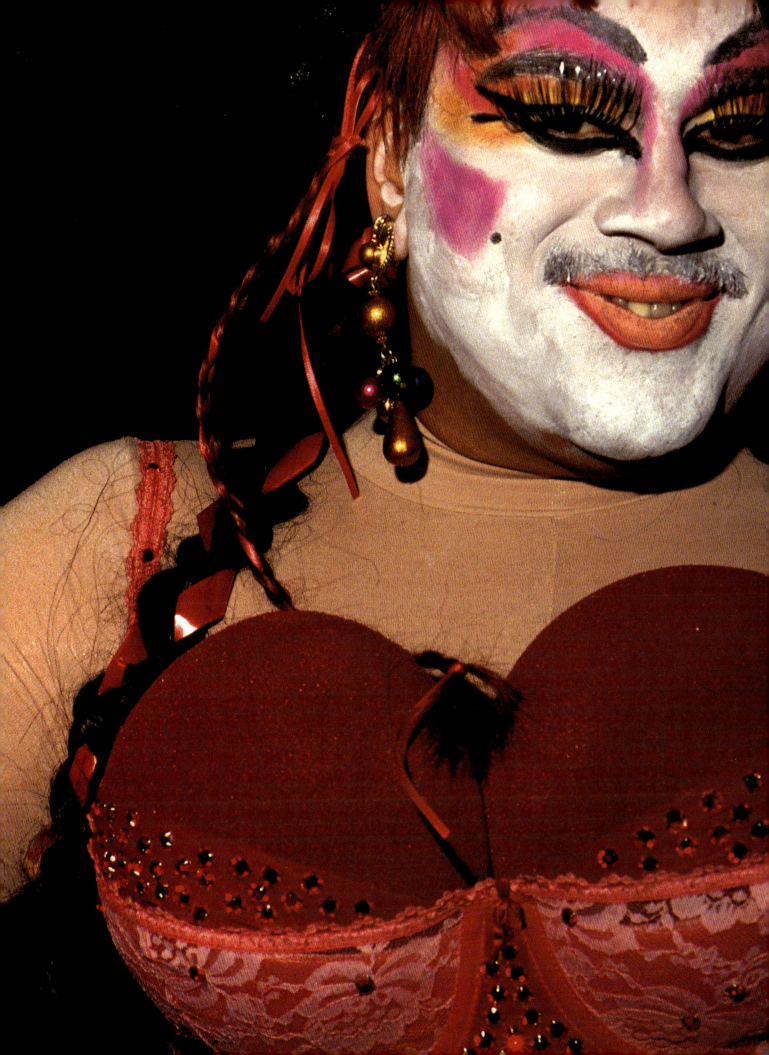

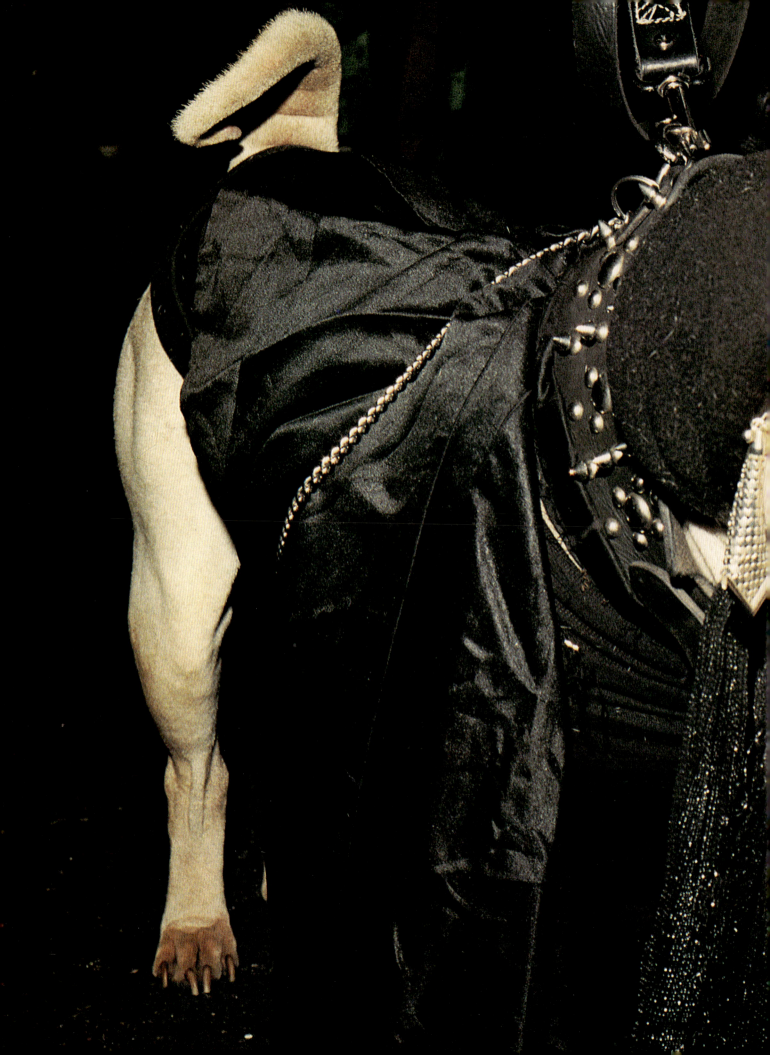

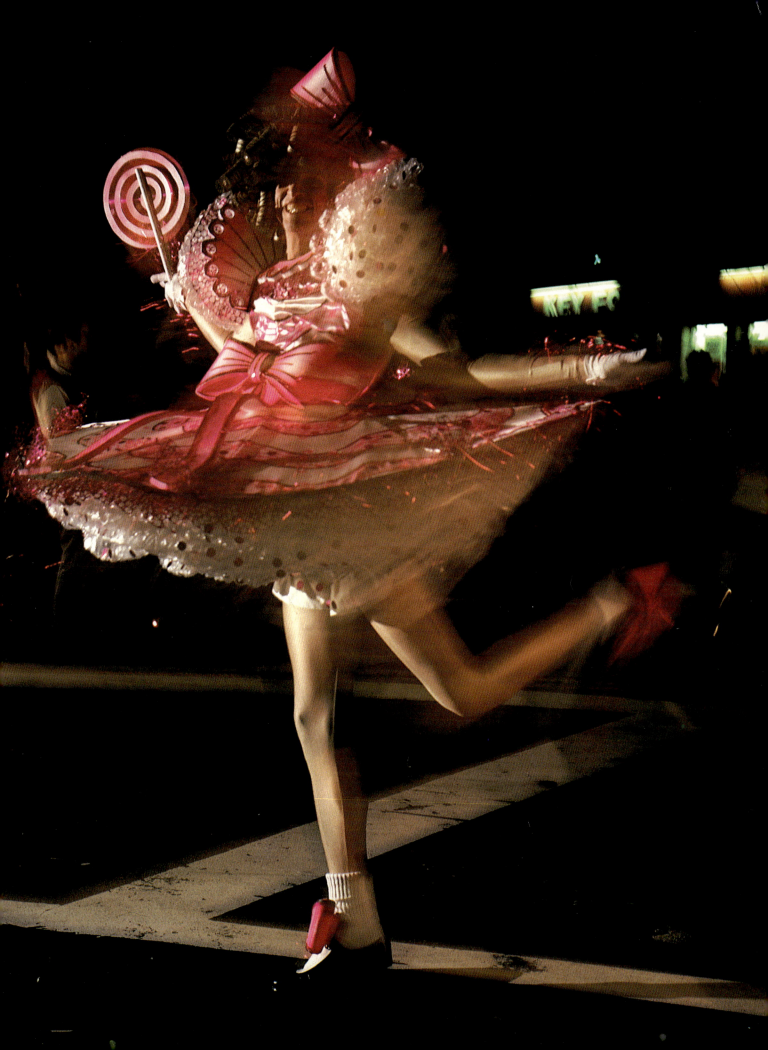

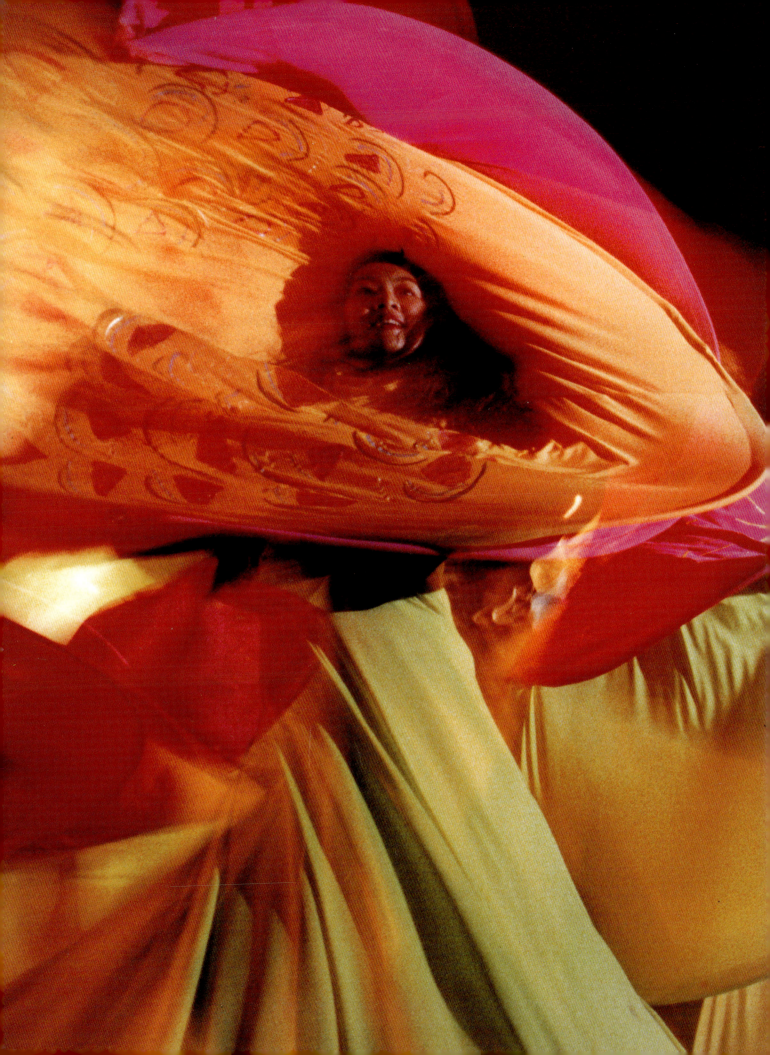

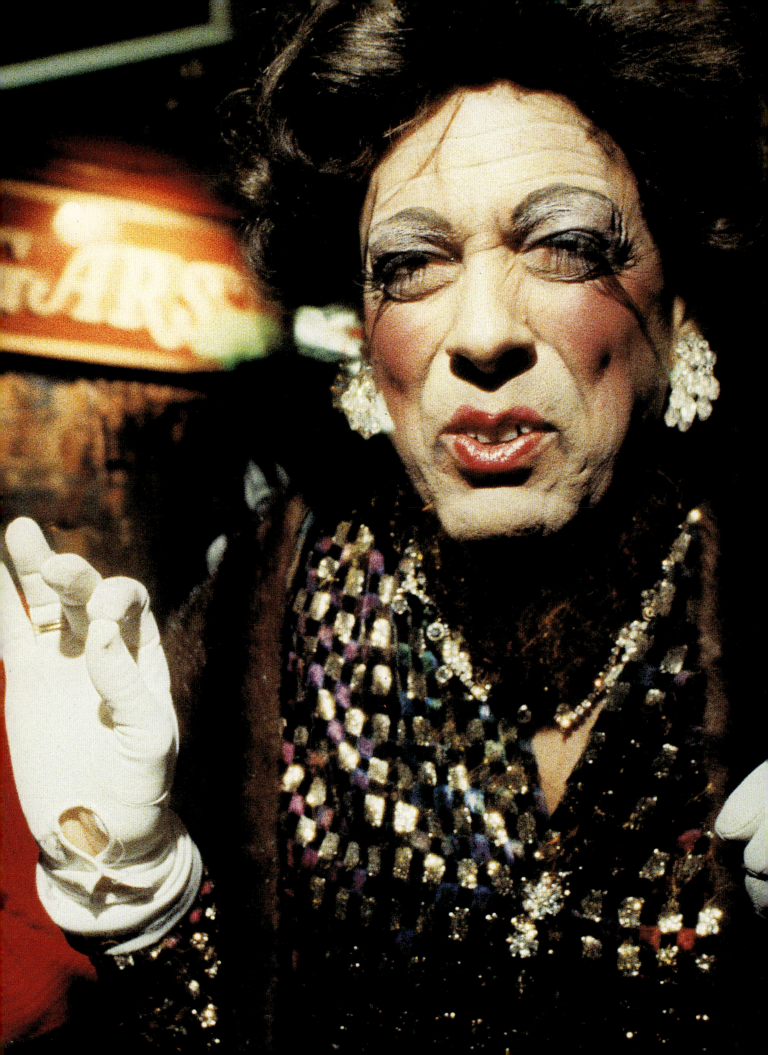

masked Culture

THE GREENWICH VILLAGE HALLOWEEN PARADE

TEXT BY **JACK KUGELMASS**

PHOTOGRAPHY BY
**MARIETTE PATHY ALLEN
ELIJAH COBB
HAROLD DAVIS
LAUREN PIPERNO
MARILYN STERN**

COLUMBIA UNIVERSITY PRESS
NEW YORK

Contents

You'd Make a Great Vampire 20

You Got Voodoo in You 28

A Real Spiritual Break 34

A Planet to Live On 80

Something They're Not Supposed to Be 88

What Halloween Is About 96

Making Art 144

Nobody Else Is Fidel 150

It's My Time to Shine 156

To Be a Part of It 164

Notes 210

Photography Credits 212

Photographers' Acknowledgments 214

Author's Acknowledgments 215

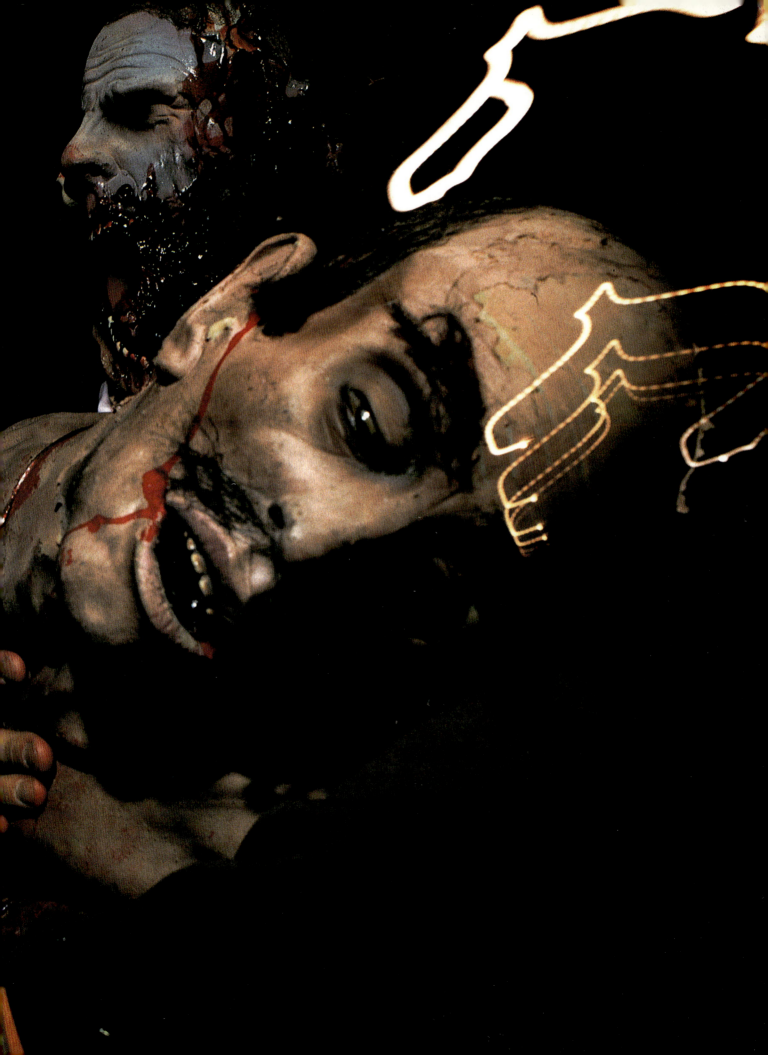

You'd Make a Great Vampire

Place: a costume rental company on the twenty-first floor of a loft in midtown Manhattan. **Time:** late afternoon, one recent October 30. Disguises pack the room. Hats made of silver brocade with lavender and green satin bows or splashes of pink-and-white plumage dangle coyly overhead. Some two dozen people wander through the shop, pausing now and then to plunge into thick rows of costumes. A couple in their mid-twenties with angelic pale white faces emerge from one such row with red suits and tails, matching capes, and hats with horns. They head to a changing room then reappear to show the results. As they gaze at one another, evil little smiles spread across their lips. Elsewhere in the shop a middle-aged woman finds a devil's outfit and shows it to her husband. "It looks very nice," he comments. "Anything to get out of here," she mutters, obviously hurt by her husband's indifference. Others, less certain who they want to be, demand attention. A woman in her fifties asks for a Scarlet O'Hara costume: "If you don't have Scarlet O'Hara, do you have a devil?" A heavyset man in his thirties wearing a conservative three-piece business suit examines a drag queen outfit. A saleswoman suggests he consider renting a Hawaiian grass skirt. "I've seen you trying to pass that off all afternoon!" he replies, sounding a little bit irritated. "That's not true," she counters, then turns to someone else and asks, "How about a grass skirt?" A well-built black man in his thirties tries on an executioner's costume with a gray face mask. The saleswoman looks at him and comments, "Hey, you're looking better all the time."

"Do you have anything an executioner might have—like whips or an axe?" he asks.

"No, we're all out of whips," she responds, too exhausted from a frenzied week of selling to demonstrate even the slightest touch of irony. Two young women are standing at the counter where finished alterations are picked up. "What are you going as?"

"A vampire."

"Oh, good."

"You approve?"

"Yes, you'd make a great vampire!"

Inside the dressing room a man in his late twenties, white with a slight paunch, tries on a costume. He opens the curtain so a friend can gaze together with him into a full-length mirror. His loins are covered Tarzan-style in fur. A matching vest is draped over his shoulders. The rest of him—arms, legs, and stomach—are bare. A black high-tech wristwatch remains fixed to his body, suggesting a visual pun about time machines and a need, perhaps, to keep himself anchored to the present. For this man and so many

others who enter this shop, the transformation they seek is a limited one. Most who come are renting their outfits as entry tickets to costume parties, increasingly common in New York and elsewhere in the United States as Halloween becomes an established adult celebration, a kickoff to the winter holiday season. But for others, Halloween has become a time for much more serious investment; they spend weeks or even months and hundreds of dollars designing costumes, creating and practicing personae, in order to perform their masquerade on the streets of Manhattan. For them, the annual Greenwich Village Halloween Parade offers not only a grand spectacle in which to display their creations but also a festival setting to bring the "saints" and "devils" of popular culture—from Shirley Temple to Saddam Hussein—down to earth, to worship, befriend, or debunk them.

Because cities are so large and diverse, most urban festivals appeal to specific subgroups while relegating others, if they choose to attend, to the role of spectators. In this regard the Greenwich Village Halloween Parade is quite unique. Participation is open to all, and the event, which changes from year to year, assumes the character of its most flamboyant costumes. But the brilliance of this parade has much to do with the fact that it attracts large numbers of people from New York's design and arts communities. And because of their talent and willingness to commit a good deal of time, talent, and money to create spectacular costumes, their vision has substantial impact on the parade. The fact that some, indeed, many of them, are gay has added a special edge to that vision.

Still, there are reasons beyond the talent and commitment of its participants that have made this parade successful. Not all "invented traditions" succeed, and those that do must rely to some extent on setting. The typical New York City parade up or down Fifth Avenue leaves behind as a memento nothing more than litter, the proverbial pumpkin after the ball; but when the Halloween parade is over, the streets of Greenwich Village retain a certain aura. The neighborhood is filled with tens of thousands, perhaps hundreds of thousands, of people milling about entirely unself-consciously in their costumes, and many of the public buildings, commercial establishments, and private homes sport their own Halloween decorations.

But there are factors other than its link to a particular neighborhood that contribute to the power of the Halloween parade. The event crosses the city's social and cultural boundaries, appealing more to an autonomous self unfettered by ethnic, class, or sexual identities, and linking participants through a common interest in assuming fantasy personae (the devil waiting to get loose, one might say). Most participants are former spectators who "joined the parade to see it better." Even the spectators tend to dress up for the occasion, thereby blurring to some degree the distinction between audience and actors. Also, unlike the ethnic parades and other holiday celebrations that have typically degenerated into what are virtually commercial fairs through the presence of so many purveyors of flags, buttons, tee-shirts, and other mass-marketed paraphernalia, the Halloween parade has no souvenir vendors aside from a few individuals hawking magic wands. For many people, it retains a certain feeling of purity despite the presence of a small number of commercial floats. Finally, while every other parade in the city strives for official recognition, this parade has no celebrities or political leaders at its head. It therefore has a quality of the unofficial, of counterculture. But it is counterculture only in a sense, because its size alone—well over a million spectators and tens of thousands of participants—suggests that the parade has successfully found a niche in the life of the city. Indeed, the increasing presence of international television and film crews (CNN, Japanese, and French, to name just a few) proves that the Greenwich Village Halloween Parade is no longer, as the New York *Daily News* suggested on October 25, 1984, "on the verge of becoming a major, major tourist event as an East coast version of the Mardi Gras." It already is, infusing according to recent estimates some $60 million into the local economy.

Parades are not easy things to document—particularly not night parades attracting hundreds of thousands of people, and particularly not this fast-moving event in which most participants wear costumes that have only a thin connection (if any) to the spirits and monsters normally associated with Halloween. And there are those intangibles that are so much a part of the spectacle, yet make it so difficult to capture the experience in words or on film: *music*—the almost continuous blaring sound of marching mariachi, reggae, and even klezmer bands interspersed among the other elements of the parade; *noise*—the cheers from the audience for outstanding costumes and the mostly friendly catcalls for the outlandish drag queens; *size*—giant

snakes, dinosaurs, hags on stilts, and skeletons, all designed both to frighten and delight; *color*—vivid reds, golds, greens, and purples intended by their creators to dazzle, especially against the black backdrop of night; and *commentary*—countless lampoons of various political figures, both national and international. In the audience many are dressed in Halloween costumes, and the masks—mixed among the seemingly normal faces—somehow seem much more frightening than anything in the parade. Even the squad cars from the local police precinct are sometimes driven by police wearing vampire fangs. What pervades the event is not so much the complete transformation of reality into a world upside down as the sudden juxtaposition of two worlds: one upside down and the other right side up, that the familiar can sometimes seem entirely unfamiliar and that unfamiliar things can move so easily in the world of the familiar. The result is a powerful sense of irony growing out of a collective recognition of this rather easily effected transposition of order and chaos. Little wonder that so many who are present, either as spectators or as participants, consider the parade a metaphor for the peculiar combination of chaos and creativity that characterizes daily life in New York City.

Others, however, consider such transpositions of order and chaos to be a collective "meditation on the arbitrary nature of gender roles."[1] Indeed, when nonparticipants talk about the parade, they often refer to it as "the gay parade." Flamboyant drag queens have long been a staple of this event: Brazilian-inspired caricata (impersonators of women with exaggerated breasts and buttocks); a drag queen Barbara Bush seated in a black limousine flanked by secret service "men" (actually women dressed as men) wearing black suits, fedoras, and dark spectacles; and four can-can dancing drag queen stewardesses, each holding a giant letter, which combined with the others spelled "TWAT." But the parade is hardly the exclusive domain of gay New York, and campy humor extends well beyond the confines of the drag queen. A man looking to create a costume at the last minute decided to wear a clothes line on his head complete with drying shirts and socks; another (spoofing the countless New York pizza parlors named "Ray's Famous Pizza," "Ray's House of Pizza," "Ray's Original Pizza," "Ray's Real Pizza," and just plain "Ray's Pizza") dressed as a giant slice of pizza with a sign that read "The Original Ray's Pizza."

Although strange juxtapositions are central to this event, not everything at the parade is intended to be humorous. The Halloween parade draws quite a few people determined to address New Yorkers on behalf of a particular cause. Bread and Puppet Theater in 1991 mounted three huge tableaux protesting (1) Columbus's enslavement of Native Americans, (2) the recent killing of 100,000 Iraqi soldiers during the Persian Gulf War, and (3) the confirmation of Clarence Thomas to the Supreme Court. The spectacular nature of these tableaux—their amazing height as well as the large number of individuals participating in them—can inspire a sense of wonder even in those with little sympathy for the political message. But even political costumers tend to use satire to bridge the gap between their message and the parade's underlying spirit of irreverence. In 1992, a few days before the presidential election, one couple came as "A Thousand Points of Light" and the Easter Bunny. "If you believe in one," they explained, "you're just as likely to believe in the other." Another man dressed as Gen. Douglas MacArthur held up a sign that read, "I knew Harry Truman and you're no Harry Truman" (a reference to Sen. Lloyd Benson's slighting of Dan Quayle in the 1988 presidential campaign). The 1991 parade saw a couple dressed as a flapper and Franklin D. Roosevelt holding up a sign that read, "If you liked the Depression, you'll love this" (a reference to the current recession's devastating impact on New York's economy); and in the same year, a man came as Saddam Hussein in an electric chair with George Bush standing by his side about to pull the switch. Given such reliance on humor, not all the political statements are readily classifiable as partisan to the left or the right: in 1992, Fidel Castro appeared posing beside a drag Barbara Bush and throughout the parade kept mediating a "squabble" taking place between two people dressed as Bill Clinton and George Bush.

While those who participate just to have a good time are probably as strongly represented as those who proseletyze for a cause, many don their costumes determined to reveal something about their inner selves. A handsome forty-year-old black man dresses as a Next Generation Star Trek Tellurian in black pants and silver tuxedo, the back of his head merging with an electrically lit white beach ball. Each year he comes as a space alien because "It's the only American monster.

Besides I feel

like an alien.

I'm the only Republican in New York." Another man dressed as a businessman with attaché case, bowler hat, and sun glasses and carrying a sign reading "Death Yuppie" is a Wall Street systems analyst who still cherishes his former life in the theater. Two young women wear Thelma and Louise tee-shirts, a cardboard car emerging in front and behind them. As they are about to discuss the meaning of their costume, a man whom they have never met before, disguised as a mobster/FBI agent wearing a black trench coat, fedora, and dark glasses ("I've always liked bad guys," he explains) tells them to pull over to the curb and to produce some identification. Such impromptu skits are quite common: drag queen nuns latch onto a man dressed as Jesus Christ; meanwhile, Bill Clinton vamps with Barbara Bush. Other ensembles are more elaborately planned. A group of men wearing the flimsiest of costumes based on a spider web motif parade their nearly nude bodies before the eyes of the city; a couple from New Jersey come as the Addams Family, while their teenage son dresses as Freddy Kruger.

Currently, the parade's thirty-block route along Sixth Avenue takes two hours to complete. As soon as the parade is over, a sanitation crew sweeps the street, and the avenue is quickly reopened for vehicular traffic. For those who wish to mingle, an informally organized event continues after the parade just a few blocks to the west on Christopher Street, New York's gay mecca. From Seventh Avenue South all the way west to the Hudson River, this street is closed to traffic throughout the night. The throngs of spectators make entire blocks almost impossible to traverse. And there is a physical contact here that is partly ecological—a narrow street and a sea of people—and partly ideological; bodies seem more public than private—they are meant to be gazed at, even touched. The event is referred to as "the promenade" because it features among others a large number of drag queens who strut along the street often in pairs, either acting nonchalant or actively seeking the attention and applause of spectators. Although the promenade is an annual event separate from the parade, it increasingly draws many of the same spectators and some of the same participants—both gay and straight—and there are more than a few people who prefer to attend this while avoiding the parade altogether.

Many of the Christopher Street participants design their routines according to the politics of the day; others are integral to the subculture, the stock-in-trade of drag queen entertainers. Lady Day, searching for space underneath bright street lights, carries a boom box and croons in lip-sync after she sets it down; Tammy Faye Bakker, with gobs of makeup, huge eyelashes, and holding a bible the pages of which are from *Gay American History*, harangues the crowd. Nearby is "Jessica Hahn Dog," posing for *Playdog*. A group of drag queens are dressed as girl scouts. Two more drag queens are dressed as dowdy middle-aged ladies. A transvestite nun with a mustache displays her metallic hair and wears the Hebrew letter "khay" (a common American Jewish symbol). Another "nun" stands on a balcony sprinkling holy water onto the crowd below. Next to her a man with a huge fake phallus jutting from his open bathrobe pretends to sodomize a drag queen. When he stops, she climbs the fire escape begging for more. He goes into his apartment, reemerges and simulates masturbation, then throws the liquid contents of a cup onto the crowd; he then hangs from the fire escape, assumes a semi-squatting position, and simulates defecation. Another man strokes an electrically lit phallus projecting from his groin while a drag queen dressed like a French courtier "performs" fellatio on him. On the opposite side of the street, two bare-chested young men wearing tight blue jeans exhibit their lean, muscular bodies by scaling, monkeylike, the fire escape of their third-floor apartment. The crowd below shouts its approval. When one of the climbers faces the street, people begin to chant, "Show your dick!" He begins to unzip and zip, sadistically teasing the onlookers. Elsewhere, a young man pulls his pants down and sticks his buttocks out a second-story window, much to the delight of the crowd, which demands a repeat performance. On another balcony a small group of men and women begin to tease the crowd by provocatively removing some of their clothing. A slender young woman strips down to her black negligée and exposes her breasts; eventually, at the instigation of the taunting crowd she removes her panties. She coaxes a man standing next to her to participate in a sexual pantomime by unzipping his jeans and placing her hands down the front of his pants. He leans over backward, encouraging the seduction. Another partly undressed woman mounts the nearly naked woman from behind and the three are joined, their bodies moving rhythmically. In the middle of the street, two men stand

on a platform and undress. When their clothes are off, one mounts the other from behind. Each time someone disrobes, the crowd suddenly swells, mysteriously sensing something salacious about to occur. The crowd pushes forward continually, each person hoping for an unencumbered view. At the edge of the throng one young man, very drunk and apparently disturbed by the activity, shouts viciously, "You fuckin' fags. I hope you all get AIDS. You perverts!" For long minutes at a time the flow of human traffic grinds to a halt. The air is thick with eroticism menacingly tinged by this lone voice of rage. Then the two young men quickly dress. The crowd disperses. The young drunk moves along. At a nearby cross street, a phalanx of police officers keeps an unmeddlesome eye on the goings on. No longer the guardians of public morality, they function entirely as traffic cops, restraining pedestrians from disrupting traffic.

Many who come to the promenade are casual visitors rather than costumed drag queens. Some, in fact, are scattered remnants of the parade seeking a little more time in the spotlight. An Arab walks by with a rug protruding from his middle as if he were riding a magic carpet. In the crowd are characters from the Wizard of Oz, a man wearing an upside-down metal colander with long strands of dried spaghetti emerging from the holes, and two men dressed as giant cloves of garlic. Toward the westernmost end of the street are two young men dressed as grotesque space aliens with flashing red eyes, silver boots and sequined hats, black zippered coats and long rubber fingers.

"We're not from here. We're from outer space,"

they explain with Hispanic accents. For the next few minutes a perfectly absurd conversation takes place on the relative age of space aliens and the time it takes to get from one universe to another, on the difficulty of finding parking space for space ships, and the best place to eat blood in Manhattan.

Although a good many children attend the Greenwich Village Halloween Parade, the event is hardly organized with them in mind. Indeed, the parade's licentiousness, as we shall see, has managed to upset and even provoke the hostility of a small number of neighborhood residents who insist, even now, that "Halloween is a children's holiday, not a Mardi Gras!" Although it may be true that historically Halloween was not a Mardi Gras, it wasn't really a children's holiday either, at least not until very recent times.

While Halloween has long been a much-cherished holiday in this country for children and adults alike, its origins are tied to the British Isles, in particular to Ireland where the holiday developed among adults, not children, and continued even after the advent of Christianity as an indigenous blend of native and Catholic beliefs. For the Druids, October 31 marked the end of the year, a time when herdsmen had to find shelter for their livestock for the winter. It was also a time of ending, a symbolic death when the world of the living and the spirit world were less divided and the living, therefore, felt compelled to propitiate the dead through food.[2] This custom, transformed by the Church to house visits and the offering of "soul cakes" in exchange for blessings, is the likely origin of trick or treating. Although the Church intended to dress the holiday in its own religious garb, masquerading as beasts and monsters may just as well have been an act of popular revelry as a celebration of Christian saints and angels. Masqueraders would march from house to house using carved-out beets or turnips as lanterns to guide their way. Irish immigrants brought Halloween to America, and Halloween revelers turned to a much handier device for making lanterns—the pumpkin.[3]

The holiday became a day for children in the New World, but this may have less to do with an American disenchantment with the world of spirits than with a Victorian-age sensibility and its disdain for adult misbehavior. Halloween's increasing popularity as an American adult festival may partly speak to a decline in modernism's rationalist paradigm and the resulting possibility of religious enchantment, given the emerging popularity of New Age religious beliefs and practices such as channeling and psychic readings. But it also has a lot to do with the license the event provides to express repressed aspects of the self, a type of behavior that became quite familiar throughout the 1970s, the period during which the parade emerged. This license provides an opportunity to publicly display oneself

or one's vision of the world as well as offering a chance to misbehave. Indeed much of the appeal of the parade is connected to the use of masks, which allows people to transform themselves, to assume other identities, to enter the world of fantasy for no particular reason other than the pleasure that such release brings. For most people, even the relatively innocuous masking for a costume party is a venture well beyond the world of the familiar. But for many of those who participate in the parade, the world is transformed and the city reimagined, at least for a few hours each year—not as a place of conflict and fear but of eroticism and creative cultural encounters.

My initial contact with this parade began in the mid-1970s when I was still a resident of Greenwich Village, and I caught a glimpse of the parade quite by accident on the way home from work. Charmed by what I saw, I immediately became a committed spectator, attending annually and sometimes wearing a face mask purchased on the fly from an impromptu street vendor the day of the parade. When the group whose photographs are featured in this book asked me to work with them, my interest became professional. Anthropologists have long been interested in the ways that people dramatize their culture and in doing so articulate seemingly coherent collective identities out of all the many possibilities that underlie social life. Festivals are collective dramatizations, and the more anthropologists have turned their attention to complex societies, the more interested they have become in such events, using them as windows, so to speak, to understand other aspects of social and cultural behavior. Although I have drawn much of my understanding of the meaning of public celebrations from such studies, this book is also rooted in current theory in cultural anthropology, particularly its stress on the emergent and multivocal nature of culture, with competing interests and conflicting sensibilities continually struggling to assert themselves. I have tried to present the material accordingly, thereby re-creating the sometimes overwhelming diversity of this event. This book is rooted, too, in humanistic anthropology's commitment to the actual voices of informants. However, I have edited where necessary for the sake of clarity, and to retain on the printed page the eloquence of words originally intended to be listened to rather than read.

The chapters follow the chronology of the parade's development and the changing constituency of its principal participants. "You Got Voodoo in You," "A Real Spiritual Break," and "A Planet to Live On" trace the history of the parade through the eyes of its founder and successor, examining their sometimes opposing visions for the event and their responses to the parade's changing constituencies. "Something They're Not Supposed to Be" and "What Halloween Is About" explore the rise and fall of "the gay parade." "Making Art" and "Nobody Else Is Fidel" look at the event through the eyes of largely straight participants. "It's My Time to Shine" and "To Be a Part of It" consider the way the Halloween parade reenvisions the contemporary city.

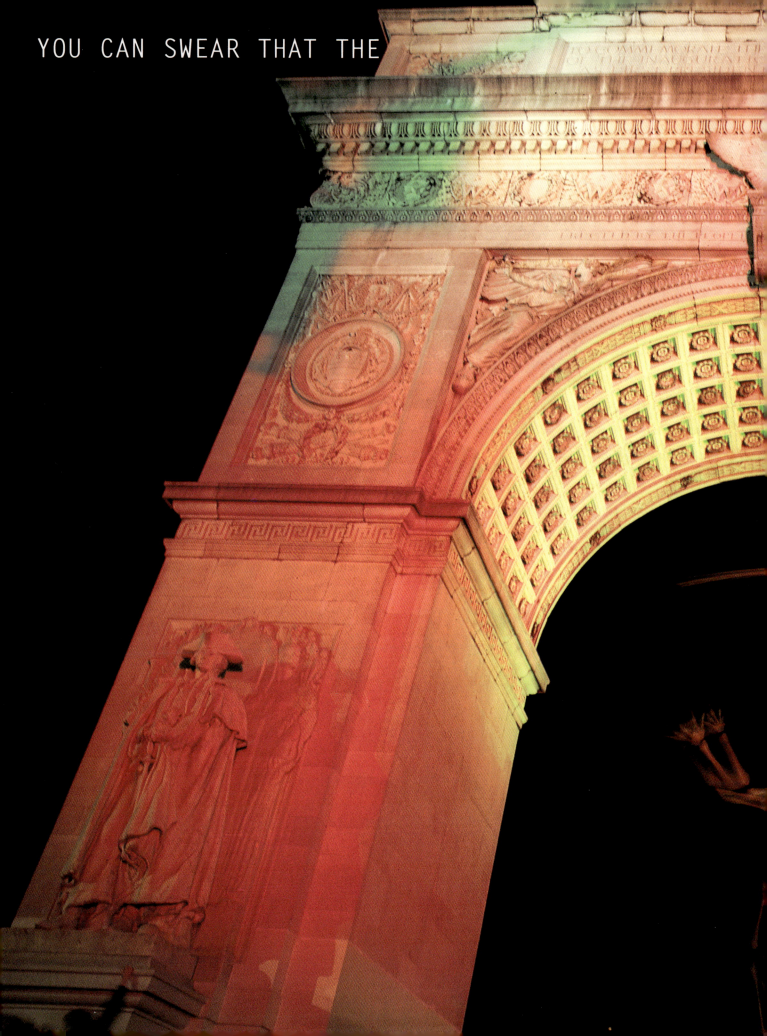

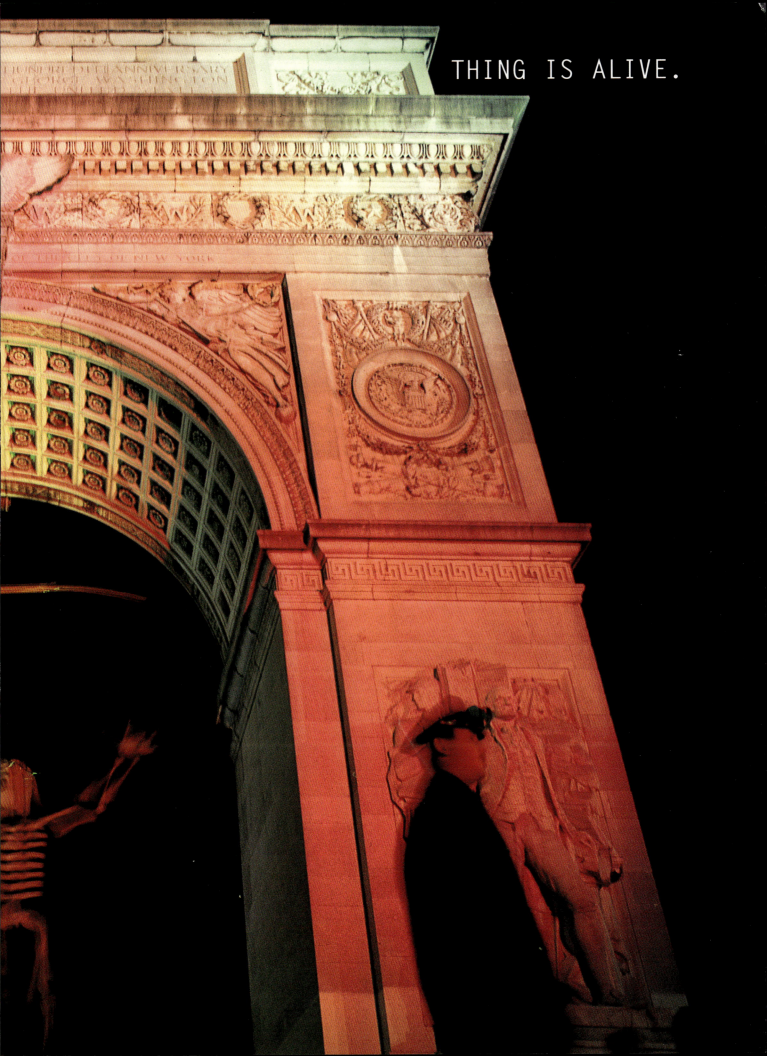

You Got Voodoo in You

On Halloween night in 1974, Ralph Lee, a mask maker and theater director, with the help of the Theater for the New City, convinced 150 friends and acquaintances to march through the streets of Greenwich Village wearing his masks and carrying his giant puppets. In doing so, Lee began a tradition that would quickly assume a life of its own, growing on a scale beyond anyone's expectation, least of all his. Lee responded by designing or incorporating from other performances ever more spectacular figures, including a 30-foot skeleton called the "Ghost of Tom" that was carried through the streets and then inside the arch at Washington Square where it performed a macabre dance; a 40-foot articulated snake capable of reaching down to kiss young children in the crowd; a giant Irish sea god riding in a chariot; and a 20-foot three-masted ship complete with scurrying rats. To help create the proper backdrop, Lee also designed the giant spider that each year climbs the side of the Jefferson Market Library and other creatures that emerged from buildings or otherwise made their appearances during the night's activities.

As the parade continued to grow, Lee sought ways to keep the event intimate. He eschewed the use of a reviewing stand, and as long as he could get away with it there were no barricades to separate participants from spectators. He tried to scatter the crowd by attracting them to eccentric vignettes, largely masked figures that he placed on various buildings along the parade's route. And he choreographed small performances at squares and landmarks throughout Greenwich Village. At a local church, for example, a group of angels would suddenly emerge to be challenged by devils who in turn were attacked and defeated by a militant saint.

Lee was particularly proud of the parade's crosstown route, which zigzagged eastward from the West Village to Washington Square Park. The very contrariness of the itinerary (most New York City parades march up or down Fifth Avenue) suggested the topsy turviness of Halloween. As the crowds increased, Lee agreed to adjust the route, but he was determined to preserve its street theater quality. He designed activities for people to do once they reached the park—singing, dancing, and watching an assortment of street performers placed around the square. According to Lee, "We would try to put as many things out there as possible that were traditional Halloween images. But there were also creatures in the parade from other theater productions that had little to do with Halloween. They were just colorful digressions, or deities of one sort or another."

For anyone watching the event, what they saw was a tour de force, the brainchild of a mask maker theater director bent on charming, if not in some way changing, the city he had come to call his home. So when Lee announced that

1985 was to be his final year as organizer of the parade, I was curious to learn why he was abandoning a project that was so much stamped by his personal vision. Lee agreed to meet with me at La Mama, an experimental theater in New York City's East Village where he was directing a play. True to his creative and intellectual passions, the play was based on a Native American myth. It was graphic and dreamlike, incorporating giant puppets, which he had created specifically for the piece. I asked about the connection between his plays and the parade. Lee began by speaking about the masks and puppets that appear in both.

"In theater, the visual images turn people on in a different way. When it's in a parade it's like a surprise creature being amongst everybody. And people really get excited about the size of it, because masks really are magic. You are looking at an inanimate object and you can swear that the thing is alive. I think that's why people—at least in our kind of culture—find them compelling. In other cultures they have to do very specifically with cosmology and the spirit world. For us that connection is not as clear.

"I often feel that a mask is like a child in a way and oftentimes the effort of making them is the effort of giving birth. I once had this retrospective of my work inside the mall at the Graduate Center of the City University. One day I was looking at it when this black guy came through. I was talking to him and when he found out that I had made these he said: 'Man, you got voodoo in you.' I was very tickled by that. It's nice to think that I've taken on a kind of shamanistic role. I do like to think that I change people's lives a little bit, because that's the purpose of doing the parade. It's to somehow help people make connections with the forces in nature or spirits that they might have forgotten about, and to bring these forces back to people's lives, to make people aware of certain kinds of potentials that might be there.

"Perhaps my creations have helped guide people in one direction or another. After all, even if most of the spirits have a ferocious or terrifying energy, they are relatively benign. And I seek out people to work the figures who have a positive outlook. And the parade helps people make connections just by the fact that it charges people up. It warms their insides. Energies are allowed to flow between people. The mask in that situation gives people permission to play with each other and to assume roles that give vent to things. The obvious example is gay people. For them to be able to be out there in the street doing their dream personae is pretty fantastic. And it's true for others as well. If somebody wants to be Ronald Reagan to the nth degree, he can do it. Or be Nixon or be some witch or guru or whatever. I don't even think people are aware of what they are revealing about themselves a lot of the time."

When I asked Lee about the parade's connection to Greenwich Village, his response revealed the strength of his theatrical vision, particularly his sense of setting. But it also cut directly to the source of his displeasure with the event's evolution, especially the loss of valued elements as a result of the parade's spectacular growth.

"Halloween has a lot to do with nature and the changing seasons and the fact that there are all those bare branches is a great backdrop to Halloween. You see a figure against those branches you can imagine yourself in the countryside. I always envisioned the parade not as a parade but as a theater event. Environment to me was very important. I liked the small streets.

I used to think that this event had something to do with neighborhood.

It used to be essential to me that the parade was part of the West Village: the narrow streets; the fact that the buildings and windows are close to the street, so that you can have masks in the windows and they can relate to the people in the streets. You get more idiosyncratic buildings, more old quirky buildings that are sagging on one end. It has a small town or Old World feeling about it. Because it's like an ancient ritual we are reenacting, the environment can help in a big way. And you can't get that on a major avenue.

"So this was meant to be a Greenwich Village community event, and I didn't think of it as a New York City event.

It turned into that, but it was never my impulse to create a city parade. My hope was that people might come to this parade and be inspired to create something similar in their own communities rather than bring more people here. Because something can happen when you have that sense of intimacy that will never happen when you have half of New Jersey and Long Island present. There's a kind of trust. People open their doors. They stand on their doorsteps. You have this wonderful interaction between people. A real spirit of friendliness emerges.

"Of course, keeping the parade small was important because I also wanted to keep it democratic—no automobiles with people throwing things to the masses. In fact, we had nine sweepers on stilts who looked like spirit women of one sort or another. They were at the head of the parade. They had brooms and they would sweep the pavement, getting the automotive vibes out and cleaning the streets up for people to be in. So when folks came to me with ideas of putting things on trucks, I would just say, 'No. I don't want that. There's enough carbon monoxide on the streets. Give us a break!' Or there were people who wanted to have their special cars in the parade, and I just said, 'You can have your car in the parade if you push it!' They would even do it sometimes, especially these great funny cars. The same thing applied to the reviewing stand. I did not want to have people up there judging other people. Bellah Abzug was there. Who knows, maybe Mayor Koch was there, too. But if politicians wanted to come there and campaign, they had to do so on other peoples' level, not from a reviewing stand.

"It gives me a good feeling to know that this has triggered something in so many people. When I was growing up, I was the person that nobody understood. Yet there have been moments in my life when I have realized that I was really connecting with people. It's mind-boggling to see hundreds of thousands of people in the street hopping up and down and know that somehow you've made them all hop. Not that it's only me who's done it, but without me they wouldn't be there. It's a wonderful thing, and it's kind of terrifying, too. In fact, there have been times when I've been in the parade by myself and I seem to lose my personality. It's partly just sheer exhaustion and the fact that there's nobody around that I know who I can talk to. So it becomes just too overwhelming and I have to get out of the parade.

"Is there a central story that I've created and that I expect people to act out? The answer is no. I never felt there was one story in the parade. There are certain characters that I create, and they inhabit certain spaces for certain reasons. But people make their own stories out of it, they certainly establish their own relationships both to my characters and to the parade. I've been curious about to what degree the parade is responsible for the revival of Halloween in general in the city. And maybe one reason why for me to disappear might be a good thing, is because then other people would be forced to pick up the pieces."

HUNDREDS OF THOUSANDS OF PEOPLE IN

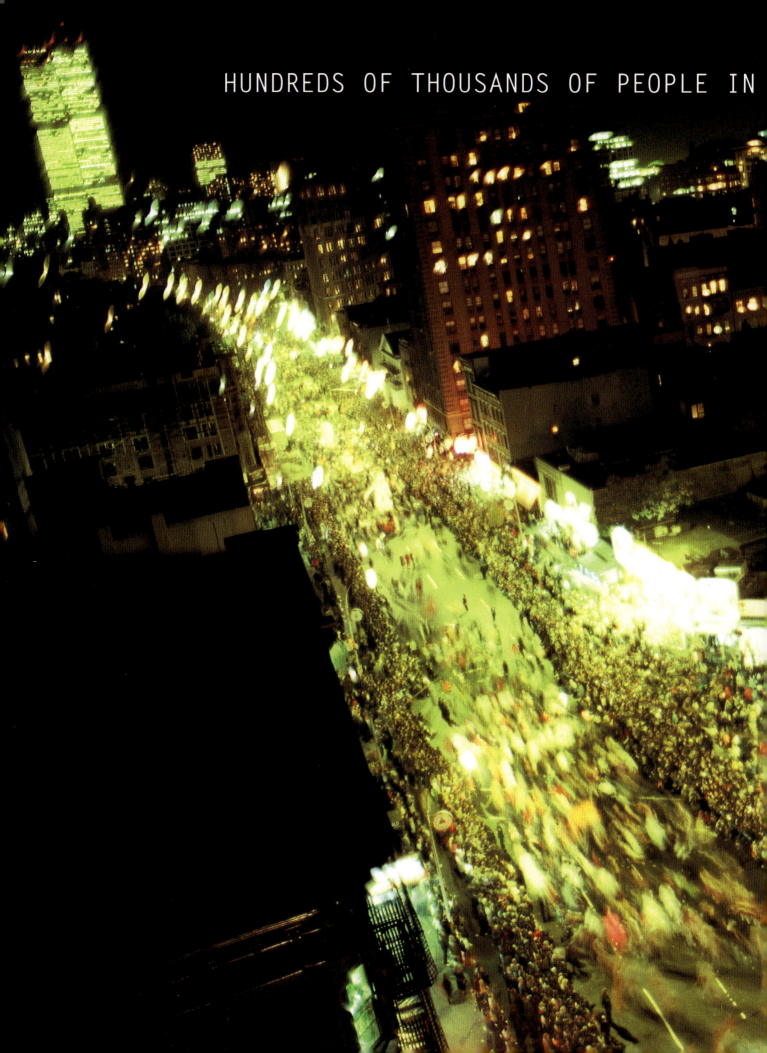

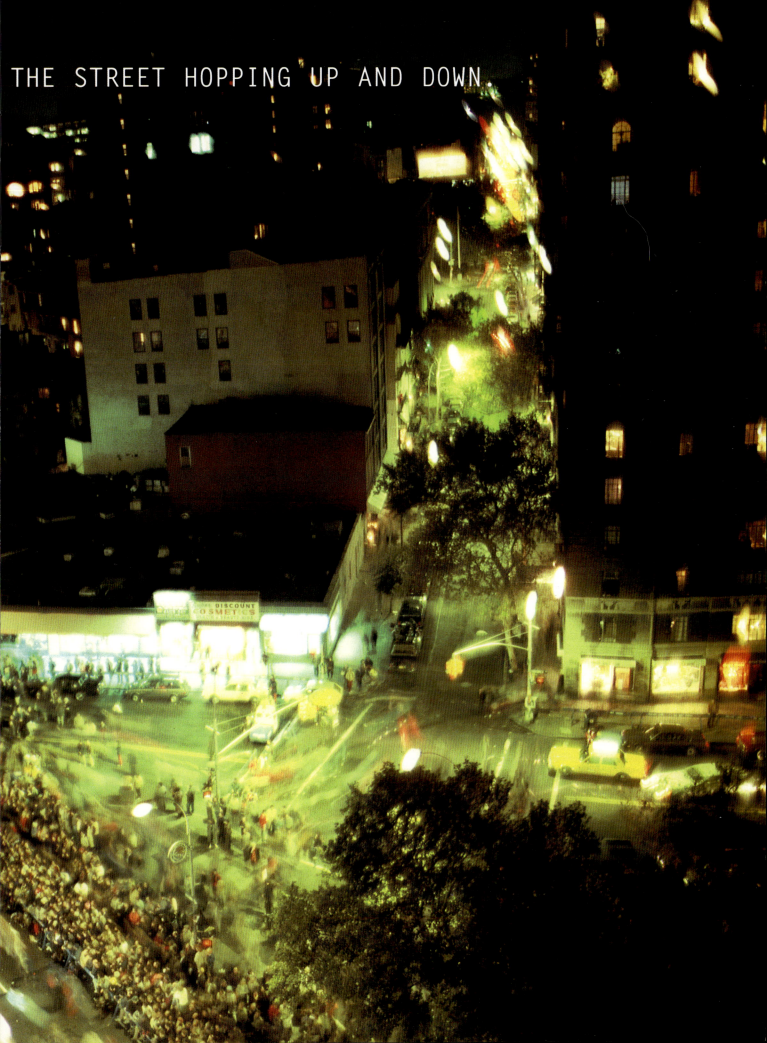
THE STREET HOPPING UP AND DOWN.

A Real Spiritual Break

Ralph Lee's decision to get out of the parade for good was partly connected to the strain of managing an event of this scale. The once intimate parade that used to take no more than an hour now required many hours, and that length of time was only partly due to the increased number of marchers. What disturbed Lee was that the event was less and less participatory and that most of the spectators now coming to see the parade were passive onlookers. Indeed, Lee had begun to consider the parade a monster. It had gotten too big, and even some of the parade's organizers were beginning to consider the density of the crowds ominous.

The 1982 parade's stage manager recalls what it was like to lead the event and confront masses of people crowding in on the marchers at one major intersection: "The truck came to a halt. I said, 'Please move out of the way.' And as the truck inched forward there was a chant that was started in the crowd yelling, 'Stop the truck!' I realized that 10,000 people were yelling at me.

They wanted to hurt me because I was on top of this truck."

To cope with the logistics of large crowds, changes were made, albeit reluctantly: barricades were introduced to separate spectators from participants, and notices were posted by the traffic department banning cars from parking along the parade's route. Eventually the route itself was

changed to allow more room for spectators. By 1985 the parade was considered too large an event to hold in the heart of old Greenwich Village—a route extending from Westbeth (the artists' housing in a recycled industrial building near the Hudson River), winding its way crosstown along several narrow brownstone streets, and finishing at the foot of Fifth Avenue in Washington Square Park.

For security reasons, the parade was switched to Sixth Avenue, a bland modern boulevard that could better accommodate the half million spectators who by the 1980s were coming from all over the metropolitan region. The parade detoured east at West Tenth Street because of the still favorable attitude of the block association, which provided a token reminder of the event's former circuit of narrow twisting streets and old brownstones, then turned up University Place, eventually ending at Union Square. In 1987, after considerable pressure from property owners in the Tenth Street block association, some of whom feared that the weight of tenant spectators piling onto aged balconies posed a threat to life and limb, the Tenth Street route was dropped and the parade was completely restricted to broad boulevards—West Houston, Sixth Avenue, and Fourteenth Street. Although the new circuit is better suited to a parade of this scale, those who recall the early years continually lament the changes. For them, the new route closes a chapter on an intimate community festival. The parade was no longer a Greenwich Village event. It belonged to all of New York City.

With its increasing size and visibility, the parade had to undergo a review by Community Board Two, the local Greenwich Village planning board. In February 1987, I attended the first meeting in which the parade's organizers were invited to discuss their plans for the fall. The meeting was used by a handful of community opponents to voice discontent about the event's size and its impact on the neighborhood. Despite testimony to the contrary (even from members of the police department), the opponents branded the parade a powder keg waiting to explode. They complained, too, that the event "had become political" and that they would "prefer a real Halloween parade, something for children."

In order to consider the issues more carefully and to solicit other opinions, the board decided to hold a special open meeting in April at which the parade would be the only issue on the agenda. When the community board met again, both opponents and supporters had brought reinforcements. For the most part, the parade's opponents were Greenwich Village property owners; the supporters were tenants. Complaints focused partly on the dangers posed by the sudden descent of so many people into an historic neighborhood. As in the February meeting, opponents also complained about the changes in the parade, the fact that it had grown too large and that it had become too political and bawdy. An older auxiliary police officer who was generally sympathetic to the existence of the parade managed to entertain the audience with a speech filled with New York cop lore and tried to mediate the two opposing sides by suggesting regulations on costumes. I cite his comments here not because of any impact they had on either side, but because they probably reveal the real basis for the discomfort opponents of the parade were feeling:

> It's not a Halloween Day parade. We just call it that. But you got every political type of cause and event showing up at our Halloween parade. If you don't like the Contras you get into the parade. If you're in favor of abortion you get into the parade. If you belong to the Association for the Prevention of Calling Pullman Porters "George" you get into the parade.

And we've had all kinds of things coming into the parade.

> Somebody was talking about bringing kids up the side streets and bringing them into the parade. I wouldn't want my grandchildren walking in the parade where some clown comes along dressed like a nun exposing a fourteen-inch dildo to the kids along the side street!

Behind much of the opposition were two closely related issues: the nature of the parade's politics—that is, its seriousness—and on the other side, its playfulness, particularly its licentiousness. "We do not want this parade,"

exclaimed one block association leader. "It's lost its meaning. It's a Mardi Gras. And Halloween is for children. It's not a Mardi Gras!"

Despite some nasty threats, opponents who attended the community board meetings failed to stop the event. Indeed, one board member who was himself opposed to the parade admitted at a public meeting that an informal poll he had conducted showed neighborhood residents to be overwhelmingly in favor of the parade. The only persistent complaint he recorded was displeasure over changes in the parade's route: local residents liked the old circuit of winding streets. Since they generally liked to view the event through the comfort of their apartment windows, the most vociferous complainers were those whose windows no longer afforded such views.

Lee had resigned by the time the community board reviewed the parade. He had left his chief lieutenant, Jeanne Fleming, in charge, and it was she who had to face the planning board. Fleming grew up in Philadelphia and received a master's degree in medieval studies. Now in her late forties she describes herself as a "celebration artist" who has devoted much of her adult life to orchestrating meaningful and frequently large-scale public events. But her involvement in this parade stemmed from personal rather than professional commitments. It began with some personal changes that prompted a journey through Africa, where she contracted hepatitis. The brush with death made her determined to pursue a long-suppressed desire to work in the theater. In 1979 she began to produce large outdoor theater pieces, and she designed clothes on the side to pay for them.

"One day after about five or six years in the clothing business I read this book called *Blue Highways* and there was a phrase in it that said, 'People who are killing time are really killing themselves.' And I realized I never wanted to touch another garment as long as I lived. So I dropped it that day and decided that I was going to find a way of making my living doing what I loved. I was on this committee of international celebration artists, and I knew Ralph Lee from that and also from being in the parade, which was always my reward to myself after the hard work of producing a fall theater piece. So a week after reading the book I saw Ralph at the committee meeting, and he told me that he wasn't going to do the parade anymore. And I said, 'You can't let the parade die! This is the best event in America—the most spirited and important event in many ways.' And I said,

'Maybe I can help you out.' In addition to directing the theater pieces, I've always been able to raise money and do all the accounting side of things, so I said that maybe I could help with it. Then I realized I was saying 'maybe.' And I just said, 'No. I'll be there. On September 1st I'll be in New York and I'll help do it.' So I did. I arrived in New York on September 1, 1983, and between that day and Halloween we substantially increased the budget for the parade."

According to Fleming, by this time Lee had pretty much lost interest in the event. "As he got more and more tired, he put less and less of his own creative effort into the parade. He also got very discouraged by the lack of support. Greenwich Village people give what amounts to $4,000 out of the whole $40,000 budget that we've done the parade on, yet people in the Village kept saying that they owned the parade and they should make decisions related to it. But then they wouldn't give any money to pay him and others to do it. And then I think he got tired of the media focusing so exclusively on outrageous drag queens, as if there was nothing else in the parade. So Ralph at that point was completely exhausted. He really didn't want to do the parade anymore."

When Lee pulled out, he was determined to make a clean break with the event. Fleming felt betrayed by Lee's decision, not so much by his leaving as by his unwillingness to let his puppets remain, because without his work the parade had lost some of its visual focus: "There still were a lot of great costumes, but I missed Ralph's work. One of the things I'd like to talk about are the sweepers because what happened with them really upset me. The sweepers walked at the front of the parade on stilts. They were old women that swept the streets of the city. They were the protective spirits of the parade—it was something about their primitive appearance, their quietness, their colors, the fact that they were performing this ritual of clearing out the bad day-to-day automotive energies in the street to prepare it for a new ritual and for magical theatrical uses. To me this was utterly important. When Ralph decided to drop out of the parade, I begged him to let us keep the sweepers. He refused. And because I believe in the power of these images, I said, 'You know, Ralph, it's almost like you're putting a curse on the parade.' And that was a real break for me with him. It was a real spiritual, philosophical break that happened between us." Lee's refusal wasn't motivated by animosity toward the event. He was reluctant to lend his puppets because of his attachment to them, which made it necessary for him to

supervise their use—something he was no longer willing to do. Besides, Lee felt "the parade should express the vision of the people running it. If I wasn't running the parade why should my images be used?"

Fleming's anger at the withdrawal of the puppets may have also stemmed from Fleming's own need to separate both herself and the parade from someone whose vision for this event, particularly its populist, sixties' libertarian spirit, is in large measure so much akin to her own. Both share a sense of the continuing need for vital public celebrations. Indeed, sounding very much like Lee, Fleming insists that "parades such as this let people see themselves as performances rather than as machines. It allows them to see the imaginative side of themselves. On Halloween night there are no social constraints. The parade gives people the license to be as weird, as sweet, as mean as they want to. They can look into their craziest mind, their deepest desire and embody it anonymously."

Like Lee, Fleming continually touts the parade's uniqueness, particularly as a participatory event. "It's fascinating to me that there are so few night parades. I don't really know of any other American event like this one. Maybe Mardi Gras in New Orleans, but the Halloween parade is better than Mardi Gras because it's not commercial. Mardi Gras doesn't allow free audience participation, so the people who come to it really are spectators. In this parade you have a choice. You really can be in it if you want to. I don't know of any other event that's open like that in the whole country. You see, to me that speaks of Greenwich Village, and it speaks of the artistic base of the parade as opposed to a city-planned event or an ethnic parade that only promotes one special group or something that's commercial like the Macy's Thanksgiving Day Parade. Populist parades of this sort always have had strong political underpinnings; this parade hasn't except in the most essential way, in that it is by its very nature a night of inversions when those who have power are out of power. The mayor of New York is not at the head of this parade. If he wants to come he has to come in disguise. So in that sense the parade is political. It's not an event that is made up of the people riding in the limousines who have the bucks. It's a parade of all the people, rich/poor, black/white, any ethnic group. You see them all there. The bands in the parade are planned to represent the wide variety of what New York City is."

Despite this apparent continuing link with Lee's vision, the more we talked, the more evident it became that Fleming had set the parade's sails on a very different tack than the one established by her predecessor. Lee sought to reacquaint New Yorkers with the spirit world, to reconnect them with nature and the changing seasons, even bringing in truckloads of swamp grass to distribute to spectators along the route of the parade. Fleming's vision has a distinctly urban tinge to it. "There's a real power of the imagination in changing people's environments. Parades let people see urban spaces not just as a place of work, but as a place for play. A parade allows people to renew their total relationship with the urban environment. Parades animate all the senses and change people's relationship to the city. It lets them look at the city in a different way. Parades provide freedom, unleashing energy. They're also connected to the cycles of nature. This is the last event before people shut themselves up in their apartments for winter. The parade releases energy for the city. It acts as a safety valve for restless leftover energy before the apartment hibernation begins." Moreover, unlike Lee, Fleming readily embraced the event's mass appeal, its integral connection to the social and, indeed, the physical landscape of the city. Take, for example, her reaction to the drastic change in the parade's itinerary and her sudden realization of this new route's dramatic possibilities:

'The strange thing is that when we had to move the parade onto Sixth Avenue, Ralph handled it very well. Perhaps he had already made his break with the event. The first time that we walked Sixth Avenue, Ralph was saying, 'It'll be all right. It'll be O.K.' And I was crying the whole way. I thought, 'How awful.' I tried to get the police to change the route to Seventh Avenue South at the last minute because I thought it looked more charming at night. It was so hard to make that change. But what saved it for me came when I turned to look down Sixth Avenue. I always walk at the head of the parade. Suddenly I saw the ancient primitive image, the parade, silhouetted against the backdrop of the World Trade Center. And then I realized what it is that makes the parade so vital—this peculiar ancient celebration that brings out the most elemental in people happening in the ultramodern cityscape of New York."

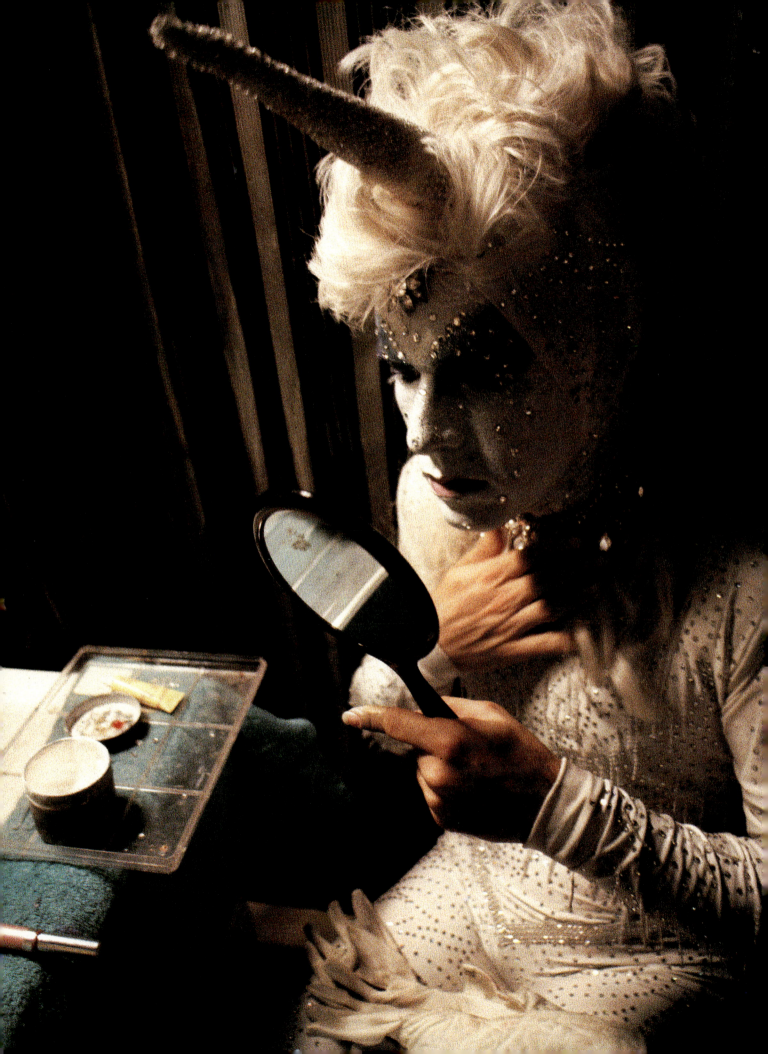

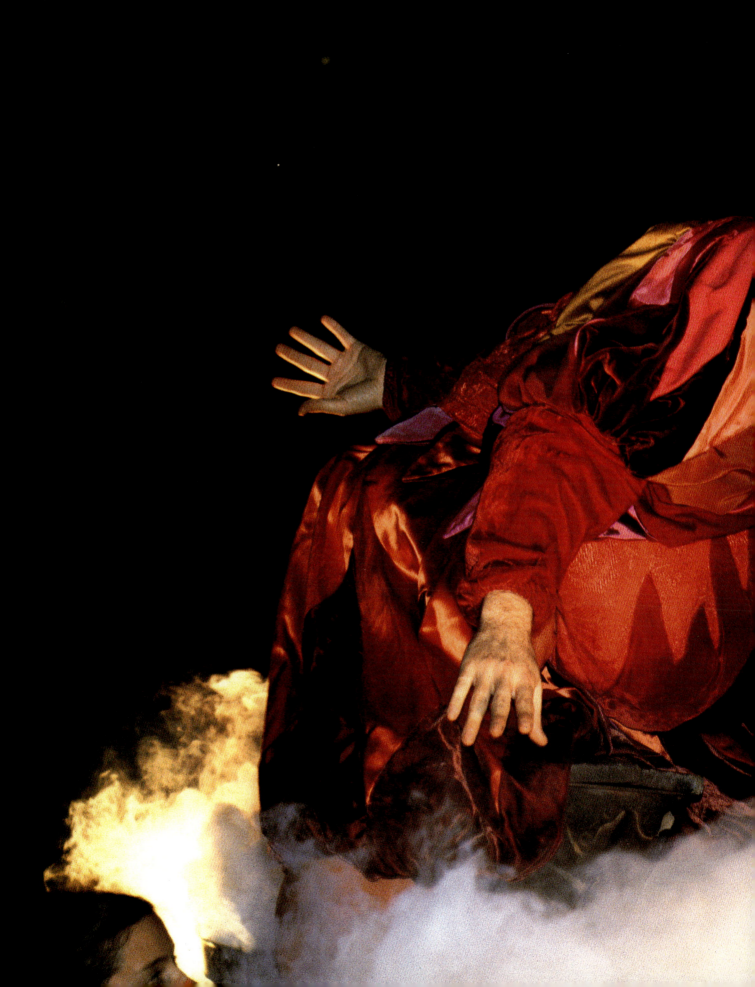

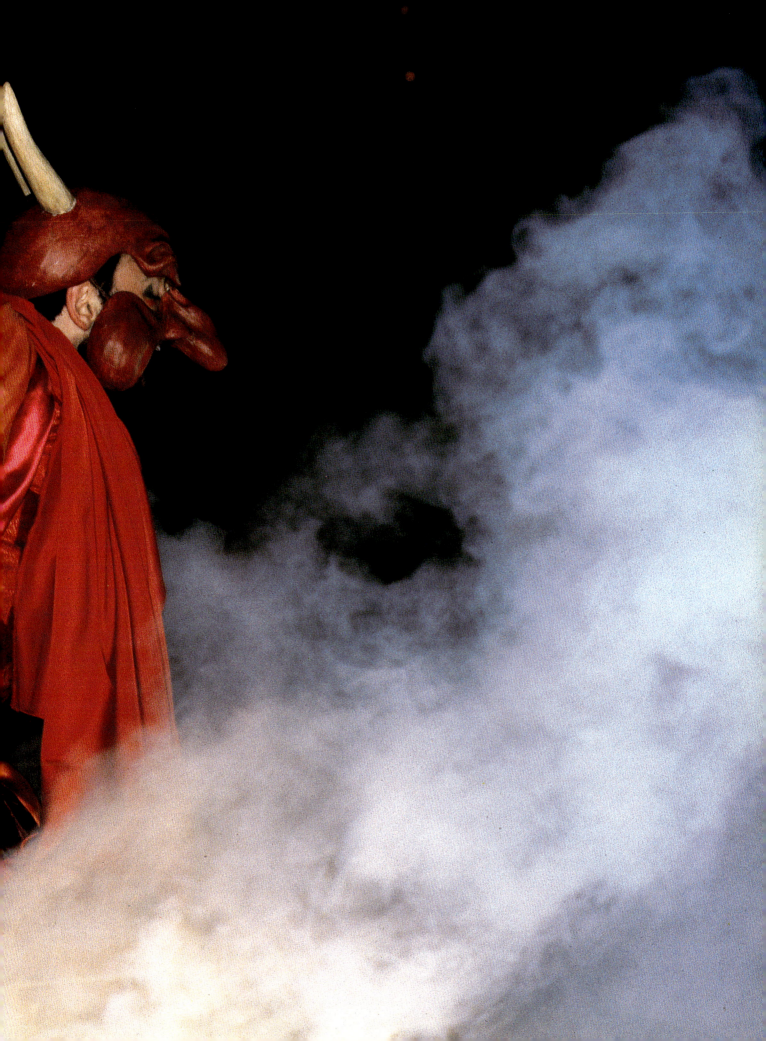

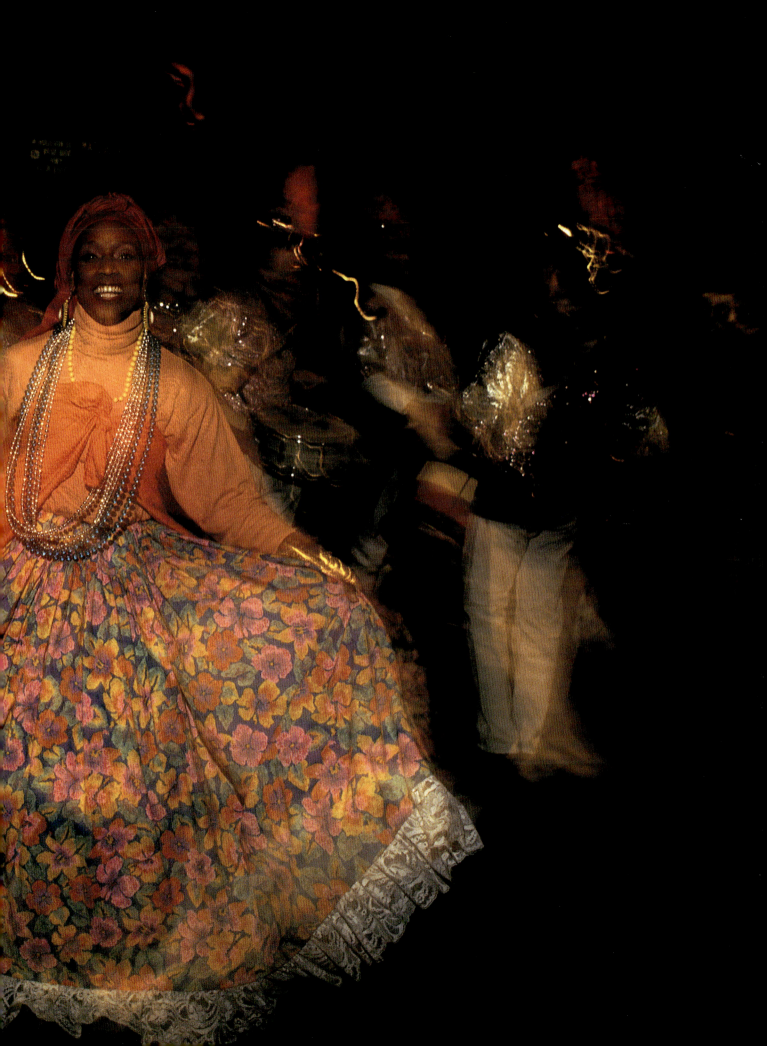

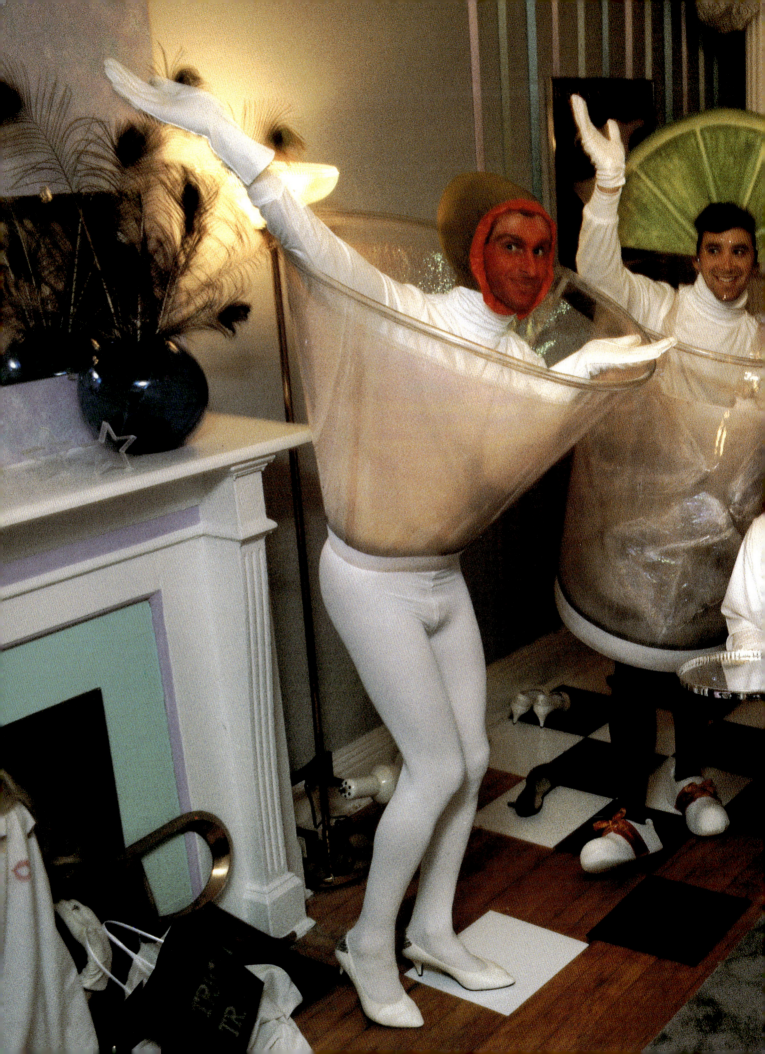

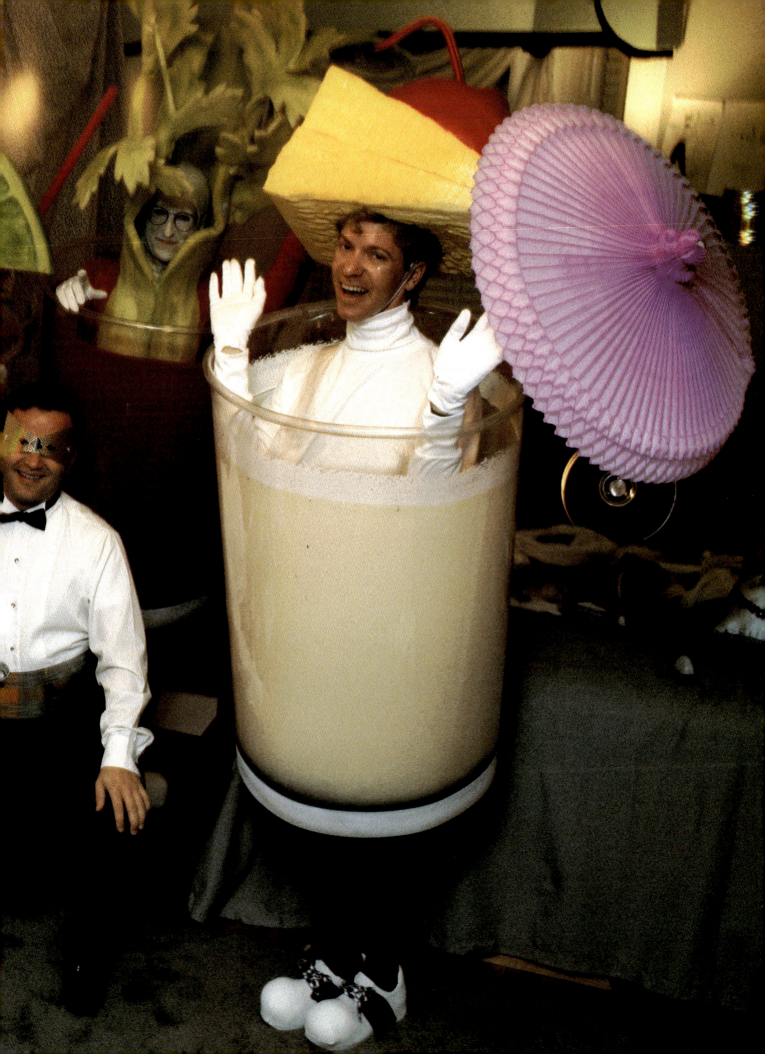

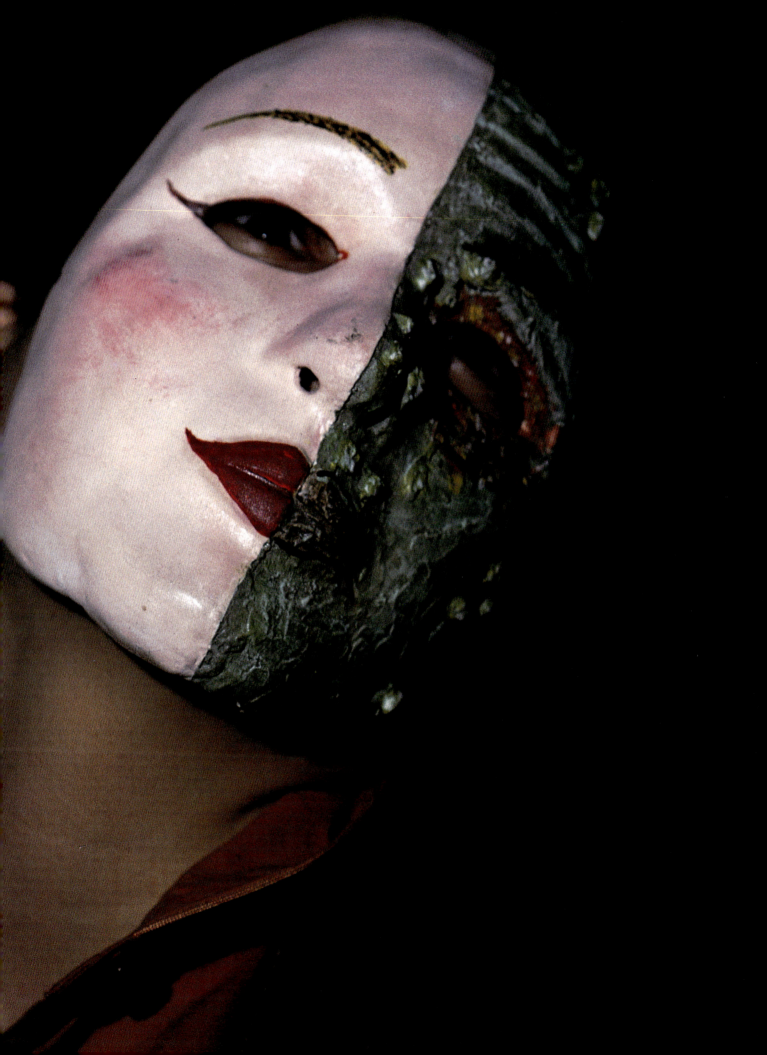

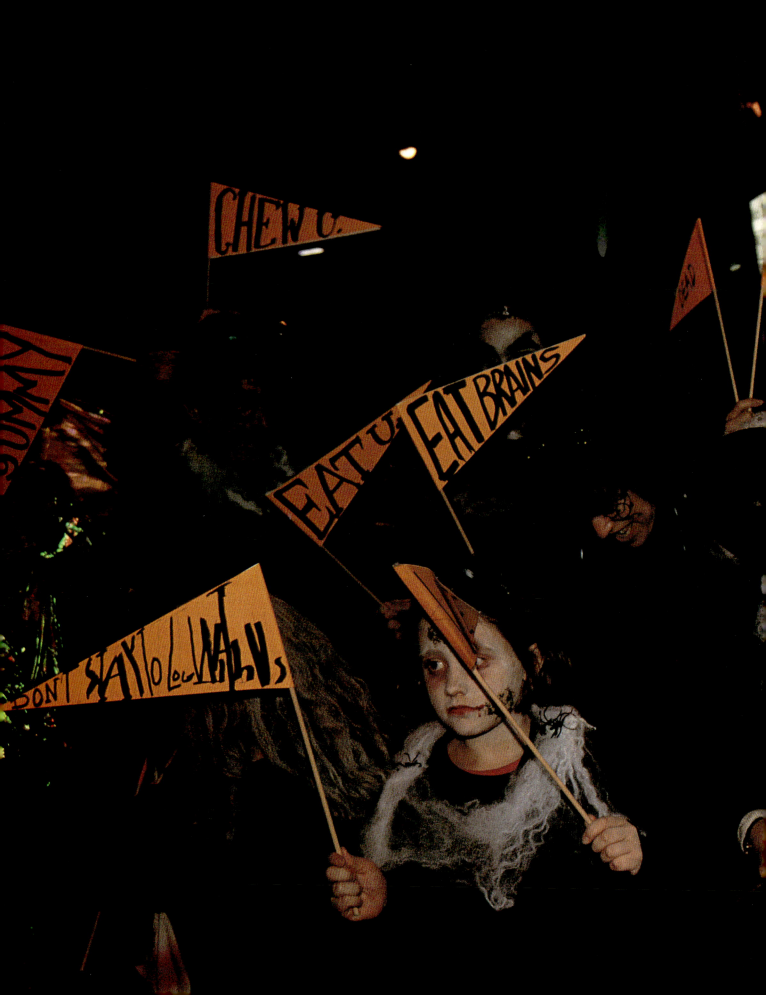

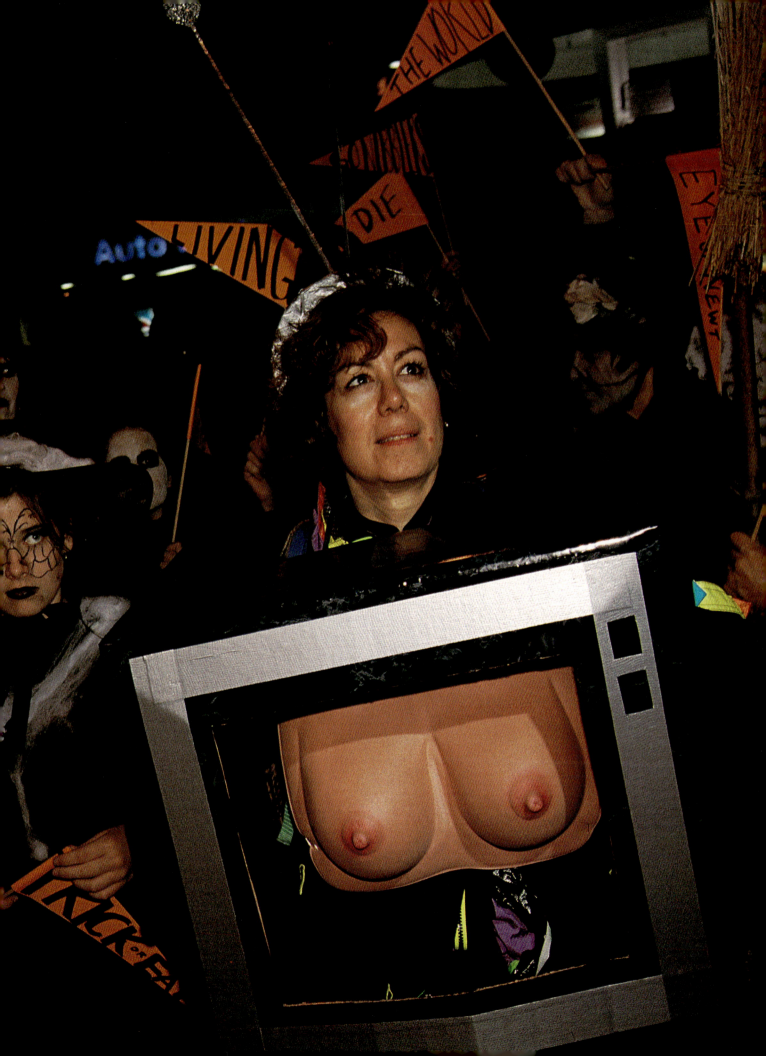

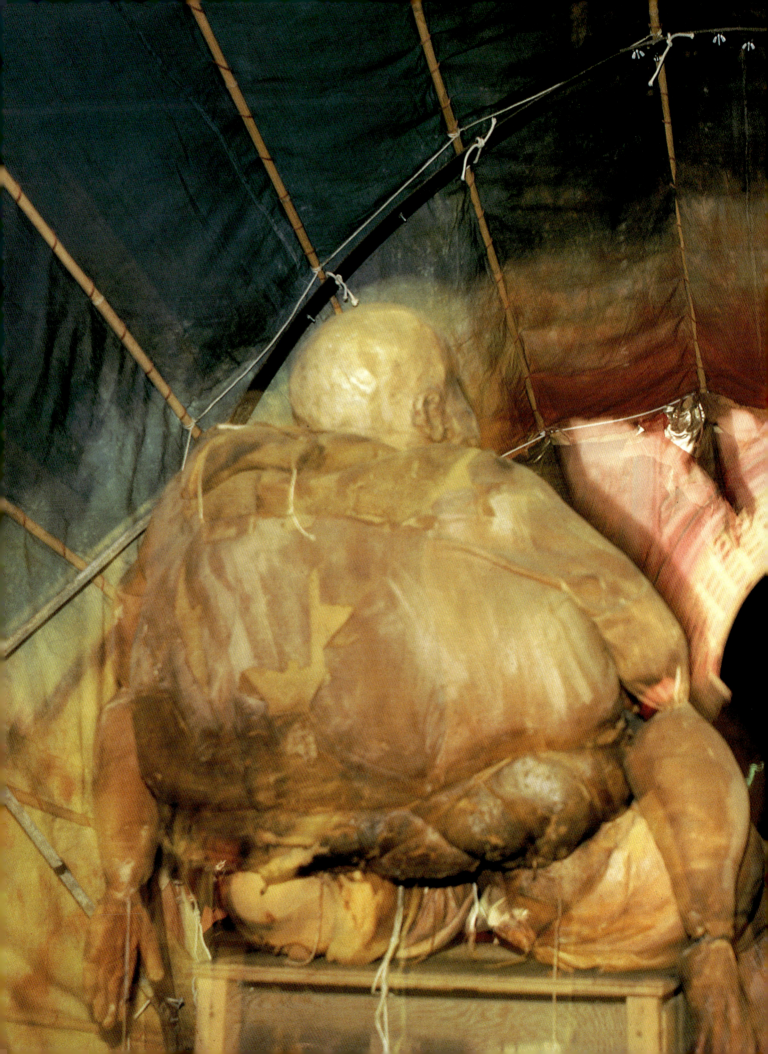

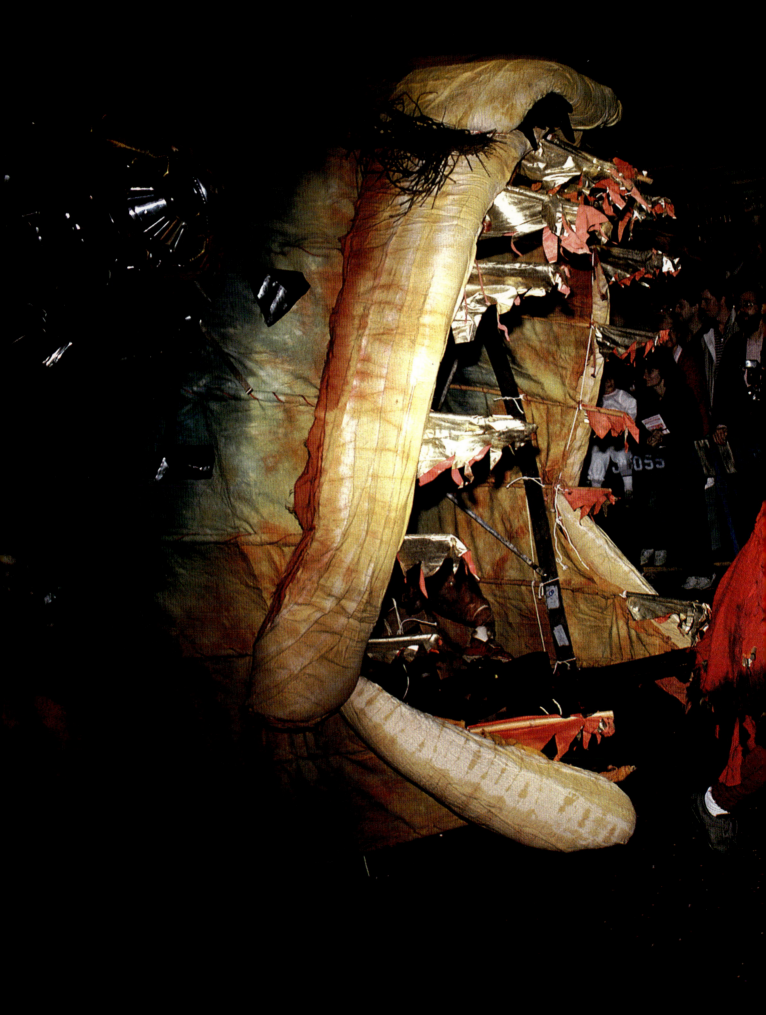

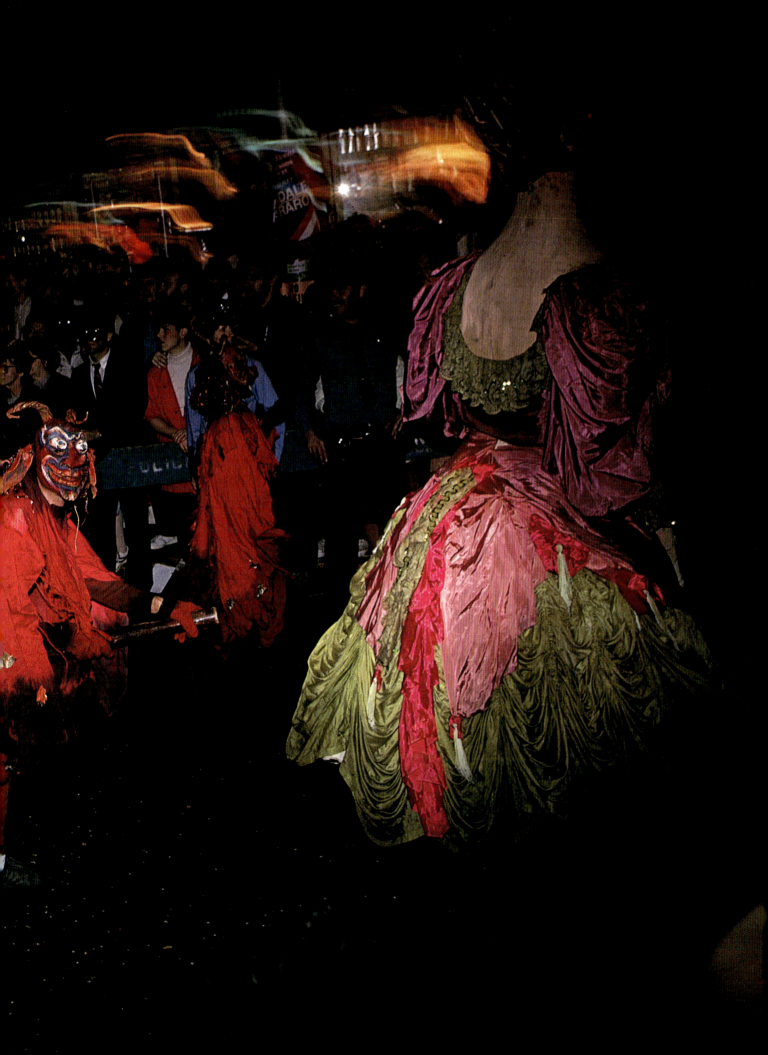

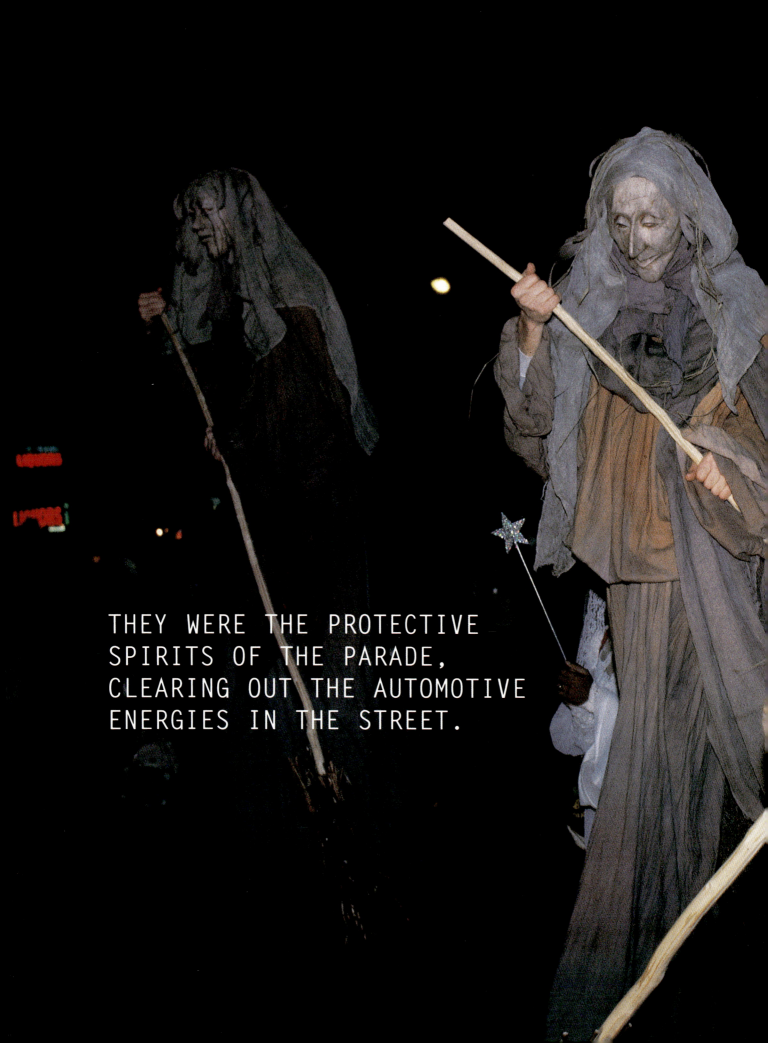

THEY WERE THE PROTECTIVE SPIRITS OF THE PARADE, CLEARING OUT THE AUTOMOTIVE ENERGIES IN THE STREET.

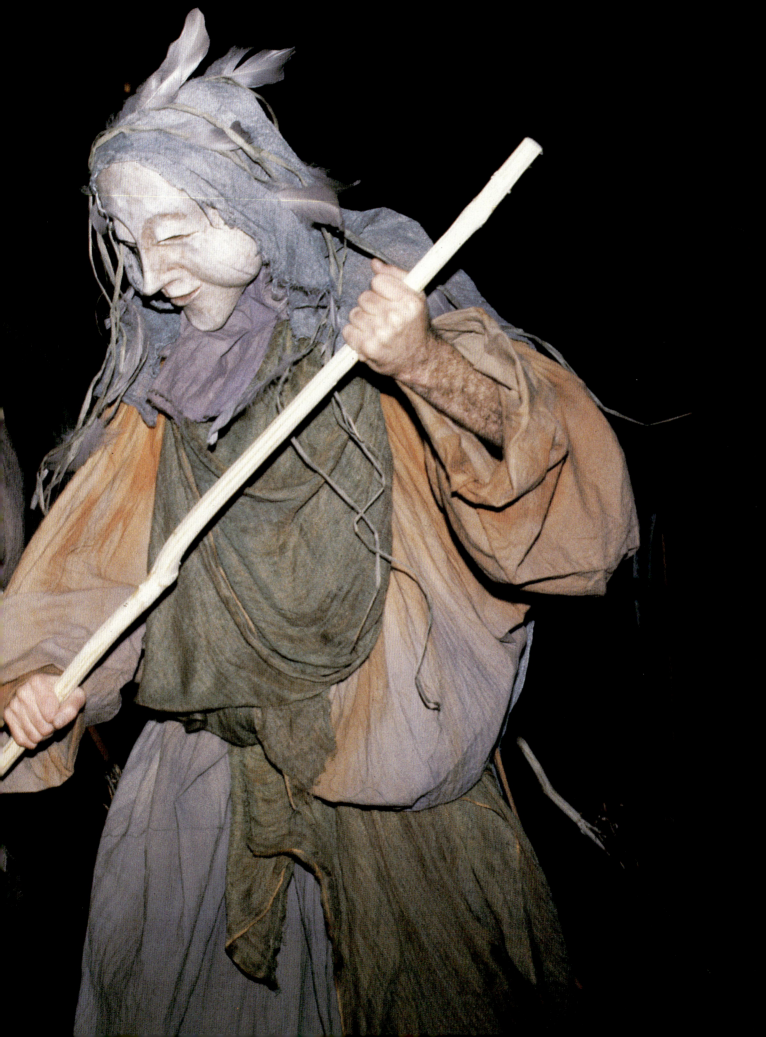

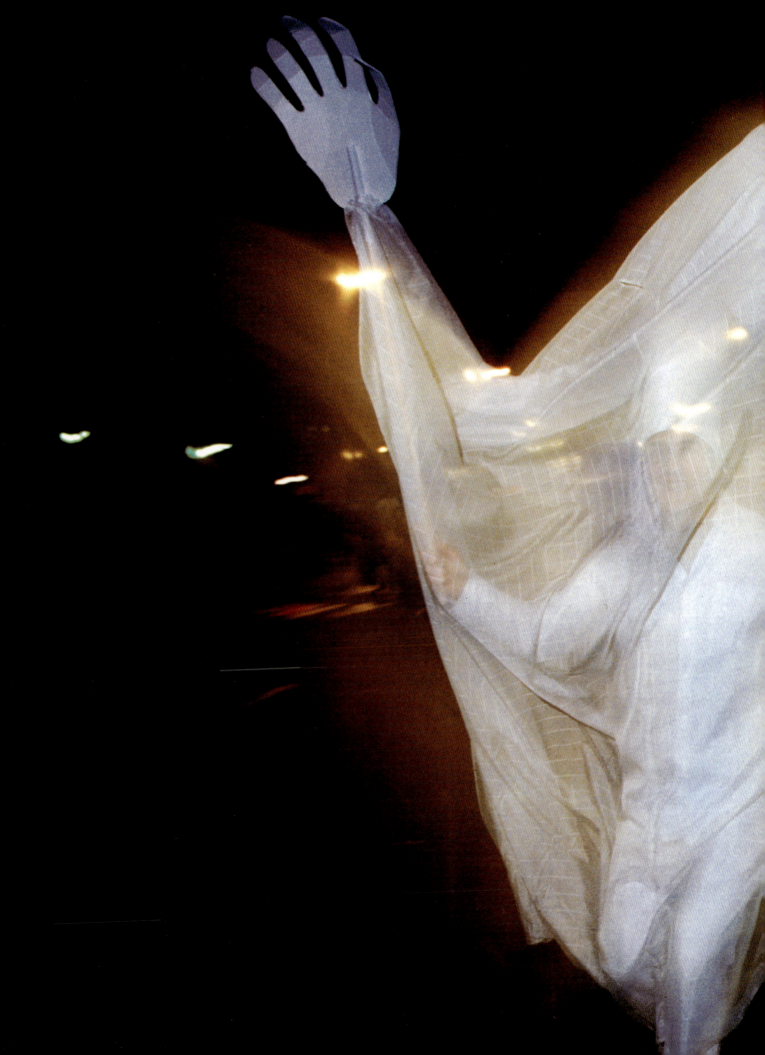

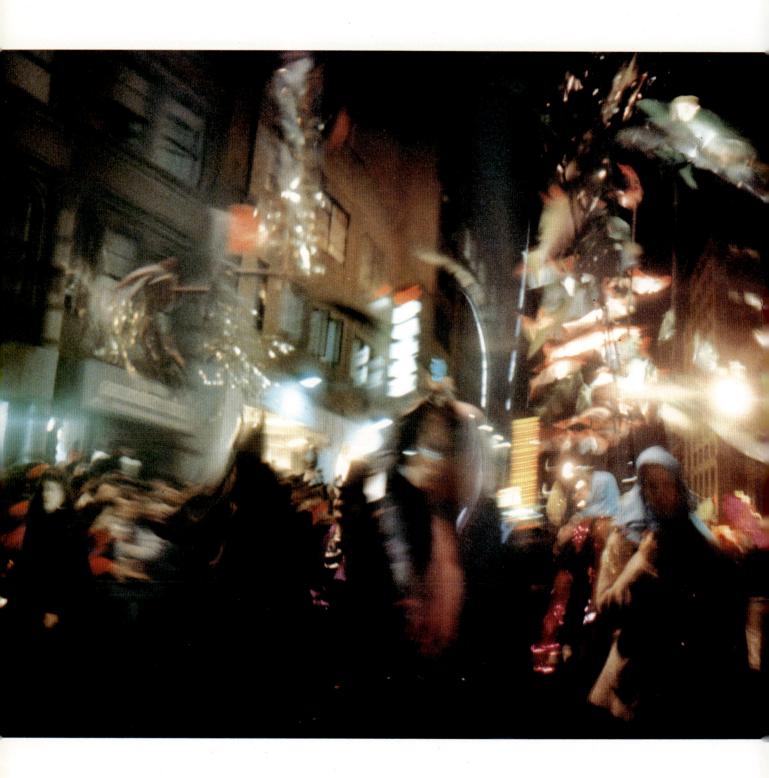

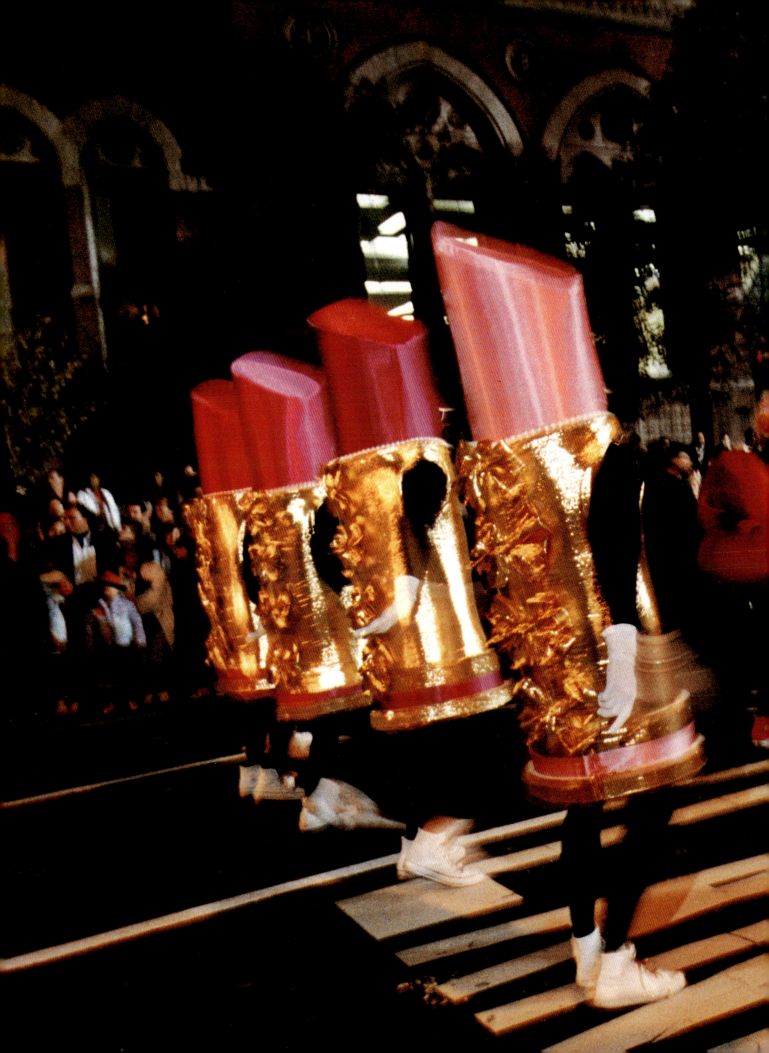

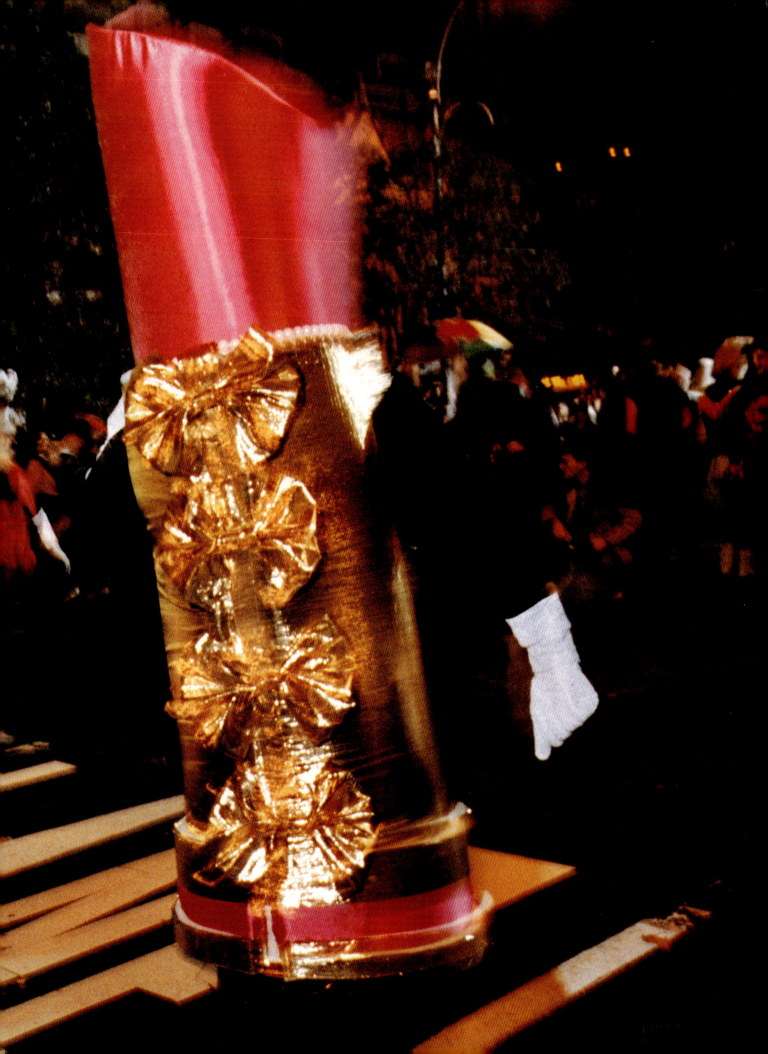

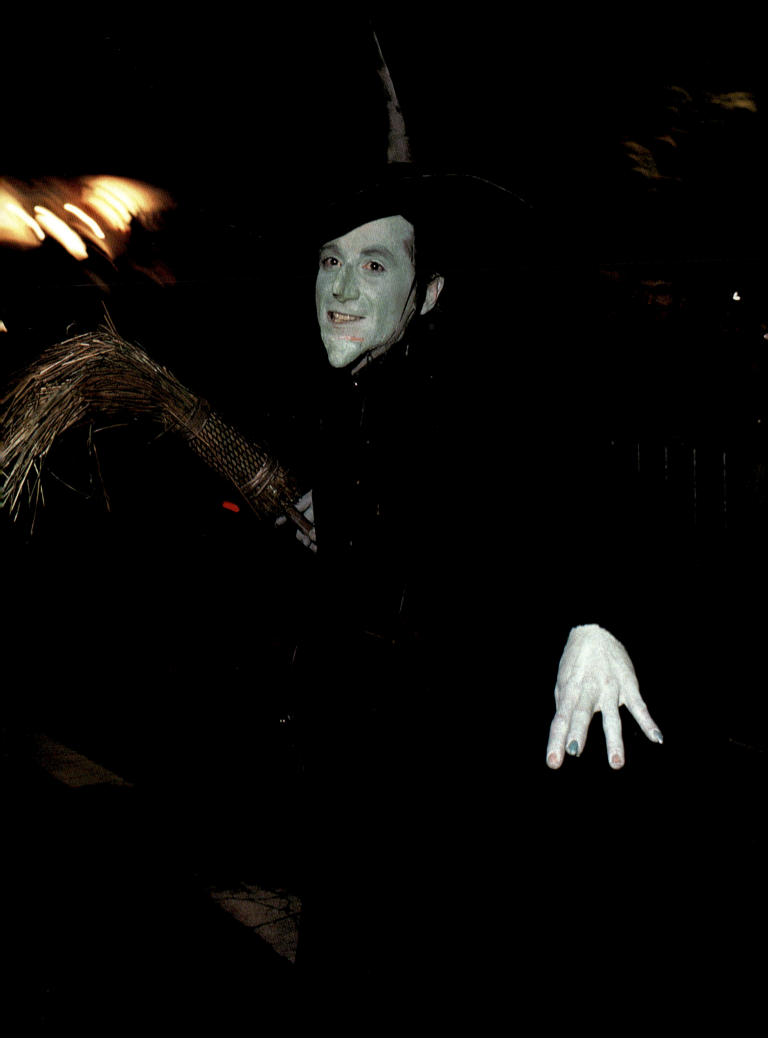

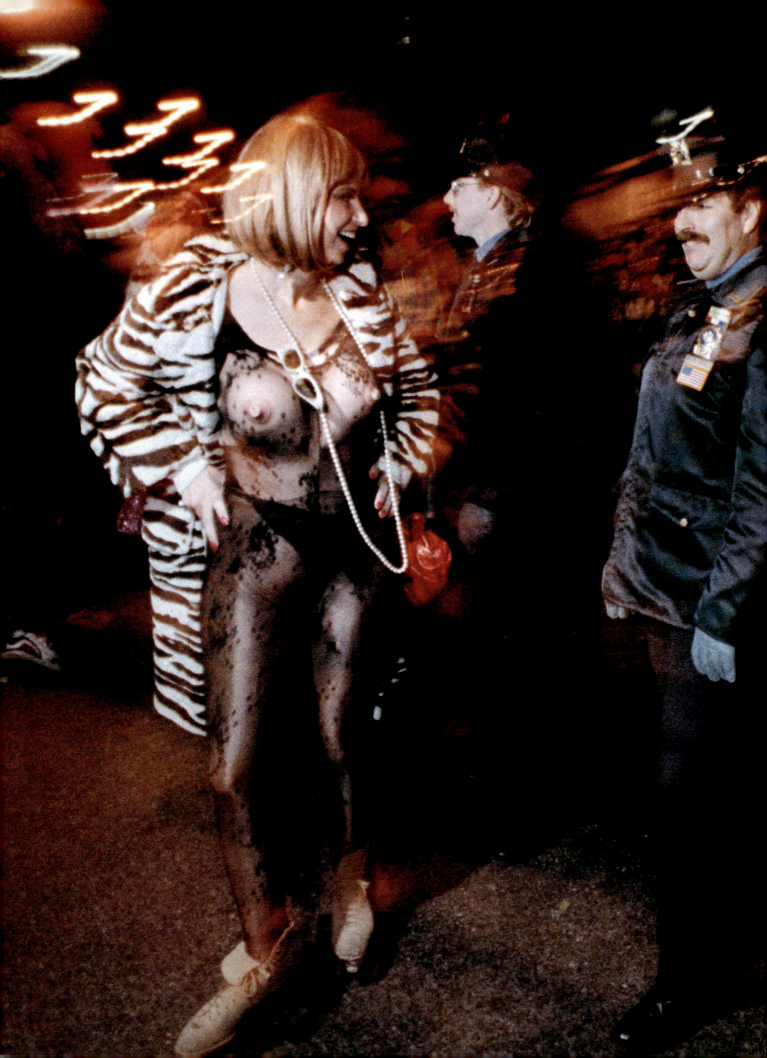

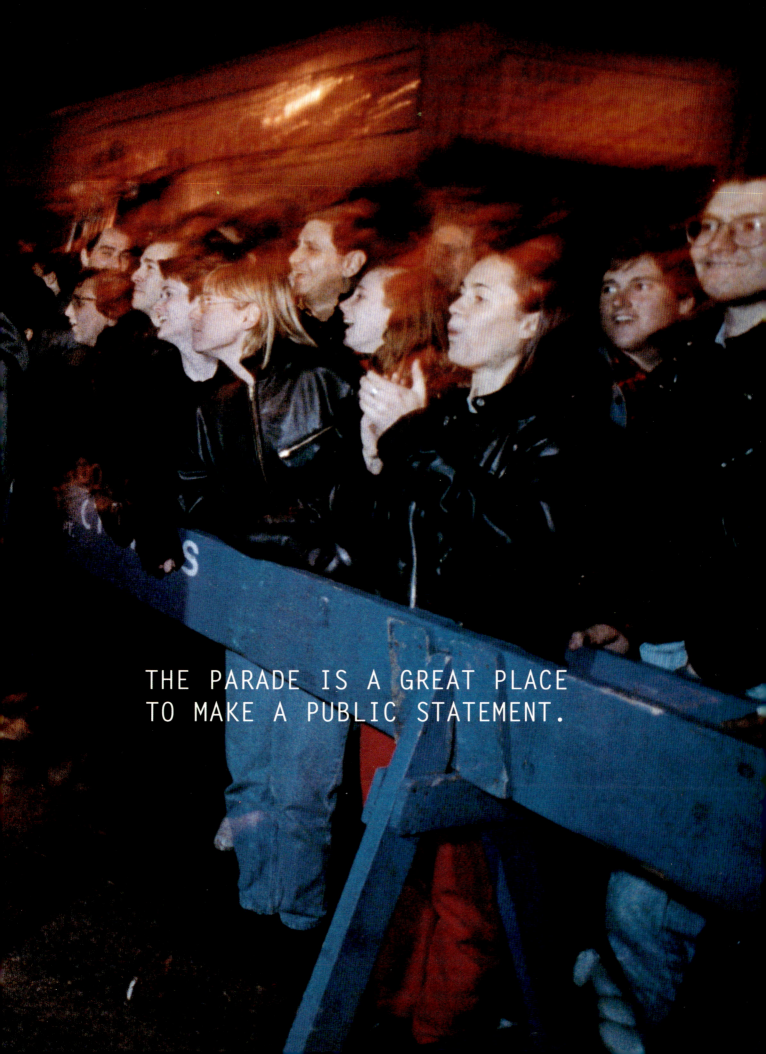

A Planet to Live On

In the years since 1987, Jeanne Fleming has assembled a small group of artists who work with her to design and construct giant puppets and masks that now act as centerpieces for the parade. Six weeks before Halloween, these five women and men live and work in Fleming's Hudson Valley home in Rokeby, New York, either breathing new life into the puppets stored in the barns of an old estate or creating new ones for the coming event. Fleming spends much of her time on the phone or next to the fax machine: there are bands to place, funding to secure, a postparade benefit to arrange, and a host of details to attend to like who will wear or carry the masks and puppets the group is assembling—such as the three hundred people needed to perform the corral reef ensemble or the nearly two hundred birds, plants, and insects that make up the rain forest tableau. All these tasks are done by volunteers—members of the Rainforest Alliance and the Sierra Club, for example, or the twenty-six members of the American Civil Liberties Union who now participate in the parade. (The group consists largely of the friends of Deb Ellis who two days after arguing the abortion rights case before the Supreme Court in Washington was up in Rokeby painting spots on cow costumes.) And there are numerous other volunteers who are not connected to any group: an architect for New York City's Landmarks Commission has become the parade's chief penguin instructing the twenty members of the Antarctica ensemble in a Busby Berkeley dance routine; the technical director of the Metropolitan Opera, hidden beneath her skirts, puts the parade's giant Nature Goddess through a crowd-thrilling limbo dance each time the puppet has to pass underneath an electric street wire hung too low.

Although Fleming envies the freedom the others have to design while she is busy administering, she consoles herself with an evangelical zeal continually confirmed through stories about how much this event means to its participants:

"I'm well known in Rokeby and one day this woman comes up to me and says, 'Are you Jeanne Fleming?' It turns out that she has a brother who was wounded in Vietnam. He was napalmed and is horribly disfigured. So he lives now in West Virginia where he works as a forest ranger. But the one day he goes out without a mask is on Halloween. He drives to the parade,

and on Halloween night he can

go up to people and frighten them or dance with all the beautiful women.

And she just wanted to thank me for organizing this parade because of what it does for her brother. So that's why I do the parade. I do it for people like him."

Fleming leaves her post now and then to sew up costumes or to host a one-day fancy hat workshop for women and children from the local community. The hats will appear on the heads of "the forty dancing ladies" who accompany the colorful dragons that have replaced the sweepers at the head of the parade. For Fleming these volunteers represent a set of concentric circles through which the intense, cooperative spirit that exists among the parade's organizers expands outward to the larger community, eventually embracing both parade participants as well as spectators. It is through the village of Rokeby that Fleming transforms New York City. And it is a view that is not hers alone.

Mark Kindschi and Maya Kanazawa are a husband and wife team in their thirties originally from Madison, Wisconsin, who engineer, construct, and then choreograph the giant crabs, snakes, and goddesses that appear in the parade. They work closely with Debby Lee Cohen, whose designs they help realize, and very much like her they are determined to use such public events as an opportunity to change the world, to rescue the city from the false god of technocracy. Kindschi is particularly concerned with the need to reassert chaos and mysticism in everyday life—which, in his view, is the primary purpose of this parade.

Debby Lee Cohen was initially attracted to the event out of a commitment to do more community art projects. Cohen is in her early thirties and is a native of Baltimore. Her impact on the parade has been significant. Not only does she design most of the parade's large-scale pieces, but she has been instrumental in steering the parade toward its current theme of ecopolitics.

Cohen: " A few years back, Jeanne received some money that had to be used specifically for a special project with a group of teenagers at the Greenwich Village Youth Center in the Pompeii Church on Carmine Street. At that time it had seemed very important that the parade reconnect to the community because so many people were feeling like there were all these outsiders coming in. And here was a group of teenagers, some with drug problems, or problems with their families—these were not all kids that were easy to deal with. Jeanne was looking for someone to build a puppet with them, and she had called about fifty puppeteers looking for someone to do it. I hadn't done any puppets in a while, and I really wanted to do a community-oriented project. I was thinking that I really had lost touch with community. And sure enough, two weeks after I had verbalized this to all my friends, the phone rang and it was Jeanne. So Jeanne and I met with the kids, and they came up with this idea to build a skeleton smoking crack. They had this image of building a little puppet. I guess because I'm small I like to build things either really small or really big. What I said to these kids was, if you build something that's big, you're making a statement. It doesn't matter really how the puppet looks. It's such a statement because no one can miss it. So we built it twenty-five feet high. For a lot of these kids, it was the first time in their lives that they got real recognition from the public in a positive way. We brought it out on the streets and people went, 'Wow, who made that?' And these kids went from standing like tough New York City kids and in seconds they melted. The puppet became a symbol for the youth center, and the kids are very, very into the parade now. Before, they thought of it as a gay event. Now they just adore the parade and the skeleton has come back every year.

"We realized that now that Ralph Lee was no longer a part of the parade, one of the major things missing were larger objects and that they have to be strategically placed. How do you keep an event theatrical that's very public but that continues to grow so much? Jeanne is a real genius at

that—spacing the bands and positioning things visually. It became very clear to us that we not only needed to build more puppets but also to have something thematic for the parade. Not that everyone had to be dressed as whatever the theme was but there had to be something that made people aware that there were concerns out there besides just having a good time. So for the 1990 parade, Antarctica became the major theme.

"Actually, the idea for the ecological themes came about through Micki Wesson, who works with Meredith Monk. Jeanne talked to her about what direction to move the parade. Wesson mentioned that in the current era of decreased public funding, arts groups that would survive would be those that would take stands and commit themselves to social causes. And I've really been into environmental issues. We also had this idea of getting a grant from Ben & Jerry's [the ice cream company] because Ben & Jerry's is really into saving the rain forests. So Jeanne wrote an application to do a rain forest section of the parade, and they funded it. For years we had discussed the need for more money and for getting commercial sponsors. But no one wanted to ruin the parade by having something inappropriate, and Ben & Jerry's seemed appropriate. They didn't impose conditions. In fact, most of the meeting with Ben & Jerry's was concerned with how they would dress for the parade. The contract with them reads that they would give us the money and they would bring one hundred employees dressed as cows. They actually wrote that into the contract! They also used the parade to introduce a new flavor—'Rain Forest Crunch'—and we organized an after-parade benefit for the Rain Forest Alliance in New York City on condition that our six hundred volunteers could come to it for free.

"I always felt that the parade belonged to the 'downtown' arts community. But I no longer see it that way.

Downtown is less conventional, more experimental,

especially in the music world. Uptown is conventional and classical. It's also true with the theater world. But with real estate prices so high, the experimental has scattered. It can be in Queens, New Jersey, or even Connecticut. Also the parade has grown so large that it's now for everybody. People come from everywhere. And that's both a loss and a gain. People say all the time, 'Why can't the parade be what it used to be? It used to be so great. And now it's so big we can't see anything.' Yet one of greatest things about this event is that it's taken its own course because it has been open to everybody. People come from other cities just to see the parade, just to be in it.

"I guess you could say that the parade has always been political because it's always been the one opportunity for anybody to come out and say anything about anything. So as times get difficult like they are right now, people need that. They need a place to say something whether it's just 'Look at me. I'm dressing up and doing something whacko and crazy,' or, 'Look. The arts need more funding.' Jesse Helms was a big theme the year he made a stink about the National Endowment for the Arts funding. The parade is a great place to make a public statement because there's the potential for millions of people to see it if it gets on the news. But even if it doesn't, hundreds of thousands of people will see it because that is how many people come to see the parade.

"So the parade doesn't speak to any specific community—gays or artists. It speaks to all kinds of communities. People even see it on TV. But when you look at the crowd the night of the parade, that's still for me, the cookie. That's my reward. Walking down the street and looking at all the different colors and age groups, such a cross section of people. Everybody loves the parade because I think it fills a certain gap that is really lacking in our culture, which is celebration. People that I know who work in offices have said to me, 'Oh, I've never done anything like that in my life, I couldn't possibly do that!' For those people it's a chance in a lifetime to perform with a mask on so nobody knows it's them. And they can totally let go. I saw that with an acquaintance of mine who's a biologist. And he's certainly not a shy person, but when he took that mask off, he was just ecstatic. I've performed my whole life on and off, and I've taken it for granted. But here's someone who never really has done anything like this, and yet because the theme was endangered species it was directly connected to

his work so he could do it passionately. And he was just ecstatic about it. A couple of people from the Sierra Club also told me afterward that they had never done anything like that in their lives. I know they've done political rallies and they've done other things, but the chance to really be playful, that is something missing in our culture. And to me that's part of what Halloween is all about.

"I do less and less theater now, because I love doing things in public spaces as opposed to a black box. But there are a lot of challenges with doing something like this. It is different than theater. You don't have professionals to carry the things. You don't have good lighting, so you never know if the images are seen the way they should be. Maybe they are on the first three blocks, but by the time they get to Fourteenth Street, the people are tired of performing with them and the puppets are just walking straight rather than dancing. It's a little bit sad, but that's how it is. It's the price you pay for having something that's so public and so underfunded. But the thing I love about doing these puppets is that it is basically anonymous. On the night of the parade when you're walking down the street and you see all these faces in the crowd light up, they don't know who made these puppets. There's hundreds of thousands of people looking at them, and they have no idea who made them. In the end I love the fact that it's anonymous, because it's like the opposite of all the work that's so disgusting in theater. You're just there to touch the public. And the public doesn't really care who made them. So in the end for me, that's the other cookie."

Cohen and Fleming had good reason to feel confident about the success of their efforts, indeed, about the future of the parade. The event was drawing an ever broader cross section of the city's population, and few who came to see it knew anything about the difficulty the group initially had filling the void caused by Lee's departure. But by the late 1980s the city itself was undergoing considerable turmoil, posing serious challenges to the viability of a public celebration on such a vast scale. New York's economy was in shambles, making fund-raising for the event difficult. AIDS was devastating the parade's most devoted participating community, and its priority as a cause was seriously impeding nonhealth-related fund-raising. Race relations were deteriorating, resulting in persistent threats of violence by marauding groups of teenagers. And the police were jittery because of a rising rate of on-the-job mortality. When the 1989 parade was all but wiped out because of a torrential rainstorm, some, including Fleming, were relieved that the event had been spared the violence then hovering over the city. The ominous mood also briefly affected Fleming's previously good relations with the police.

Fleming: "Every year we have extensive meetings with the police at Manhattan South Precinct where we discuss how to handle the crowds at the upcoming parade. The police really like the parade. Every year, at the end of the last and largest meeting, I often tell a funny story from the parade. It gets everyone laughing, and we end on an upbeat note. Before the 1989 parade, the thing I thought of to tell was that I was worried about rookie cops coming from other parts of town who don't know the parade and its outrageousness. A big item in the news that week had been the story of Zsa Zsa Gabor slapping a cop. Since the parade is topical, I thought one thing that might happen in the parade would be for some drag queen to dress as Zsa Zsa Gabor, go up to a cop and maybe even slap him the way Zsa Zsa had done in real life. At this point the chief got red in the face. He was outraged. He turned to me and said, 'If that happens the person who does that is going to be arrested on the spot! I'm notifying all of you,' he said to all his commanders there, 'I'm notifying all of you that if anybody does that, they are to be arrested on the spot and you, Miss Fleming, if that happens, I'm holding you personally responsible!' Of course he was right, but I'm sitting there thinking, 'There could be a hundred people or two thousand people like that, and I'm personally responsible?' So 1989 was an extremely tense year in the city with racial tensions and a lot of police killed. There was a somberness about the police that hadn't been there before. As it turned out, it rained that night (the only time it did in the parade's nineteen years), and only a few Zsa Zsas showed up. But one was really great. This was in a group of three men. One came as Zsa Zsa, one as Imelda Marcos, the other was Leona Helmsley. All were dressed like these women normally dress, but their dresses were made of prison stripes. They all walked together under umbrellas in the rain right up Sixth Avenue.

"Actually, I was relieved that it rained that year. There had been a lot of violence in the city. A gang of 'wilding' kids out to mug or harm people was sighted walking south toward Union Square just before the parade began. There was a weird atmosphere hanging over the city, and it was getting too close to the Village. Even on the night of the

parade there was a lot of violence throughout the city. The headline in one paper read "Horrorween." But even so, the press unanimously agreed that the spirit of the parade once again kept Greenwich Village safe on Halloween, that the only thing good in the city that day was the parade.

"I guess I feel that the parade is still the only event in New York that has retained its original character. It's not the same city that it was five years ago or maybe even three years ago. But the parade keeps on working its magic. It just creates so much fun for New York, and it gives everybody who wants to a chance to come out and either watch or be in it. I mean now with the killing and the riots that happened in Crown Heights in 1991, people are really afraid. But on Halloween night they'll all be able to come. The West Indians will be able to come and there'll be klezmer bands in this parade, too. And everybody will be able to come together and not have that fear of each other. It's a night where the city's not a scary place to be, especially not in the Village. So for that reason alone the parade needs to survive."

With these initial setbacks well behind her, Fleming has become increasingly optimistic about the parade's future. Some of the confidence stems from the fact that none of the anticipated violence came to pass and the parade remains one of the safest public events in New York City. But her confidence also stems from a conviction that the parade has been able to change, that it's not bound to a seventies vision, and that in addressing social issues the parade has sustained its own voice without Ralph Lee. Still, Fleming remains committed to continuing the mythic dimensions of Halloween that first attracted her to this event. So Lee's vision lingers, increasingly transmogrified through the imagination of others.

Fleming: "I think taking on environmental themes to direct our own creative energies has made a big difference. It was the right choice in a lot of ways. We needed something artistically and spiritually that mattered to us and could inspire new images of Halloween after we had made all the ghosts, witches, and bats that are traditionally associated with Halloween. And the world needs creative ways of presenting important issues. In recent years, especially after I got pregnant, I found myself feeling differently about the global environment. Debby Lee also politicized me a little bit, and I liked the images she created on the environmental themes, because they are still Halloween images. They're evocative, and the images that are part skeleton and part alive are appropriate to the season. They speak clearly of those things the world is in danger of losing, that could become extinct. So the images take on a larger dimension than the purely political. They become mythic because they represent something larger than just themselves.

"I also feel part of what artists have always done is to point out those things in society that need to be changed or made better. So we are fulfilling that function. And yet I also missed the purely mythic dimension of our earlier work. In 1991 I said to Debby Lee, let's do two sections to the parade—one environmental and one mythic and dreamlike. Debby Lee was going to make all skeleton fish and a giant net. And some of the other designers began to feel that just making a series of skeletons wasn't where we wanted to be with the parade. We—namely, the other designers, Gigi Alvaré and Ama Aldrich—wanted to do things that had color in them, that would inspire people on another level. I would say that nine-tenths of the people watching probably don't even know that the puppets represent endangered species, even though we carry a sign that says that! If you're at the parade and a giant fantastic spider monkey lifts up its hand and takes off your hat, you're not thinking 'Oh, boy, this is a spider monkey from the Amazon rain forest!' You're just enjoying the interplay with this fantastic larger-than-life creature. They're fantastic images. But they're symbols also of something we have to worry about losing. They work both ways. So, we were feeling that there needed to be even more deeply mythic images and

we decided to make dragons, the mythic symbol of the imagination.

We would do a ritual creating magic at the head of the parade, drumming up with a dragon dance good imaginative energy for the city. In a sense, the dragons replaced the sweepers. In terms of the parade and its future, the fact that we decided to make images that were both symbolic and political—that worked in both directions—has been part of what's made the parade be taken more seriously by the press, by funding sources, and by the community in general. In terms of preserving the parade as a forum to do anything you like, that choice has been one of the best ones we ever made. And I'm glad we did it."

Not everyone agrees with that assessment. Because of the success of the parade, the event has attracted an ever larger number of participants, some of whom use it to advocate on behalf of a particular cause. As a result, and to a lesser degree because of, the introduction of ecological themes, there is a certain amount of discontent among some long-standing participants in the event, particularly some activists within the gay community. For them, such changes in the parade represent a loss of center stage for their own group, and they experience the loss as one more assault on an already beleaguered community.

Fleming: "There's still a tremendous amount of gay participation, but proportionately there are more of other kinds of people coming to the parade now. When I think of how that change came about, I think of Lou Reed's song, 'The Halloween Parade.' It's a beautiful song. It made me cry when I heard it. It's about all the gay people who used to be in the parade and who have since died. I knew almost every one of those people. Every year I call up all the regulars, and it's a frightening thing to do because you never know whether someone's going to be on the other end of the phone. I remember one man who the last time he was in the parade came as Rock Vegas. He's the one who used to come as Shirley Temple on roller skates. He died two years ago. He had led the AIDS march on Washington.

"One year we had this weird thing happen with the New York Native, the gay newspaper. They love the parade and always write it up, but when they heard that our theme for that year's parade was going to be endangered species they called me and they were freaked out. They had talked about actually coming and stopping the parade by marching on it because they felt that they were the endangered species and we were making fun of them! Of course that wasn't true, but it showed the sensitivity within the gay community. I told them 'Why stop the parade? If you disagree with us come and say what you need to say in the parade.' Eventually they understood that 'endangered species' was not what they thought it meant, and everything worked out alright."

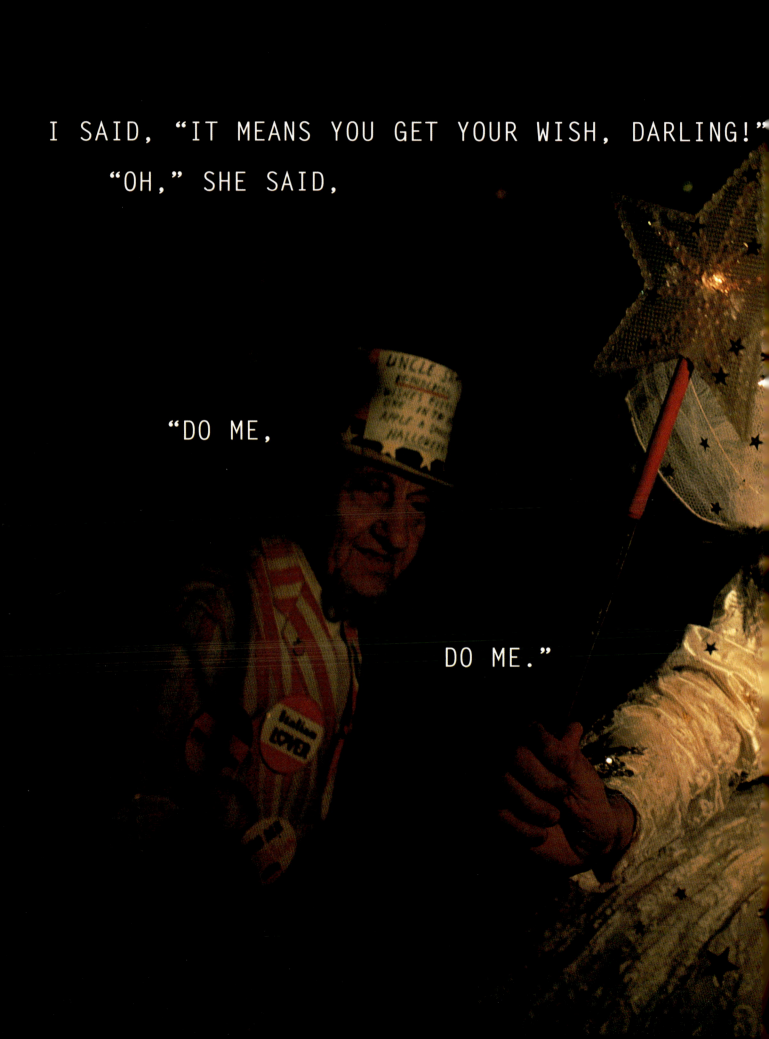

I SAID, "IT MEANS YOU GET YOUR WISH, DARLING!"
"OH," SHE SAID,

"DO ME,

DO ME."

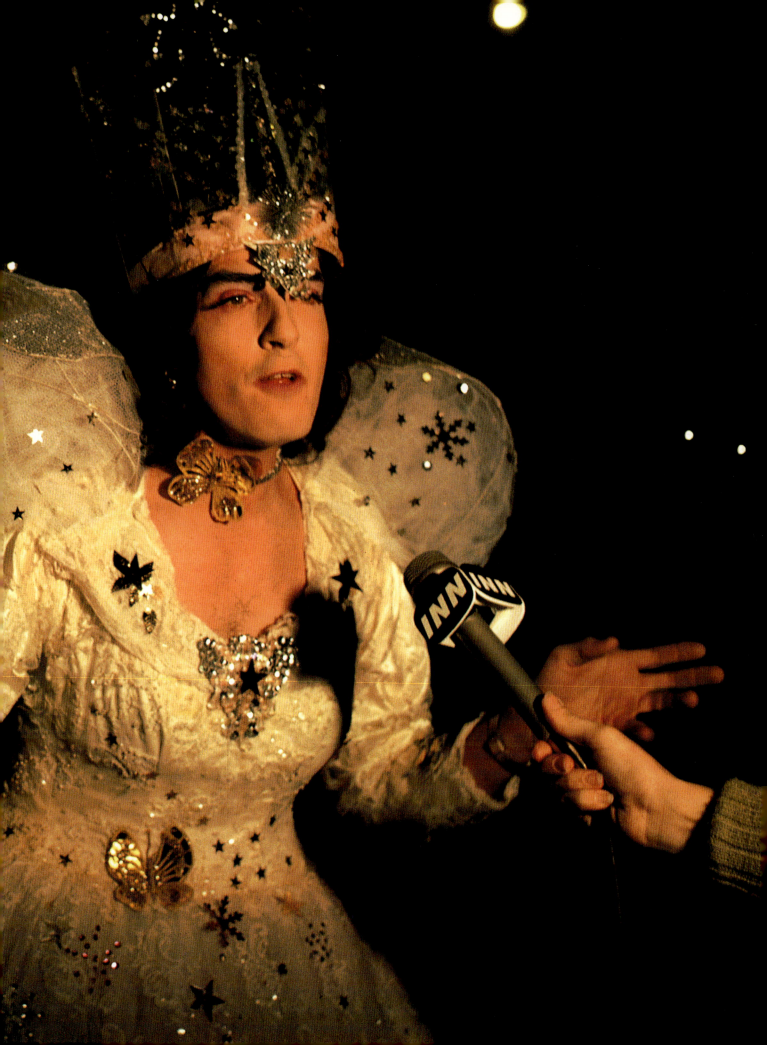

Something They're Not Supposed to Be

Their sense of the event's appropriateness as a venue for their own or their group's self-expression is precisely why some gay participants are angered by the parade's increasing appeal to those completely outside the gay and arts communities. Almost since the event's beginning, talented gay designers had turned to the parade as a giant public stage to display their work, themselves, and their vision of the world. The campy nature of their costumes readily distinguished them from the horror and sci-fi masks worn by so many straight participants; their flamboyance—indeed their hilarity—was well suited to the exuberant nature of the celebration. Although the presence of so much camp seemed to undermine Lee's spirit world vision for the parade, Lee himself liked such unlikely juxtaposition. But I also use the word seemed, because underneath the parody sometimes lies a utopian vision peculiar to the gay predicament within a predominantly heterosexual, patriarchal culture. And in that sense the campy costumes had a seriousness very much akin to the parade itself.

Ross Burman is a freelance fashion editor and stylist who appeared in the parade for many years with a group of friends.

"The first year I decided to do the parade, I thought I would be Connie Francis. I sort of pulled the thing together, and

I took so long to put my makeup on that I missed the parade completely

got downtown about 10:30 or 11:00 o'clock at night. So that was that. We just walked around and went out to dinner. Later we went to Christopher Street, then we tried to find some clubs that we could go to. My best friend Danny was Veronica Lake, and my roommate-to-be was 'Tippi Hedren and the Birds,' and a female friend of mine was Marilyn Monroe. We were all just celebrities. There was no concept at all. We did this all weekend at different clubs, and we

decided that we would never go out four nights in a row like that. It just takes too much of our time.

"We hadn't yet gotten to our conceptual Halloween. It was fun but I felt there was something missing, something wasn't clicking. There were a hundred other people dressed exactly the same way we were, doing exactly the same thing, and we felt we weren't reaching a degree of design that we could. So the next year we decided we would do something conceptual, and there'd be four of us doing it. We went through everything in the world, and we decided on sixties' stewardesses. Then we came up with the idea of 'TWAT,' which stood for 'Transvestites Will Attempt Travel.' I was the head stewardess because I was the tallest and I was the most vocal and I was the funniest, so I was Connie. We all had names: Connie, Barbie, Luvie, and Tippie. And I was Connie, formerly of Lingus Airlines—Connie Lingus. So that's where that went.

"We started planning 'TWAT' in August. A friend of mine made the patterns for the costumes and basically did the sewing. The costumes looked rich and expensive. We used a bright yellow because we wanted to be seen. We were all wearing the same color, but we also wanted a definite look to each of us so we opted for a separate color in stockings, scarves, and gloves. I became red, Barbie became purple, Luvie became green, and Tippie became blue. But everything else matched. I went up to wholesale jewelry showrooms to get tasteful earrings, because we wanted to stand out in a field of drag queens. We wanted to be conceptual but not be Lana Turner, Marilyn Monroe, or Jayne Mansfield. We wanted to do something that would sort of be camp and sort of fun and sort of more accessible to people, because we felt that it would be a very accessible thing to be flight attendants. You could do the whole spiel, and people have met flight attendants whereas they have not met Marilyn Monroe or Joan Crawford. As it turned out, we were very well received. It was beyond our wildest dreams. People would applaud us as we walked through the parade and screamed for us. And people recognized us out of costume afterward that we had never met before. They would come up to us and say, 'You were the 'TWATS.' You were wonderful!' It was incredible.

"The next year we played a group of Chinese prostitutes—'The World of Susie Wong'—which drew some hostility from the audience. We were too glamorous, whereas with the stewardesses we were like everyone's friend. The next year we wanted to do 'Chanel Cycle Sluts' to coincide with the opening of the Chanel Boutique on East Fifty-seventh Street. These were motorcycle girls á la the late sixties or early seventies. We couldn't get it together in time so we opted for the stewardesses. Once again we were very well received. People wanted to know where we had been the year before because they missed us. We were disappointed that the China Girls costumes weren't well received because we spent so much money on them—$500 or $600 apiece. That's why we feel we should do a concept. We should make a statement about what we're doing, not so much a political statement—it just happened when we did the 'TWAT' thing that TWA was on strike then. So everyone was saying, 'Oh, how political of you.' But it just happened that way.

"To be very blunt about it, the reason I do these costumes is because I love the adulation and the attention. I become a different person almost. I become an entity that is part of me that is not a part of me. I mean, I can say and do whatever I want to. And it's just a wonderful feeling to be able to do that, to be able to approach anyone I want to and say something risqué, or say something funny. Also, when you get into drag it brings out all the female mannerisms that you have but you keep low key. But it's very easy to adapt to them when you put on high heels and stuff. So that makes you a whole different kind of person.

All of a sudden your hands are swooshing all the time. You're so animated.

But I think it also might make you a complete person. And it wouldn't be the same if we were doing it and there was no

one else doing it either. It's with the whole group. The whole atmosphere means a lot.

"People say this is a gay parade, but I think the parade is for everyone. Because the people who do it really enjoy it and it seems like the people who watch it really enjoy it. The first time we did it I was worried that we'd be sort of offensive. It's not a nice word—'twat.' And the first time we flashed the T.W.A.T. letters we each had, everyone just screamed and yelled laughing. We were all amazed by the reaction of the people. Our jaws dropped to street level. We had never been to the parade before. The year before we had wanted to so we went to Christopher Street. People there weren't cheering. They tell you how good you look, but it's not the same thing. Because we put a lot of work into it, there's something we want from it. We want this adulation. We want to be seen. People should say the next day, 'Did you see those 'TWATS'?' It's a very theatrical thing. And we really appreciate people who have also spent as much time and energy as we have in putting things together. We don't think twice about going up and telling them how wonderful they look and how incredible they are.

"One of the things that's great about this parade is that all kinds of people participate in it—artists, stockbrokers, wall street lawyers. It's just normal people who let loose. It's a real release for people. You get an emotional rush. And we don't drink at all when we do it, but it's like a drug. Drag is our drug. It's like a movie that's going on and you're in this movie and someone has written a script and it's just coming out. It's a wonderful release, it really is. And I don't know if it's so much the drag part of it, although I do think it's more the drag than just being in costume. I think if we were just dressed up as Batman or Bullwinkle or something it might be a little different kind of release."

Robert Tabor is a designer in his twenties whose clever large-group costumes (such as pink flamingos, giant goldfish, and slices of pizza) earned him a good deal of adulation. Tabor was born outside of Boston and came to New York to pursue a career as a graphic designer. Almost from his first parade Tabor became enthralled with the idea of doing ensemble costumes—the larger the group the greater the challenge.

"My approach is to take things and blow them up real big. Like six-foot-high pizzas. I take a lot of everyday objects that people take for granted. I just exaggerate a lot. I always try to think of making someone into something they're not supposed to be. That's what provokes the reaction in people. The cocktails are so relatable to everybody, probably too much so. It was immediately recognizable. It's a real up kind of thing. I try to pick things that are more campy, more festive—like flamingos, which is a trendy thing right now, things that are relatable to people.

"More than anything, I do it for the challenge of it. Since I'm doing it for myself, I don't see that many boundaries to it. I'm sure if I was working for someone else there'd be a hundred and one boundaries, but I just like the fact that it's a departure from my everyday career.

"I spend a long time making the costumes. I started the flamingos in July, sketching and shopping for fabrics, then sewing in August and September. I use a lot of painted foam rubber and airbrushed fabrics. It took about two and a half months to make the costumes, working evenings and weekends. I did the work myself, and then I had to find people to wear them. That's getting easier because the costume wearers are having more fun so they now volunteer. The participants range from realtors, lawyers, retail people, one or two other fashion designers, a publicist, and two architects. The routine we used for the pink flamingos emerged from a feeling I had that the costume could be enhanced by a few simple dance steps and V-formation things. I tried to bring out the character of the flamingos as a group, although they each had their own character: Miss America Flamingo, Nurse Mingo, Officer Mingo, Wall Street Mingo, House Wife Mingo, Weight Lifter Mingo, Punk Mingo, Cowboy Mingo, and Cheer Leader Mingo.

"What do I get out of doing it? I get a lot of satisfaction more than anything. We have won a few prizes: a thousand dollars two years ago at a disco for the Cocktail Party, then this year at another disco for the Pink Flamingos. The money went to pay for the whole thing. But really it's just more fun to do it than anything. There's a lot of satisfaction knowing I can pull something like this off. And it's good exposure. People come up to you and write down your name. Also, the parade is almost like a little meeting ground. Everyone gets together, and I see people that I really don't see any other time of the year.

"Halloween for me is a chance to develop any character, wish, whim that may be inside you. It's the chance to bring it out, express it, and in a sense masquerade your true self. And it's a chance to be totally creative; there's no boundaries whatsoever, and you just try in a sense to fool

the people that know you. I love the creativity in this parade. All the concepts and thought processes. I've never seen so much energy in one event, especially creativity wise. I enter the parade not so much as a professional but as a person. I feel like my own sense of creativity is on parade more than as a designer.

"To a degree, the parade is related to New York City. If you look at the parade and you see the outrageousness of it, that in turn tells you that New York is outrageous. Also, the parade brings out creativity in people who don't deal with creativity every day. So they can go for it just for one day or one evening. It promotes unleashed creativity for everyone. So it opens up a part of the self for people."

Tabor's assertion that by fostering creative activity Halloween "opens a part of the self" suggests a subtle political agenda of artists participating in the parade with distinct ideas about the mental and perhaps even the physical health of individuals and society. That agenda is particularly apparent among some gay participants determined to create a sense of wellness in the face of the terrible disease that is ravaging their community.

On October 31, 1987, two hours after the parade is over, in the middle of Christopher Street and Bleecker I spot Fred dressed as a fairy godmother in a white gown, silver crown, and a large wand with a tinsel ball at the end. He is casting magic spells on a row of Japanese tourists who in turn are shooting him with their cameras. He doesn't pay much attention to me (I suppose because I'm busy with a note pad rather than a camera), so I cannot exchange stardom for a spell. Feeling somewhat slighted, I approach him and ask for one. He looks strange up close with his stubby complexion. But he's friendly and in response to my request he casts the spell. "Do I get a wish?" I ask. "Yes. Anything your heart desires." "I want your phone number. I'd like to talk to you." Two weeks later we're sitting at the Bagel And, a fast-food restaurant on Christopher Street.

Fred isn't dumb. I knew that when I called him to confirm our appointment. Before hanging up he tells me to look for someone in red glasses and brown curly hair. I, of course, would have looked for a man dressed as a fairy godmother. Fred spots me even before I recognize him. Out of costume he is a tall, slender, good-looking man about forty. I learn that he is a playwright and lives in a still not gentrified block in the East Village. Fred has been involved with the parade either as a spectator or a participant for the past ten years.

"This costume came to me. I just said I wanted to be the good fairy. It just came to me. It was like a gift. I think that's creativity. I also used to be in children's theater. So I have access to the fairy tales, and I also had access to those costumes because my friend Norman ran a children's theater and he had all these costumes in his apartment. But that was really secondary, because I was going to do it anyway even if he hadn't had the costume. This just had a strength to it which surprised me. People saw this, they knew, they waved to me across the street, they came up to me and said, 'Oh, give me a blessing.' You know, 'Make my wish come true.'

"The costume was designed by someone who's done a lot of work for dance companies. It's sort of a takeoff of a ballet dress from the eighteenth century. It was beautiful. Sort of a white satin with glitter and silver sequins. I wore a blonde wig with glitter and a wonderful crown like a headdress, which actually was from the Snow Queen. I made the wings myself from foam that had been used as packing for a stereo. I used wire and glitter. When I finished gluing, I smiled because I thought, 'Yes, there's something so fanciful and frivolous about glitter that it's like the antithesis of being practical and down to earth. The wings looked kind of frumpy and weren't straight. They looked kind of like I had done a lot of flying around. I liked the bedraggled aspect of it. I wanted to be slightly frumpy as if I had gone through the mill a bit myself and had still come to the fact that goodness is the bottom line. And I wore white tennis sneakers sort of like Yuppie women who go to the office in sneakers. I thought, 'Well, the good fairy has got to save her feet, too.' I made the wand from a wooden dowel and I put an aluminum tin-foil Christmas tree ornament at the end of it.

"It's sad to see all those costumes in Norman's apartment and realize that it's really the people wearing them that make the costumes come alive and not the other way around. Some of the jewels were falling off the crown. They looked sad in the apartment. But once I got it on and I got out there it came alive.

"What kind of performance did I do in the parade? I wasn't actually in the parade. Crowds make me nervous. In a sense, conformity makes me nervous, too. So I thought I would just work on the peripheries and whoever needed me would find me. I went from Christopher Street to the Metropolitan Community Church on Seventh Avenue where I met some friends, and we went out to a coffee shop. And then I

came back to Christopher Street and Bleecker and I just stood there and held court for a while. That's when I met you. When I went to the coffee shop, none of my friends were in costume and I wasn't sure if I should enter because a meeting was in progress. But I said, 'Screw it!' and went in. The meeting stopped, and they all applauded. They loved it, and I was a big hit. Then we all went outside and I granted a few wishes. My friends couldn't believe how into the character I was.

"I was in the parade once as King Frost. I was in a beautiful kaftan, multicolored in icy colors, with a full face mask and a beard and a big hat and big, long fingers in gloves. I felt very protected, which was great because I was nervous about going out like that in public. Then I realized how well children and people in general responded and the goodwill of the crowd. Last year I went as a reindeer. I had on antlers. But I had lost two friends who died that month, and I couldn't get into it. One died from AIDS and one from cancer. I was in grief. I wasn't going to do anything. But I had the antlers on hand for a show I had done. So I put them on, and it made me feel a little better. But also I think this year, having gone through a grief process, I could say that life is too short and this world needs some love and goodwill and some healing. And I was ready to really go out there as a persona. I felt I was a persona. I wasn't holding back.

"This year it seemed to me there were a lot more observers than participants. But even so I was touched by the crowd. I was going up to people with all their facades and defenses, and 98 percent of the people just melted. There were three black kids, very, very angry teenagers. I went up to them, and with my wand I went bonk, bonk, bonk, and they melted. One guy came as a ghoul. I bonked him on the head and nothing happened. I did it again and he just stood there. He wouldn't give me an inch. He was just stubbornly staring me down. So I said, 'Oh, come on.' And I bonked him. And he melted. A Korean woman came up to me and said, 'What does it mean when you bonk them on the head?' I said, 'It means you get your wish, darling!' 'Oh,' she said, 'do me, do me.'

"Then another woman dressed as a frog hurled herself at my feet and she said, 'Make me into a prince!' I kept going like this [Fred motions with his outstretched arm as if he were waving a wand] but it didn't work so I figured I would try it again. I thought, 'Maybe if she wanted to be a princess it might have worked. It's too complicated, I can't deal with it. It's two wishes.' Or maybe I could do it, but I thought that she needed to live with it a little longer. Also, I thought it was touching; there would be a group of friends and they would say, 'Oh, get him. He really needs it!' I could tell that this person was really hurting. Whether it was for personal turmoil or heartbreak or a physical situation. They come up to me with such earnestness, saying like, you know, 'Make this better!' And

it was a very rewarding thing to hit them with the wand. It seemed to cheer them up

anyway. People have this innate reverence for the power of this mythological figure. And I guess that was what I was thinking of. It was really the power of goodness that captivated me about it and also instructed me. I had no idea that I would get such a response going out as some embodiment of mercy and goodness. It was really very gratifying. A friend of mine who was with me and is very spiritual, kept saying, 'Fred, you're really healing people.'

"I even had a fantasy of going to midtown dressed as the good fairy. I may even do it. I think there's a magic in Halloween that allows people to suspend things and allow certain fantasies and let their own wishes come true. So I don't know if that would work on a Tuesday afternoon in the middle of 'reality.' But it did work on Halloween. It certainly did. I was just impressed with the power of goodness. I guess that Halloween is a custom we have. On a certain day we feel this. On a certain day we feel that. We're patriotic on the

Fourth of July. We feel a certain sense of renewal around Easter in the Christian world. On the other hand, I'm also into astrology. Halloween is in Scorpio. And it has to do with the sense of death and renewal, too, which is the sign of Scorpio. The Christians have taken that up and made it All Saints' Day. Before Christianity, that is when the dead people rise from the grave. It's sort of the dark side of it. That's I think where the ancient roots are from. And so it's both sides. The dark side on Halloween and the light side on All Saints' Day, which is both sides of Scorpio in a sense. But I felt like I wanted to be a good figure on that night. It's funny, but I guess it's just like that out of darkness does come light. Maybe that's mixing up a lot of symbols, but it seems like out of negativity is a lot of potential for good. And I just felt like my costume was a lot more successful than the people who were trying to be scary. I felt like there was a magnetism and a magic coming from me.

"Do I see this as a gay event? No. I don't see the Gay Pride March as a gay parade either. I see it as a people's event. People just being themselves. I'm gay myself, but I'm definitely a person first. For me the parade is an opportunity to explore sides to being human. Whatever you've got to work on. A friend of mine went as the wicked sea hag witch, and she said she'd never do it again. She went to McDonald's and pressed her face against the glass and was picking her nose. People hit her. They were negative toward her. She was, perhaps, getting out some of her anger and resentment. But it's sort of what you sew you reap. She said she would never do that again. But I think she had to do it that time. I see people getting out anger at the Church. They cross-dress as nuns. There's a guy from that church on Christopher Street with a cross impaled through his neck and he's like this manic preacher. I'm at peace with the Church. I think God is all around. So I don't need to make fun or work out anything with the religious world. I just felt so full of love and goodness this year. I think after going through the grief process, it was such a devastating experience; it's funny the ironies of life, but it released so much goodness in me and so much love. I could have gotten cynical, too.

"I suppose Halloween really must be some sort of primal ritual for people, some kind of need to act out something. I think it's becoming New York's holiday. And that's great. It's a chance for New York to celebrate its diversity of character. It's really a very creative city, even despite all the yuppification and gentrification. Also, you know New York is in some ways perceived as a city of greed and of practicality. Money talks. I think this is perhaps a cleansing ritual for the city to recall where its heart can be—one of fantasy and imagination. It can relinquish some of that hard edge.

"Is this a peculiarly Greenwich Village vision of the city? Well, the West Village is considered the gay capital of the city. Gays have a lot of lessons to learn, but in a sense they have allowed themselves to break from some conventions about gender and other conventional roles a human being can play. The straight world has that more defined. When someone comes out as a gay person they have to question all of that. They may come up with some stereotypical answers, but there really is an opportunity to come out as a truer individual. I certainly don't think that's limited just to gay people, but it's something that gay people definitely have to deal with. The parade allowed me to act that out for myself. I think the parade allows people to reveal a lot about themselves.

"Take the promenade on Christopher Street. It's almost like the adult version of the Halloween parade. I'm wondering if it isn't something about the ambivalent sexuality of it that attracts people. This city is very alienated from its sexuality. I think that's why we have all the pornography and all the acting-out places. Christopher Street is like a sex center, and people are confused and fascinated about their sexuality and about what gender means.

"So the promenade has a sexual charge in it. You know, men dress as women, flirting with straight men. I've seen straight men flirting with female impersonators. And they know it's a man, and they're enjoying it. It's titillating. I don't think it means they're necessarily gay either. But it allows them a release from these preconceived notions about what it means to be a straight man and a gay man. There's a mix of everyone there. You can really feel the tourist aspect of it. I was a little resentful initially because I realized it's really not my place anymore. On the other hand, I realized that people need to be reminded of this other side to life—this life of imagination. So I thought, 'Well, OK. It's changed. It's not my ball game anymore, but let them be here and let me be here, too.' And I felt accepted by them. I felt they got something from me, and that gave me something back. I had to shift gears, though. I felt like, instead of being in an aquarium all on my own, it was more like being in an aquarium being watched. I was aware of all the outsiders."

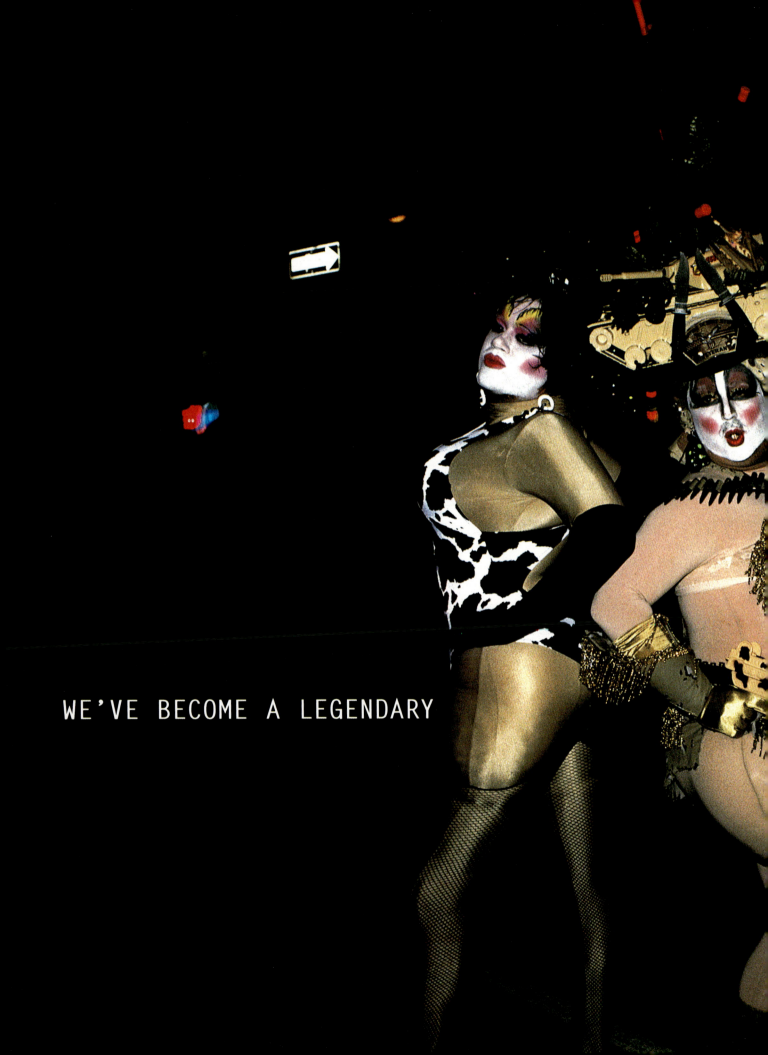

WE'VE BECOME A LEGENDARY

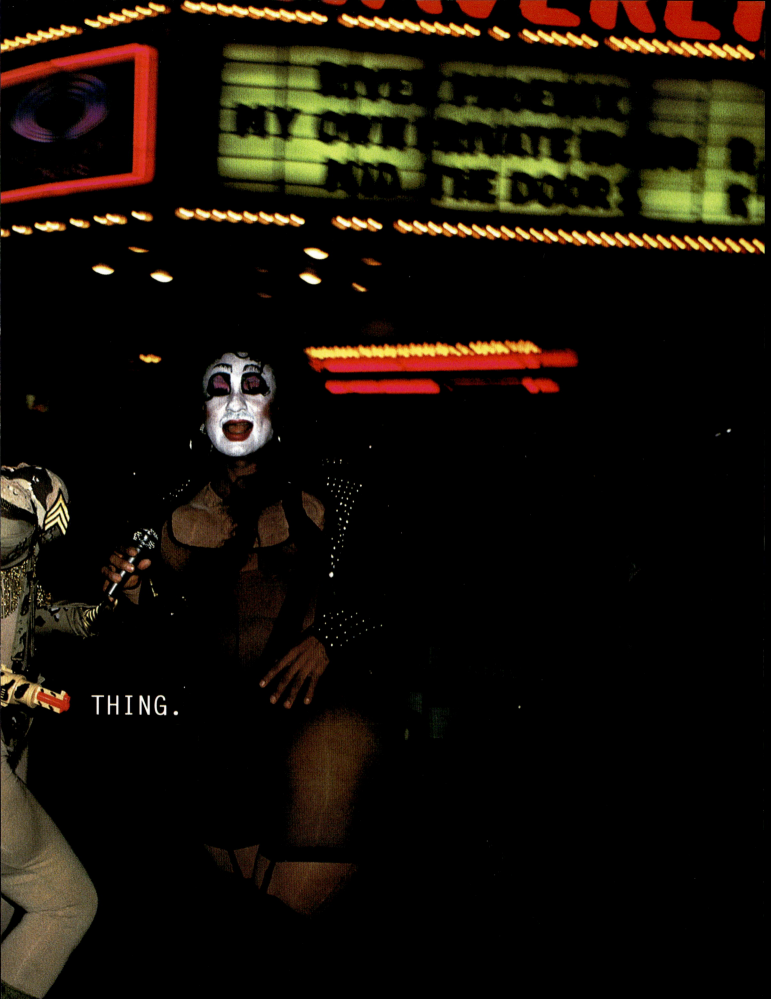

THING.

What Halloween Is About

Although many have noted a decline in a visibly gay (i.e., drag queen) presence in the parade, in part due to the appeal the event has for an ever wider audience outside the gay and arts community, interviews with participants attest to the extraordinary appeal that the holiday Halloween itself continues to have for the gay community. The reason for this is not difficult to fathom since "dress up" indicates the malleability of gender and that its characteristics are culturally rather than naturally determined. But performing drag also highlights the distinctly parodic sensibility that underlies gayness, stemming undoubtedly from the ambiguity of male and female within gay culture. This is why they take the parade so seriously, why they so frequently refer to Halloween as their Christmas. What better holiday could there be for a community born out of choice rather than blood, without prior existing kin, ethnic or neighborhood ties? Although the same could be said for many straight people who live within America's largest cities, it holds even more so for gay people. Indeed, what better holiday for people accustomed to hiding identity and masquerading the inner self in the trappings of someone else's codes of conduct? Given the very deep connection Halloween has to the gay experience, no wonder so many gay participants feel quite erroneously that the parade was in origin a gay event now infiltrated by straights and that the entry of even a small number of commercial floats, large numbers of store-bought and a fair amount of blatantly political costumes (created for the most part by participants themselves) is a betrayal of their holiday. The following interviews are with two drag queen participants who continue to see the parade as an integral part of their individual and communal lives as gay New Yorkers. The final interview suggests a much greater degree of alienation from an event that now reaches out to include so many different kinds of New Yorkers. Although he, like many of those interviewed, denies the connection, it's difficult not to tie this sense of loss and decline more generally to the epidemic ravaging the gay community rather than to a substantial change in the quality of the parade.

Daniel Wintrode is a hair stylist and makeup artist who owns a small hair salon in a fashionable part of the Upper East Side. He is in his thirties and has participated in the parade for nearly a decade, since not long after arriving in New York. For the past few years he and several friends have dressed as *caricata*—exaggerated female forms—with the same basic body but clothed each year in different bras and panties.

"We try to make different social comments—sometimes funny, sometimes more serious. Every year people actually wait for us to come. They bring pictures of us that

they had taken the year before—some have pictures of us from every year. We've become a legendary thing. So it's kind of fun. One year we did a tribute to the Eiffel Tower. The next year it was to South America, then to Chinese take-out food and Coca Cola. That and the tribute to France are our two favorites. Last year I did a stuffed banana, and I made it into *Us* magazine. This year we did a tribute to war. We called it Desert Storm. I had a tank on my head with rifles—children's plastic rifles, of course—leaves, hand grenades, binoculars, plastic knives, a green helmet with a Desert Storm veterans patch on the front, and hand-grenade earrings. The bras and panties were made of Desert Storm camouflage material trimmed in gold fringe. I had gold epaulets, admiral stripes on the breasts, and combat boots. That's about it. I called myself Desirée Storm, some people called me Rambette. I also carried a child's machine gun with a little recoil action at the end that lit up and made a lot of noise. The name Desirée Storm came about because of one of my clients who has that name. It wasn't to make a political statement. Not at all. It kind of turned out that way every time the press interviewed us.

"My idea for a costume usually hits me about Labor Day Weekend. The Banana King came about because I was walking by a store and there were these beautiful half-peeled silk bananas, and I thought this would be great. Desirée Storm came about because I was walking past a toy store and there was a tank in the window; it was six dollars, and I thought, 'I hope it's not heavy.' And the next thing you know I was wearing it on my head. So, I don't think it was political at all. I kind of wanted to make fun of what went on because I think it was not necessary. Being a person who works with the public, I have to be able to talk about a lot of different subjects with a lot of different types of women—punk for the sixteen-year-olds, opera with the seventy-year-olds—so, of course, it affects me. But I really didn't understand it. The one thing that stood out in my mind was there were so many women involved—the women who were taken away from their babies. And so I guess that's how it all came about.

"Why do I do the parade? It started off as fun, then I started going after prize money at the local discos. If you plan your week right and your costume is strong enough, you can go between Brooklyn, Queens, and Manhattan and make quite a bit of money. With the stuffed banana I won $1,700, which paid for the costume and a vacation in February. This year [1991] I did not compete. I judged two contests instead because I was winning every year and people were getting a little sick of it. So the costuming has gone through many phases from fun, to money, to this year where it's basically tradition.

"What do the costumes mean to me? I think being gay. Halloween is a very gay holiday because it allows the expression of dress up and part of our life is pretend and dress up. There's so many people who have to live in the closet or be someone else once they leave for their office, so it's the holiday we relate to very well. These particular costumes were done as a parody of women, and I think that most gay men do have a feminine and a masculine side and that's what getting in touch with all that is. I think we do it to poke fun a little bit at ourselves. The pads make it such an exaggeration.

Women love the bodies because they all relate to cellulite,

and the butt and the hips are so exaggerated. And everyone has a good time. The men lust for us, and the women just gawk. It's amazing how many people look at us and they don't relate to the fact that it's padding. They think that it's our bodies.

"I suppose that Christopher Street has become a Mecca for straights to visit. They need escapism more than we do because they live the lies. I've been very fortunate because my life is my own. I've never had any interference from parents. People go to the Village because they can live recklessly through other people. I know the sadness out there. I see twenty clients a day. I know what they're doing. I hear the stories constantly. Also there are some very sophisticated people who come and revel in the fun. All types come. I'm not offended by people who come to gawk. Women are fascinated by the breasts. They grab me and I

grab back. They scream. The husbands get upset. But I say, 'She grabbed me first!' Women photograph their red-faced husbands with their head on my breasts. It's their carnival, their release. It's part of the fun too. I only get offended if people try to cause me pain.

"Also, to gay people Halloween is a release. It's breaking down the barriers one day a year. We do have Gay Pride Day which is usually the last Saturday every June, which is a political thing. But I think this is more of a festival of enjoyment of being all the hidden things you've kept suppressed and just going crazy. And straight people come to see the gay people make fools of themselves. This year I was struck by the fact that there were all these political statements in the parade. People marching against fur in the Halloween parade with masks on. To me that's crap. That's not what it's about. I'm not pro or con fur coats. But the bottom line is that this is Halloween. It's trick or treat. It's dressing up. It's that whole feeling. It's not about 'save the farms by dressing people up in cow outfits.' Leave that shit for later. I hated it. Our costumes are making a serious statement by poking fun at women, at sexploitation.

"Do I see the parade as a gay event? This used to be a gay parade. Yes, it used to be ours. The Village used to be ours, too. Through AIDS we've lost it just like San Francisco is totally changed now because of everyone dying. I don't think it has to be anybody's parade. It doesn't have to be straight, it doesn't have to be gay, it just has to be a night when people can enjoy themselves by being somebody else and releasing all that energy. This year for the first time I was egged in my costume. And I went through so many feelings about it because, first of all, I work so hard getting it together that just the idea that somebody's trying to take that away from me, to destroy it, is very frustrating. And usually it's very ignorant people who do that. So there'll always be people who'll try to take the fun out of it, who'll try to make something serious out of something that's not.

"One friend was egged two years ago. His costume was destroyed, and he won't do it anymore. I always go back to Sheridan Square after the parade and mingle with the people on Christopher Street. I let people take pictures, but I will only stay for a short period of time now, because the longer you stay lets the people who're going to cause problems have enough time to get there. They usually arrive later, egging and beating people up. Sometimes groups of kids go through with bats. Imagine being in a crowd of people next to you, body to body, and having all of a sudden young kids with three-and-a-half-foot-long wooden sticks and yelling at the top of their lungs running through a packed crowd and hitting people with these sticks. It's frightening because there's nowhere to run. And if you happen to have a four-and-a-half-foot headpiece on your head, and if somebody bumps into you or swats it, you're either going to have a cut on your head or you're going to lose it in the crowd. Or it's going to fall on someone else, and they're going to be hurt. So these things ruin it. It takes the fun out of it.

"When my friends and I came home one year after being egged we talked about not doing it the next year. But then again it's quite a rush to have your picture taken so many times and not knowing where it's going to wind up. One year I was in a bank window in the Village. You know, I'm walking down the street and there I was.

It's kind of fun being public domain sometimes."

Jeffrey Wallach appeared in the 1991 parade dressed as an English nanny pushing a fifties-style pram containing a grown man in diapers and accompanied by two other adults, each dressed as a little boy and little girl. Like Wintrode, Wallach is in his mid-thirties and has participated in the parade for a dozen years. He travels widely and uses his knowledge of other carnivals to create his Halloween characters.

"I first began to participate in the parade because, being a costume designer, it's kind of hard not to say yes to something like that. It's an opportunity to show off your finery. The parade then was smaller. It was more like family. I participate in Gay Pride Day to make a political statement about numbers so politicians will take note. However, the Halloween parade was to be with my friends. It's a big

Mardi Gras carnival celebration. It's a chance to go out and have a blast.

"I used to look forward to seeing the new Ralph Lee puppets. It's lost some of the charm, but it's gained recognition. It's less family and drag queenie stuff, and because of the economy the costumes are not as clever as they used to be. Something is missing in the parade for me—that sparkle that the fags seem to have an edge on. It's sad. I was hoping the rest of the world could catch up.

"In previous years I've done huge showgirl costumes with six-foot-high pink feather hats, long feather tails, rhinestones, and so on. This year I decided to do something simple. I guess it's something about the personality of the performer because I got just as much attention as I always get. We were just guys in costume. We did nothing sexual at all. And unlike previous years there was no animosity from the crowd. So this year was total fun for me. Everybody could relate to the baby and find it nonthreatening and humorous. Drag queens use too much mascara. They overdo it. That's when you can't fool somebody. The simpler it is, the easier it is to get someone to look twice because they're not sure. That's the fun in dressing up.

"Why should it be nonthreatening? It doesn't have to be. But I've been confronting people's fears for years in the Village, and I'm no longer interested in doing that. I guess when you get to be over thirty something, you lose a lot of that young enthusiasm. I already know I'm gay. I don't have to prove anything. Last year some friends wanted to go as a group, so we went in very simple pirate costumes, not as transvestites. The fun is in dressing up, not in the sex thing. When I needed to assert myself and find myself I made sure I would wear the most outrageous clothes I could. However, I got past that.

"To tell you the truth, I do the parade because I just want to have fun. I want to see who's been clever this year. I do costumes every day. I don't need to see costumes. I need to see good costumes or costumes executed with love. I want to see people encouraged to make art live, to be out there, to have fun, to laugh at themselves, to dance in the streets. I don't see much reason to live on this planet if we can't have fun. I enjoy it when people can laugh at themselves. That's when the specialness comes out in a person, when they open up and find out who they are, rather than find out who they're not. Prejudice and racism only come from what you don't know, the fear of becoming that other person. Finding out who you are and living that leads you to not have those fears.

"What does a pirate costume have to do with who I am? A swashbuckling adventurer? Oh, I think that's me. A mothering nanny, that's me. A flaming feather-covered showgirl? That's me too. But that's just how I am. My friend belongs to a Christian youth group, and they came as '101 Dalmatians.' And to me, to see all these people being silly puppies was charming and so much fun, and certainly nonthreatening to anyone. As the parade became less drag queenie and more open and more mainstream and it moved onto Sixth Avenue, it became a space for political folk. Last year a whole group of people who were walking in front of me were handing out 'Don't Wear Fur' flyers, and I thought that didn't belong in the parade, but I wasn't about to tell them not to be in it. What annoyed me was they weren't in costume. There was a Christian group dressed up as sheep. At least they were dressed up and into the spirit of the whole thing. You don't have to love their pamphlet, and you don't have to read it. But at least they were in the spirit of what was going on. There was a group handing out condoms, and they were in their costumes in leather. As I said, once the drag queens cleared out there was a whole big area for political folk to come on in. And in New York people will go to great lengths to get some kind of attention. If the TV cameras are there, the fur activists are going to show up.

"The changes in the parade have a lot to do with what's happened to the area. The Village isn't the home it was ten years ago anyway. It's not that kind of a family village. The Village is only a word now. The diversity that has moved in has made it be no longer an artist's community within the city. I don't think it will ever be that again. Who lives in the Village now? Everybody. In this city you live where you can afford to live. The economy has a lot to do with it. You don't look for a community. Spanish Harlem ain't that Spanish. Black Harlem ain't that black. Drugs are everywhere. It's tough to live anywhere or everywhere. So I see lots of families in the Village. I'm happy for that. When you mix up lots of people you get better understanding. At least I want to believe that.

"Gay used to be an oddity, but in New York it's no longer an oddity. Besides there's not as many outrageous things going on in the streets anymore because there's nothing we have to prove. The medical situation has certainly changed the face of the planet. Look. The designer

Brandy Alexander died of AIDS. He was an institution in the parade. However, I don't really believe that it's AIDS that has changed the parade. It has to do with the parade's becoming mainstream and becoming recognized. I personally would like to play down the AIDS thing and the parade. I'm there to have fun. There's not as much outrageousness because we don't need that anymore. We're past that. You see, my roommate died earlier this year. I'm sad that a lot of those people don't walk with me anymore. But I have to go on. Yeah, I'd like a whole lot of those friends to be here this year walking with me in the parade. I suppose a lot of those people were some of the more outrageous ones. They went pretty fast. They were the wild ones who tried everything. Yeah, there's validity to the fact that it isn't as gay as it was because of it. But I just don't think along those lines. I guess that's me."

At the end of the interview Wallach gave me Steven Rosen's phone number; Rosen had appeared in the parade as the little boy in a sailor suit in Wallach's "Nanny and her Pram" routine. Rosen, who is in his thirties, ekes out a living as a costume jewelry designer. Even more than Wallach, Rosen denies any connection between the impact of AIDS and the decline in the number of drag queens in the Halloween parade. Rosen has appeared in five previous parades: in an antique Napoleonic uniform and devil mask with gold mylar (also made by Wallach); as a member of "the happy family," with giant smiley faces; as a house of cards. One year he appeared in drag as a Hasidic Jew. Whereas other costumes are more purely whimsical, in doing the Hasid Rosen had a point he wanted to make.

"I had on your basic hat with black telephone cords stapled to the hat that looked like huge sidelocks down to my feet. A black overcoat—

I looked like your basic Hasidic Jew except I was wearing fishnet stockings and your basic sensible pumps.

I tried to think what a Hasidic Jew in drag would wear, and I decided it would be something very plain and sensible. Also, I can't walk in high heels. Although I'm Jewish myself, I can't stand Hasids because they had been fighting against the gay rights bill. That was the first time I ever marched in the parade."

Like Wallach, Rosen has utter contempt for those who insert their own political agenda into this event, without carefully cloaking it in humorous garb.

"When I first started there was nothing political in it except some fringe people giving out pamphlets. Since Act Up and Queer Nation became politically active, they used to do things in the parade. Now there are other groups in it doing things. The parade has become very political, but this is not the holiday to do it. You can't help make a political statement if a man dresses up as a woman. The personal statement is the political statement. But it's all done in fun. Now there's the antifur people—all liberal causes—the environmental people, three Saddam Husseins in electric chairs, it's kind of tasteless. There was someone trying to remind people how many Iraqis died in the war. Tasteless. That's not what Halloween is for. You wouldn't do that on Christmas. Halloween is like Christmas for me!

"When I first started going to the parade, it was within the community. People were making personal statements, it wasn't an outreach thing. It was all artists and gay people—everyone watching and participating. Now a lot of people are gearing what they're doing to this huge humongous crowd, which is basically suburban straights. So that's

where you get all these political things. There were these great stewardesses called 'TWAT' and they're not there any more. There was a lot more outrageous sexual stuff. I think it's tamed down. Those things still exist because I see them in the bars afterward, but I don't see them in the parade.

"Last year they had Mardi Gras in New York for the first time. The idea was that it would only be a Village thing. A lot of people threw Mardi Gras parties, and restaurants had Mardi Gras specials. It was a new thing, and I didn't know any of the traditions behind Mardi Gras—how to dress and what to do. I think a lot of people were like that. It's kind of foreign, but the whole concept behind it was to have something to replace the Halloween parade that would be just a Village celebration, to capture the spirit of the original Halloween parade. It's very cold so you don't really want to dress up in a really great costume. That's one thing that's always made Halloween so great.

It's the last chance for all the gay men with great bodies to show them off before winter.

"I don't think the changes are because of AIDS. No. There are always new people. A lot of our best and brightest have died. But gay people are all over the place and being born each day and they all come here. And there'll be more gay people to come up in future generations. But a lot of gay men don't want to do this for the gawking straight people; they want to do it for their family, their gay family."

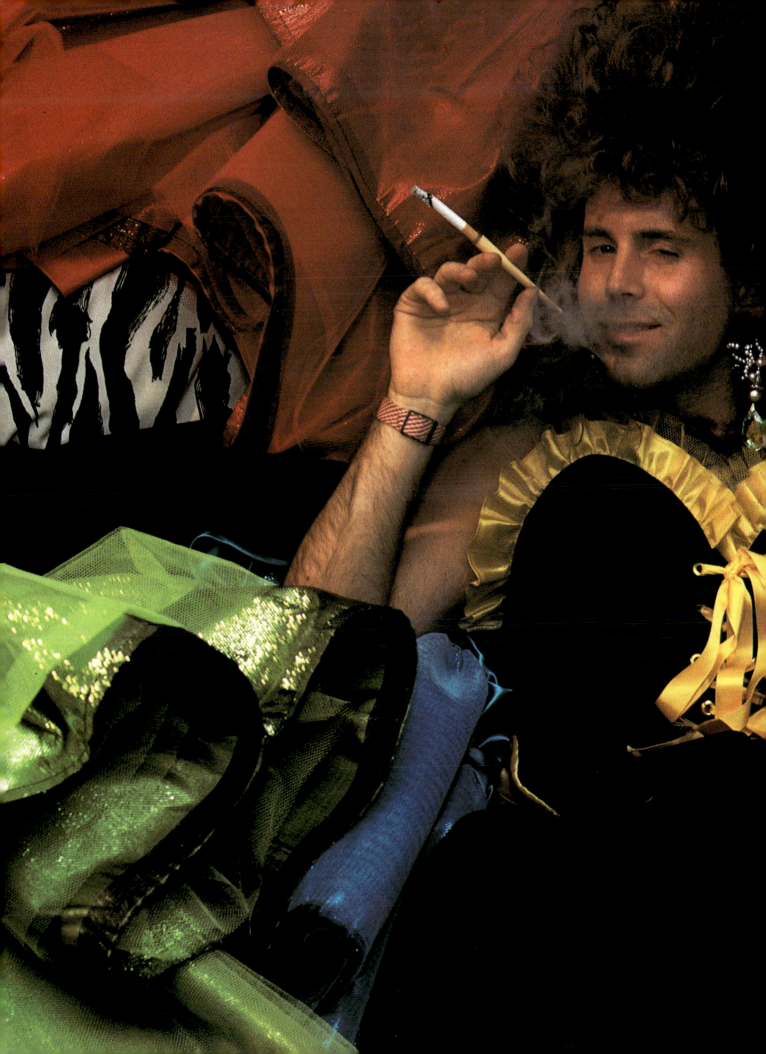

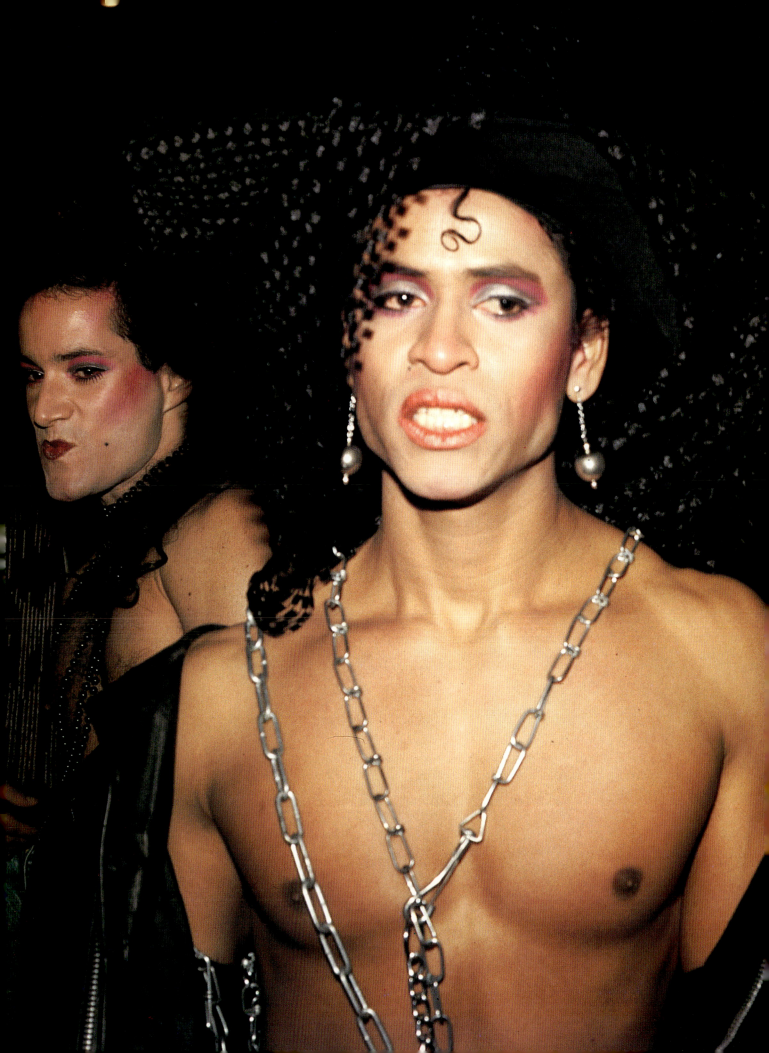

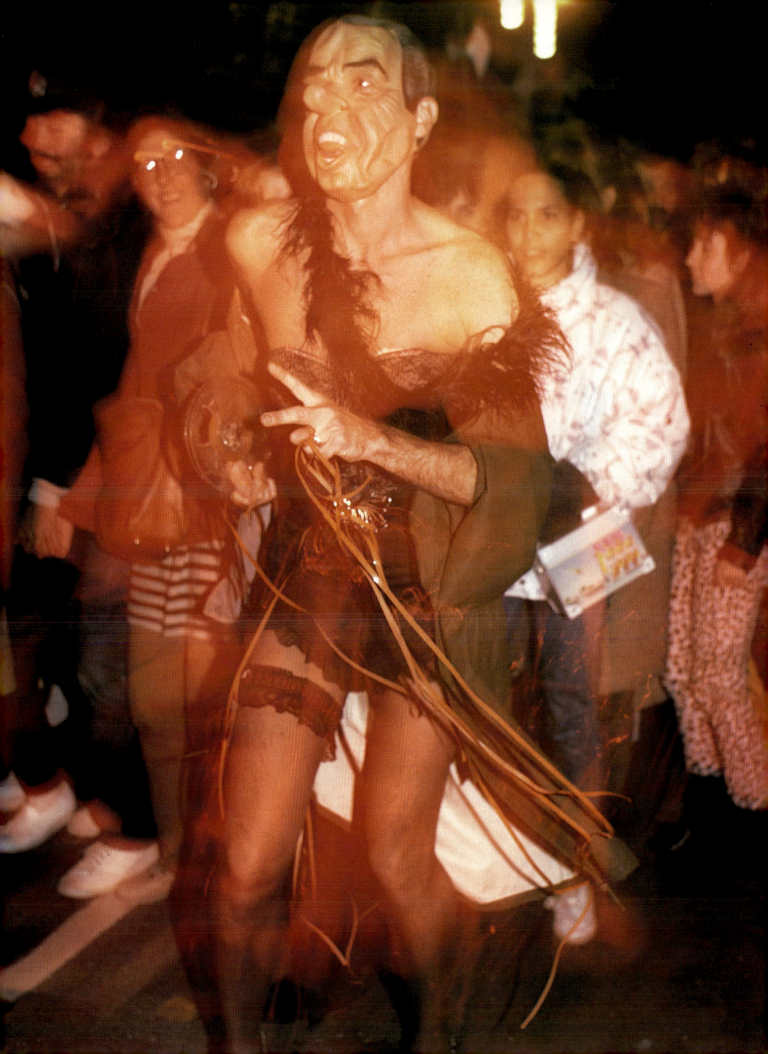

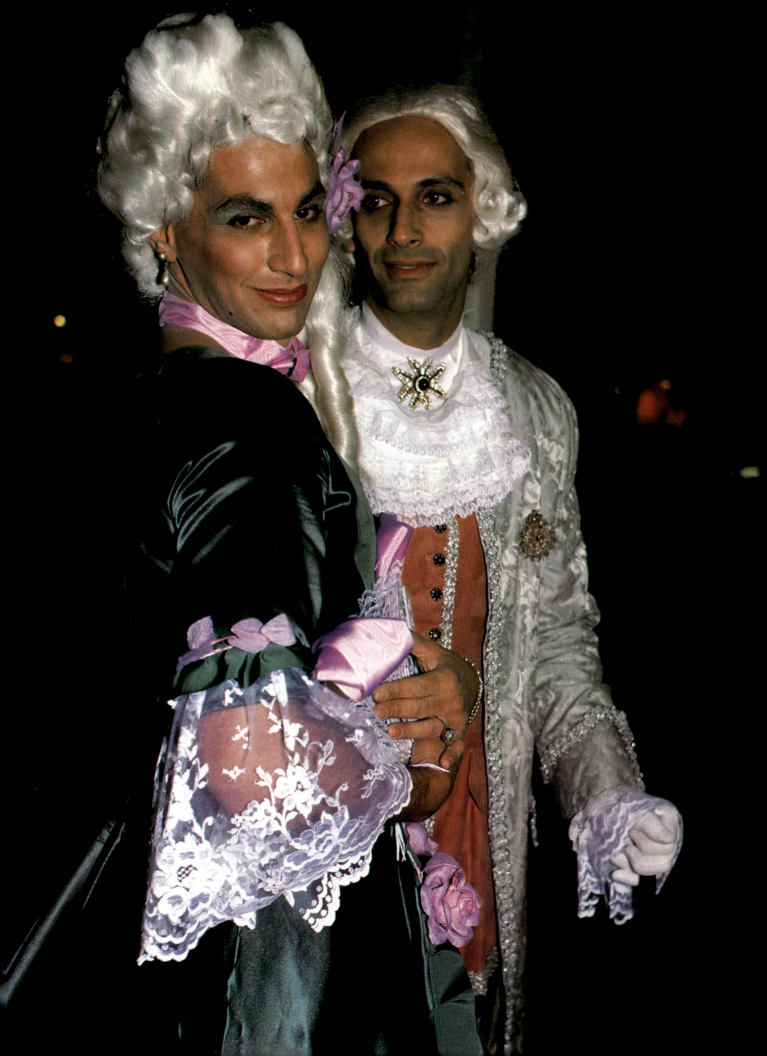

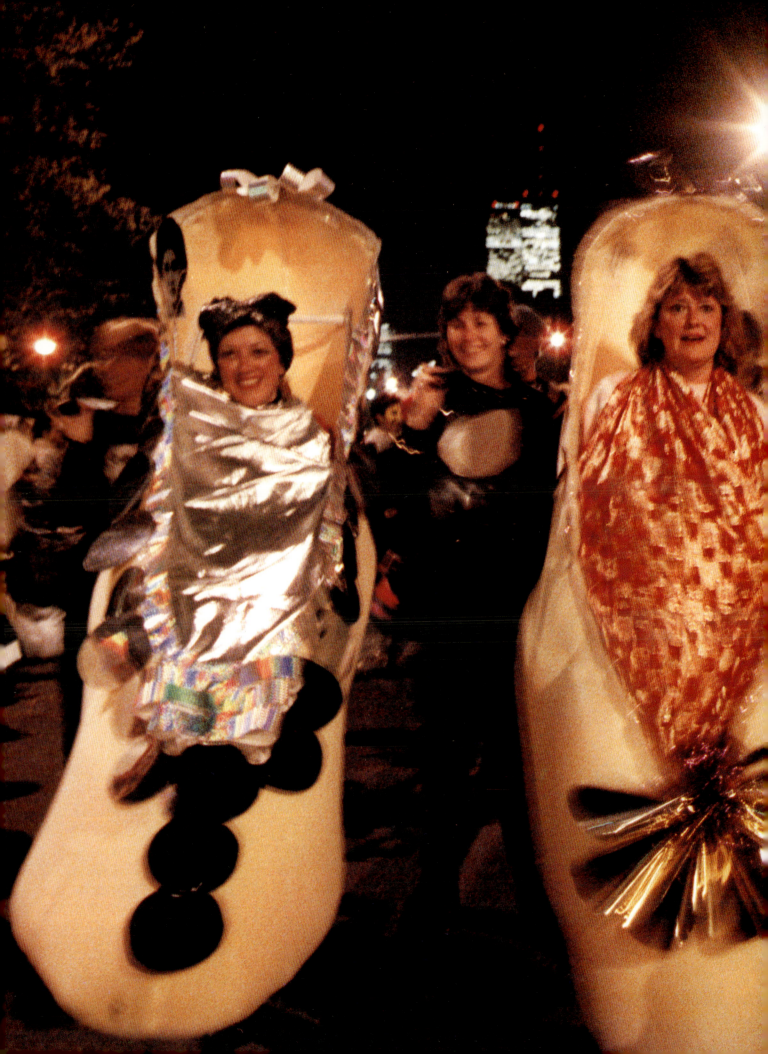

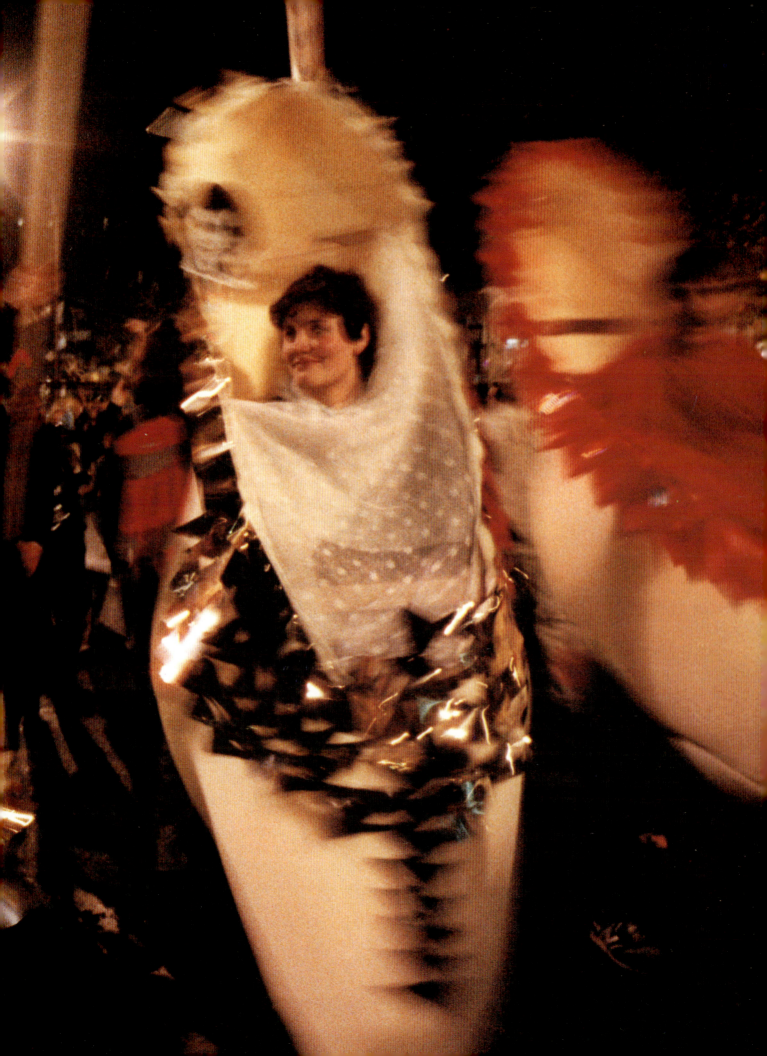

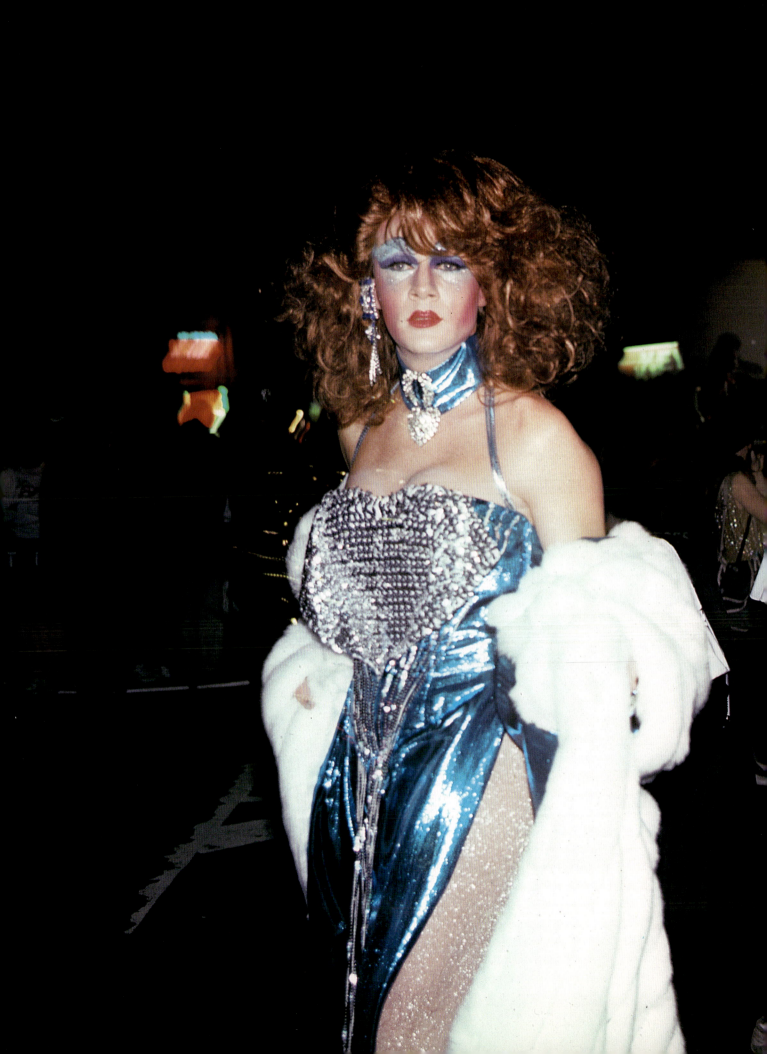

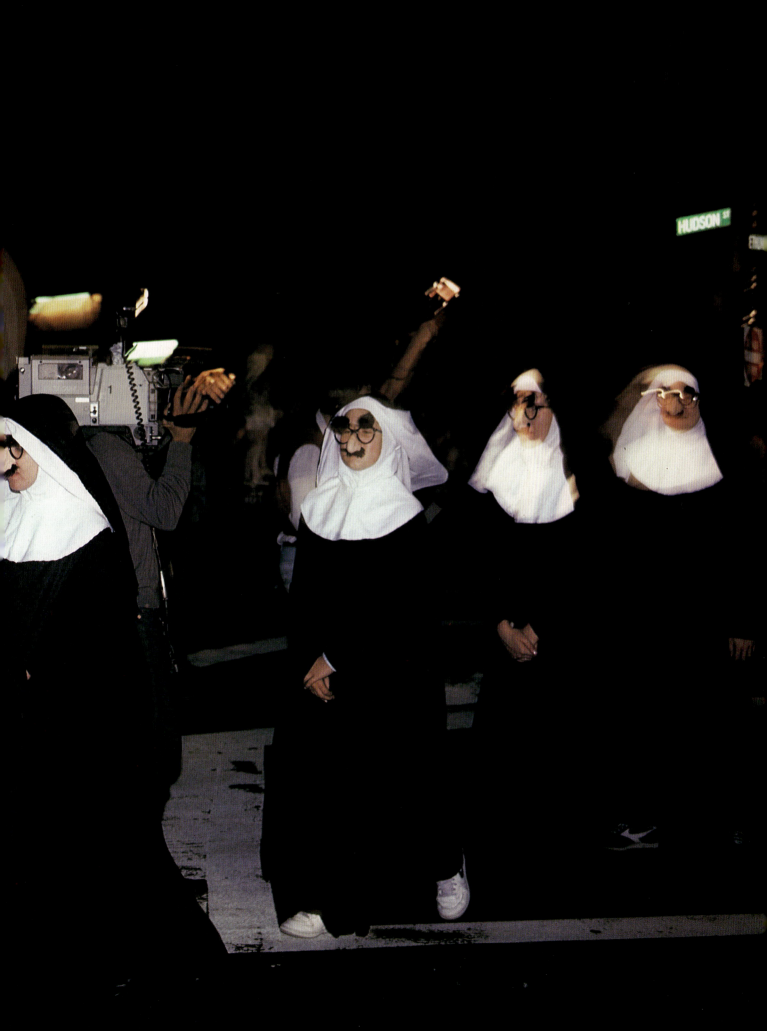

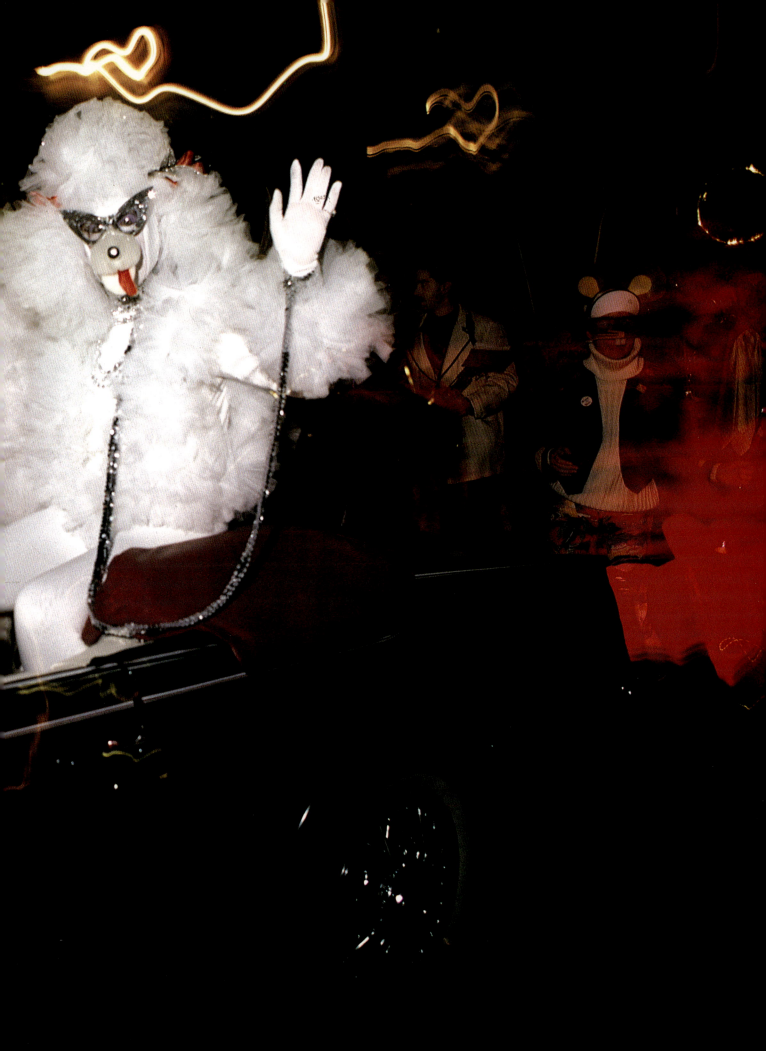

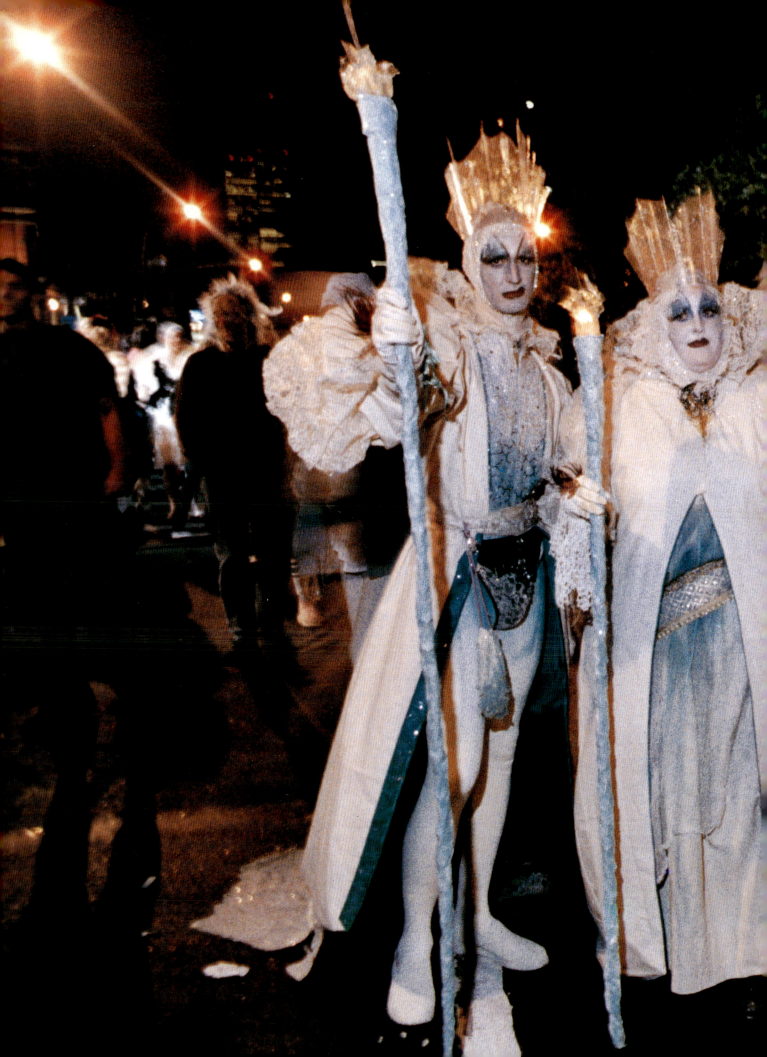

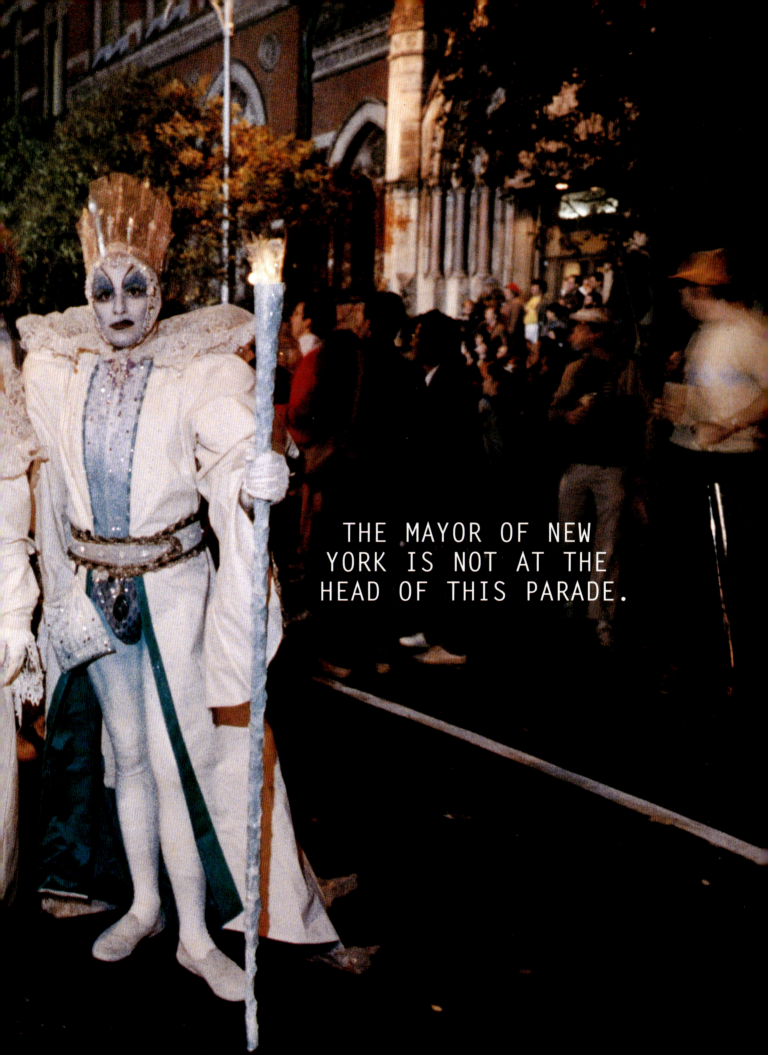

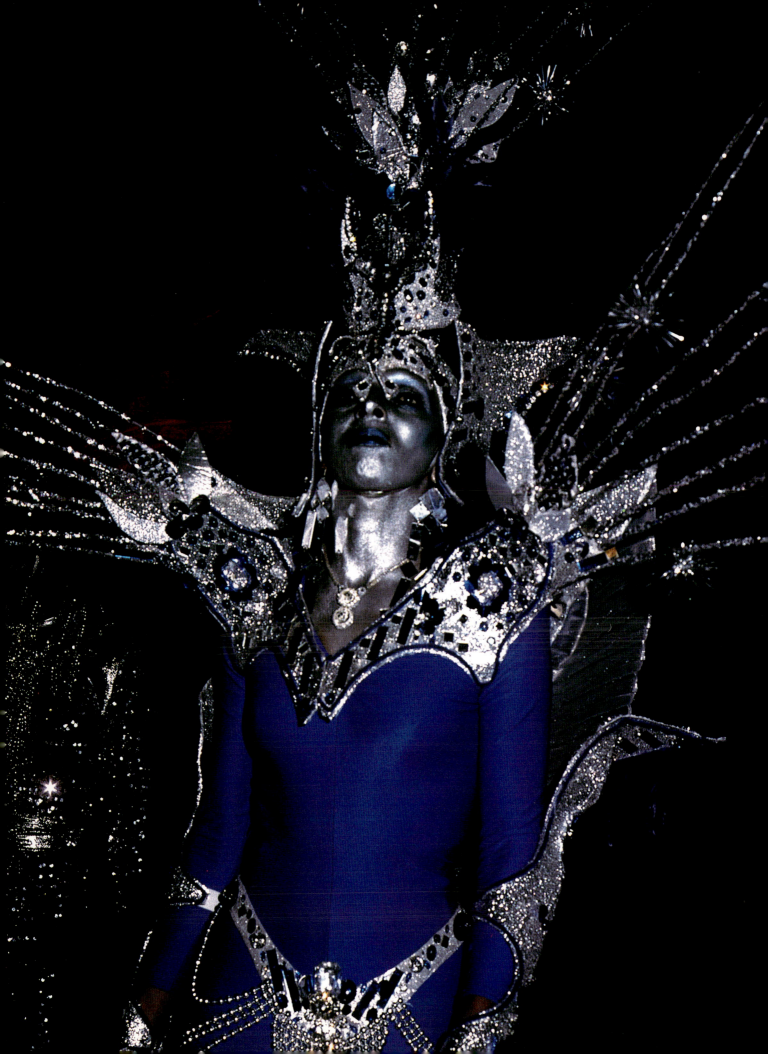

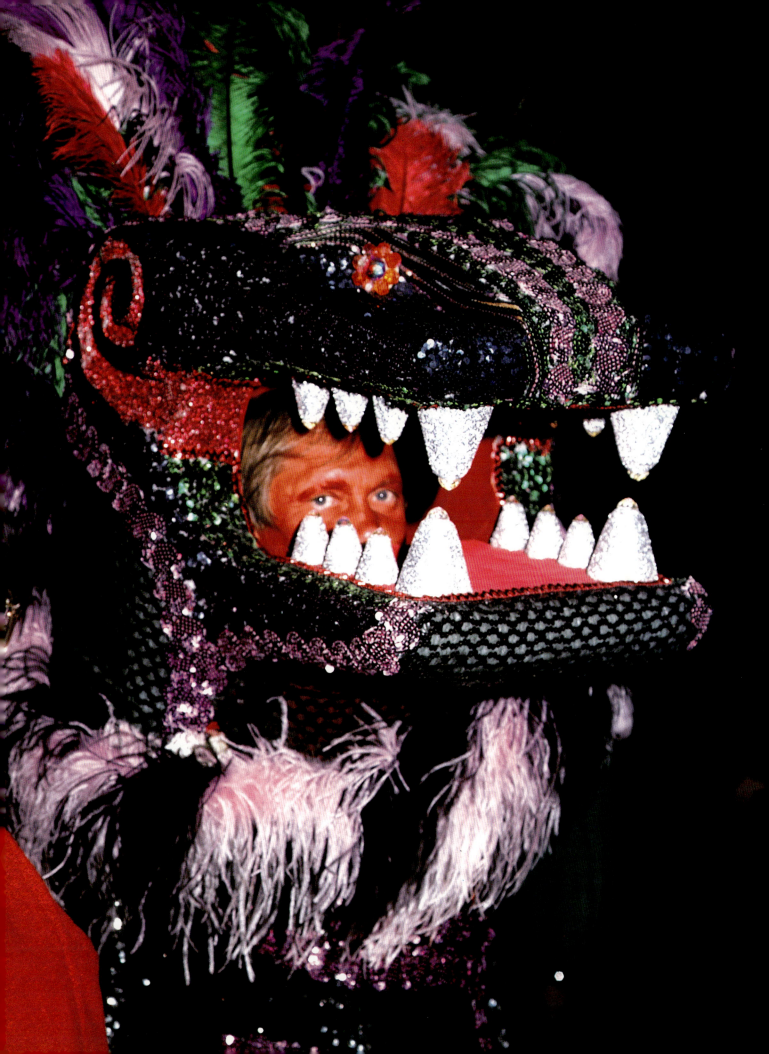

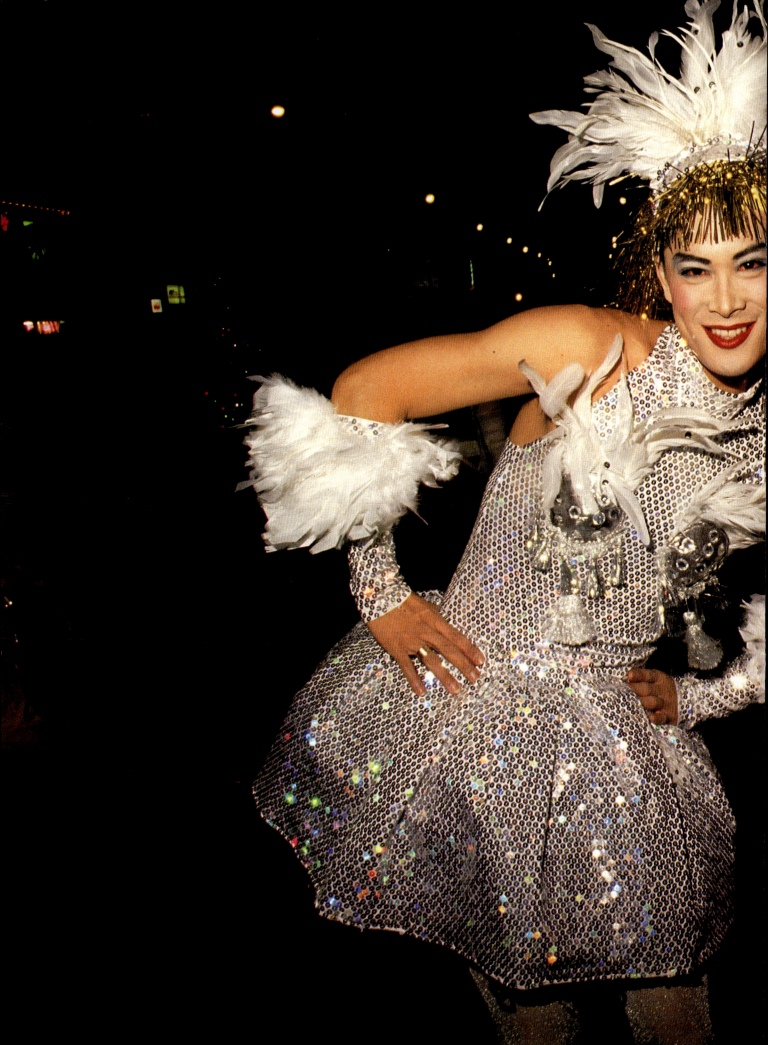

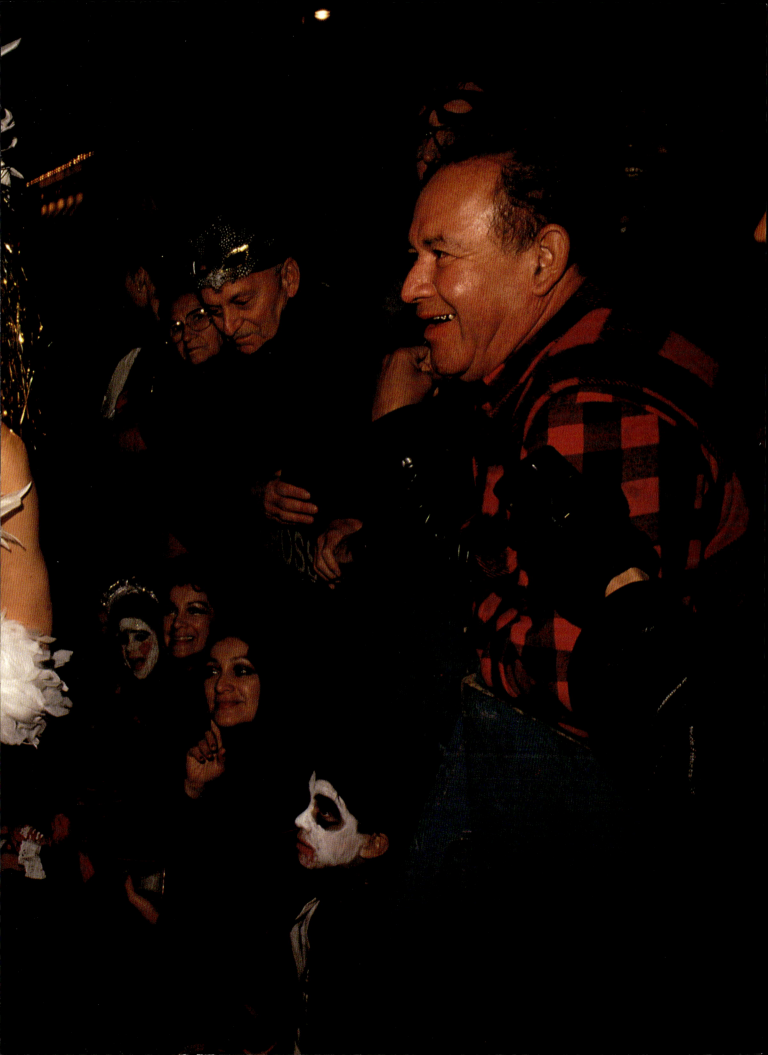

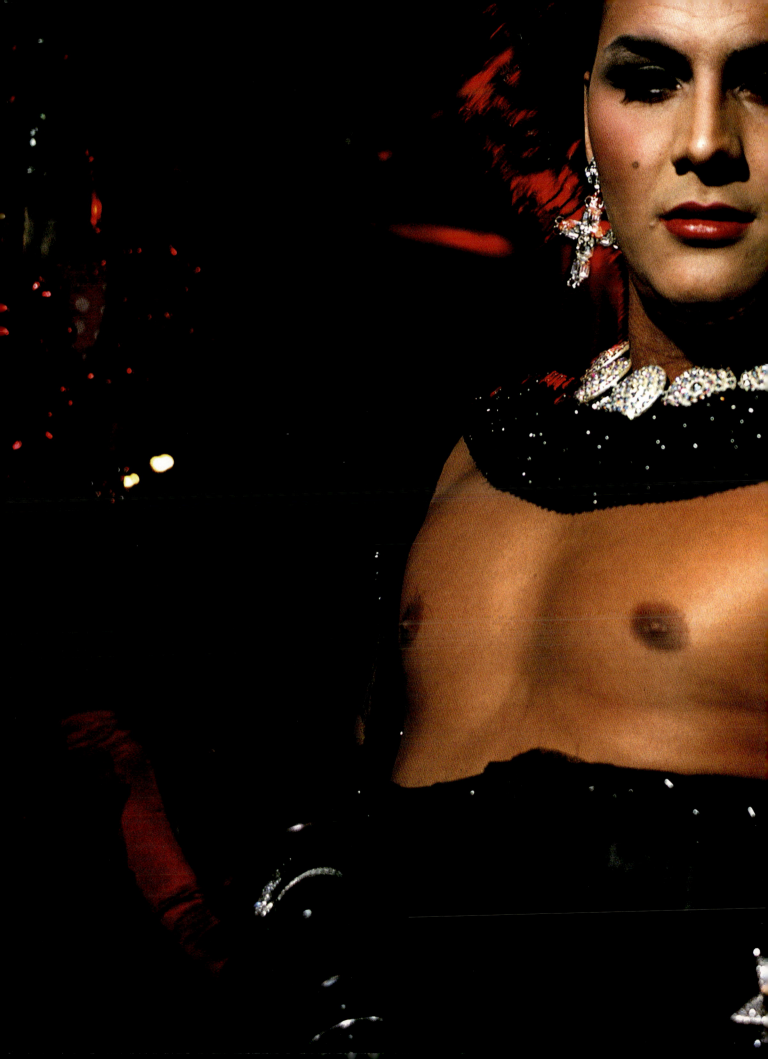

WOMEN ARE FASCINATED BY THE BREASTS.

THEY GRAB AND I GRAB BACK.

THEY SCREAM.

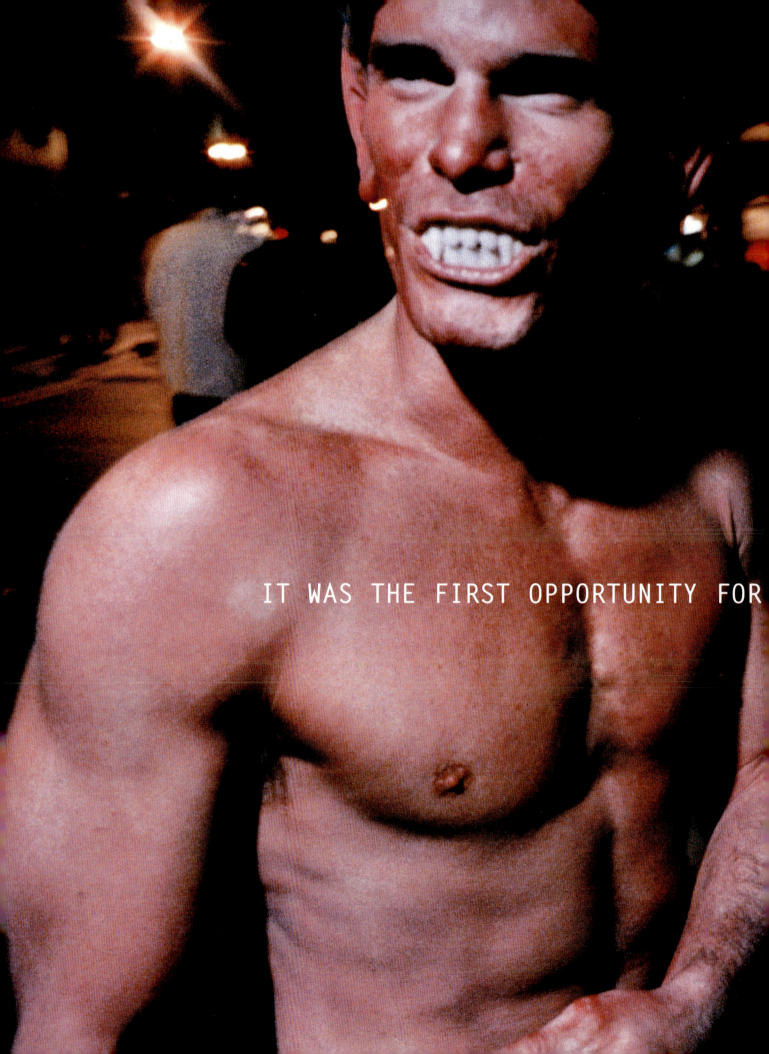

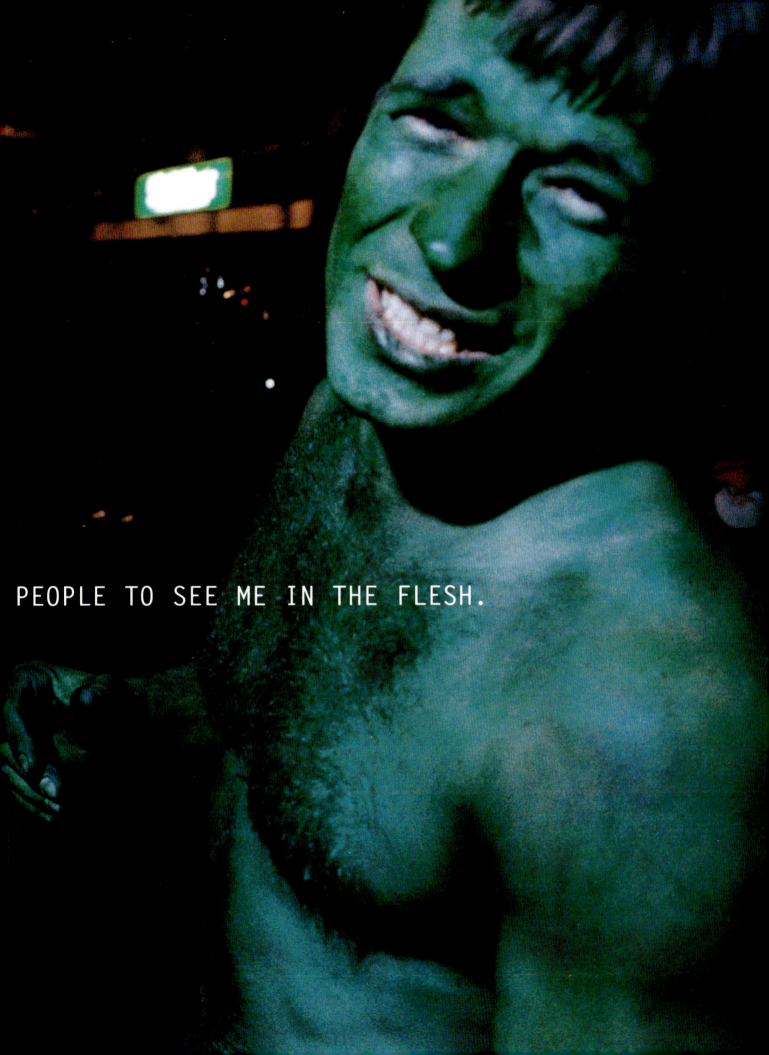

PEOPLE TO SEE ME IN THE FLESH.

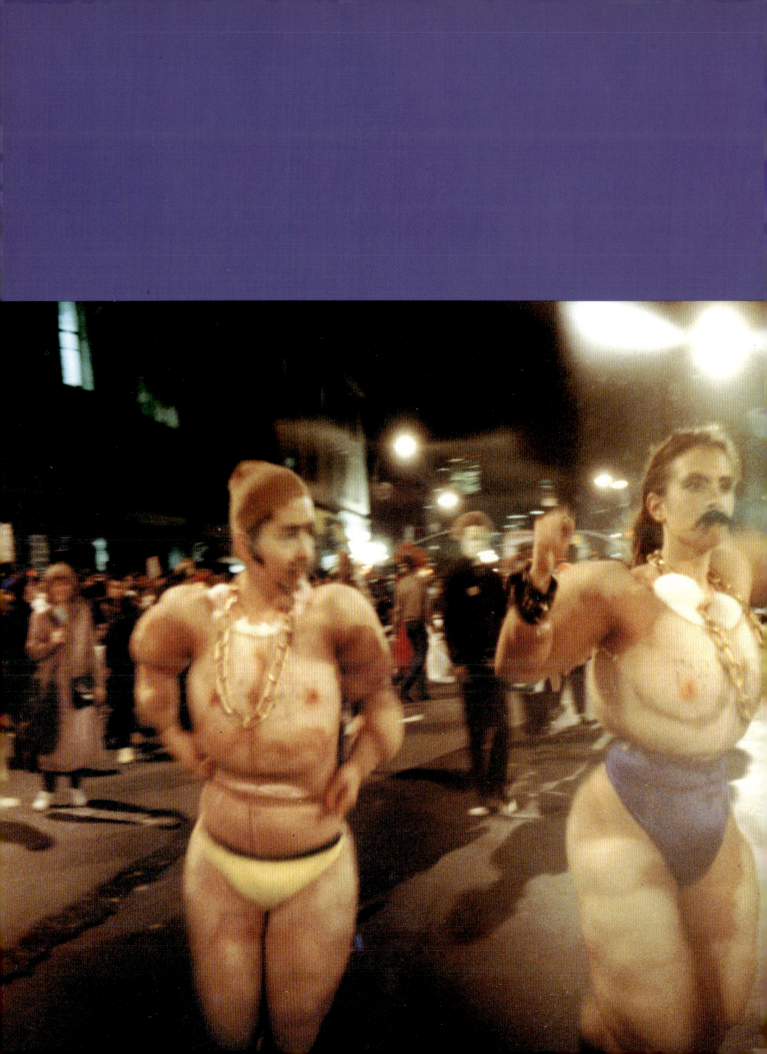

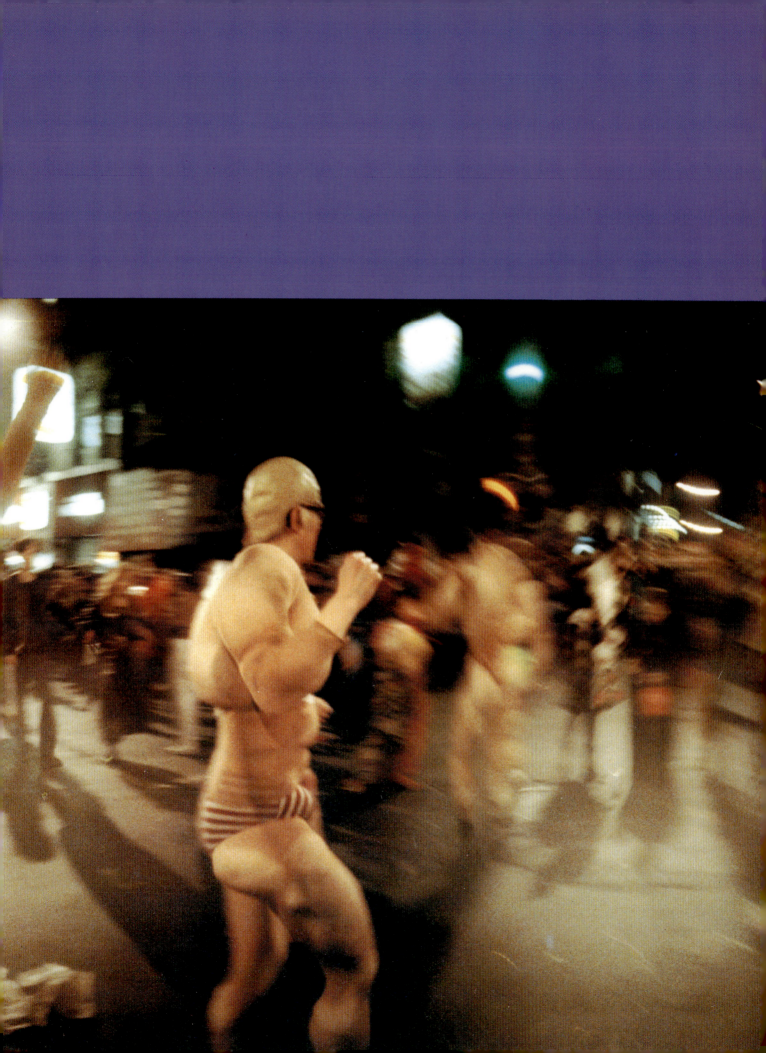

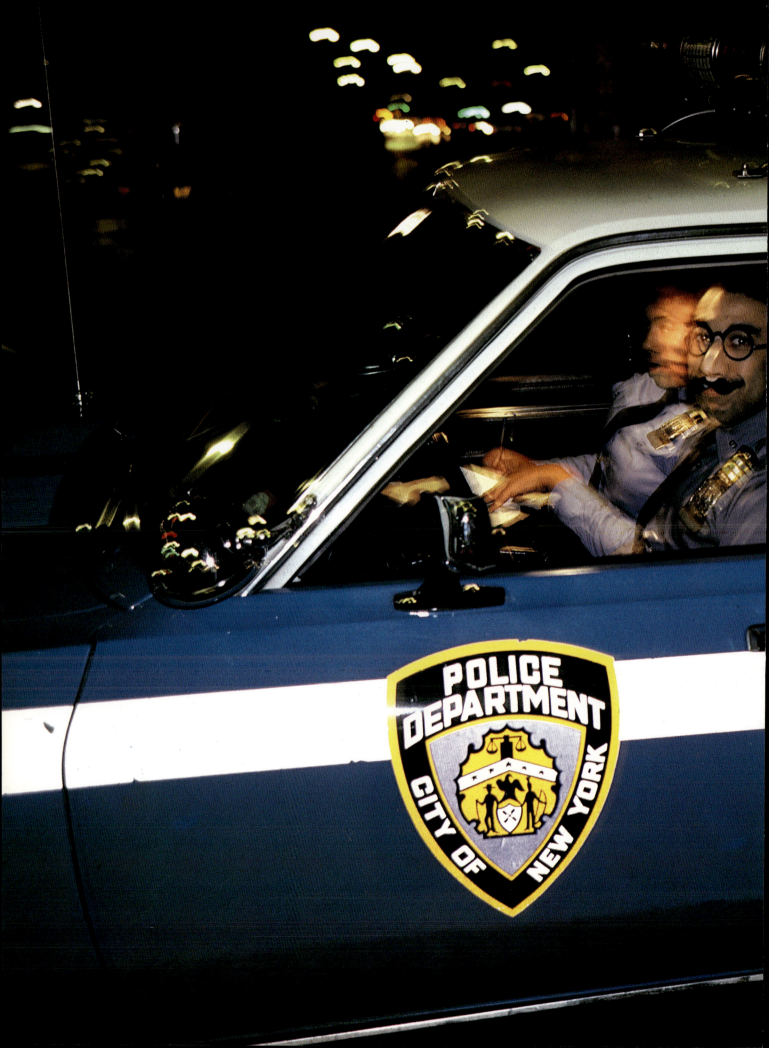

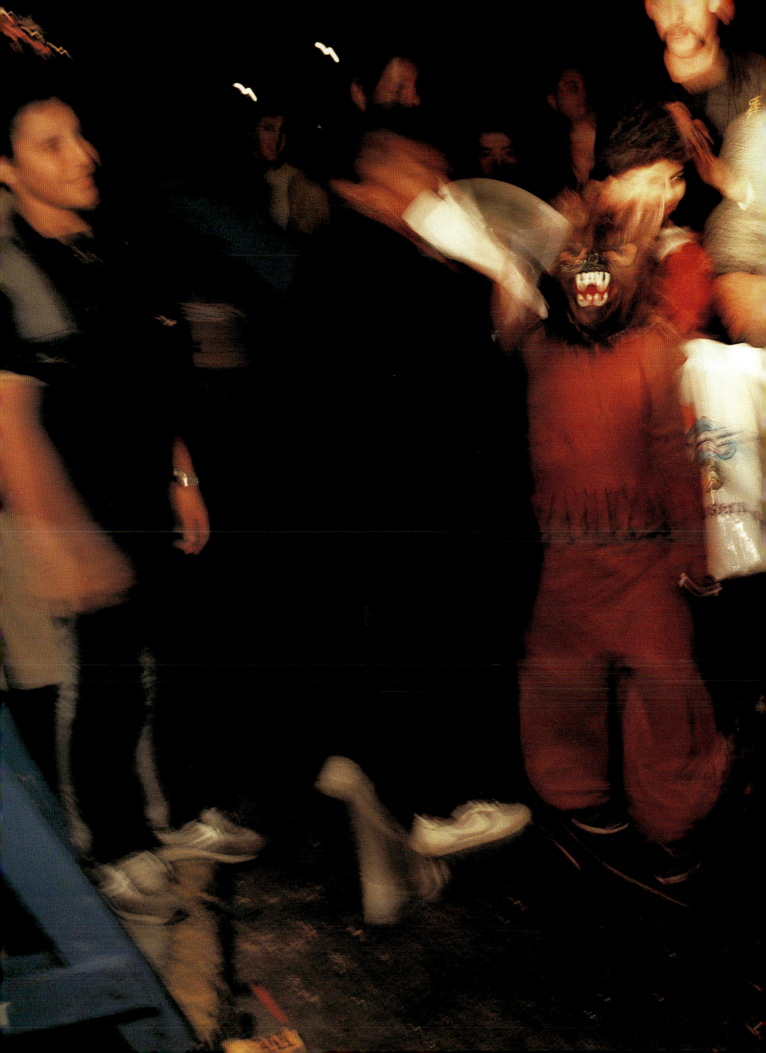

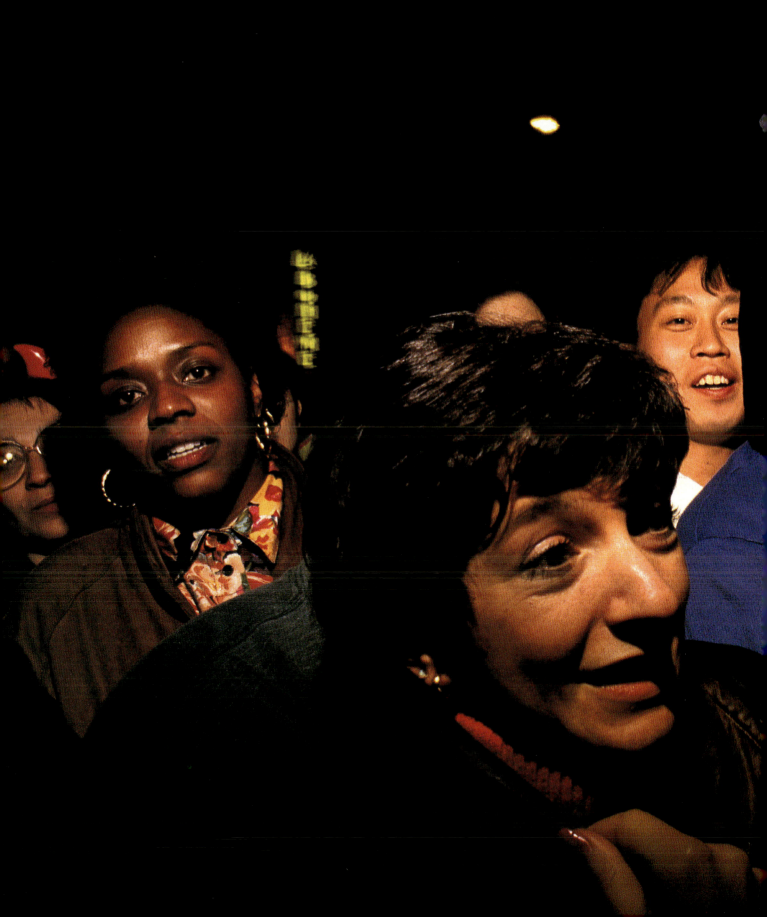

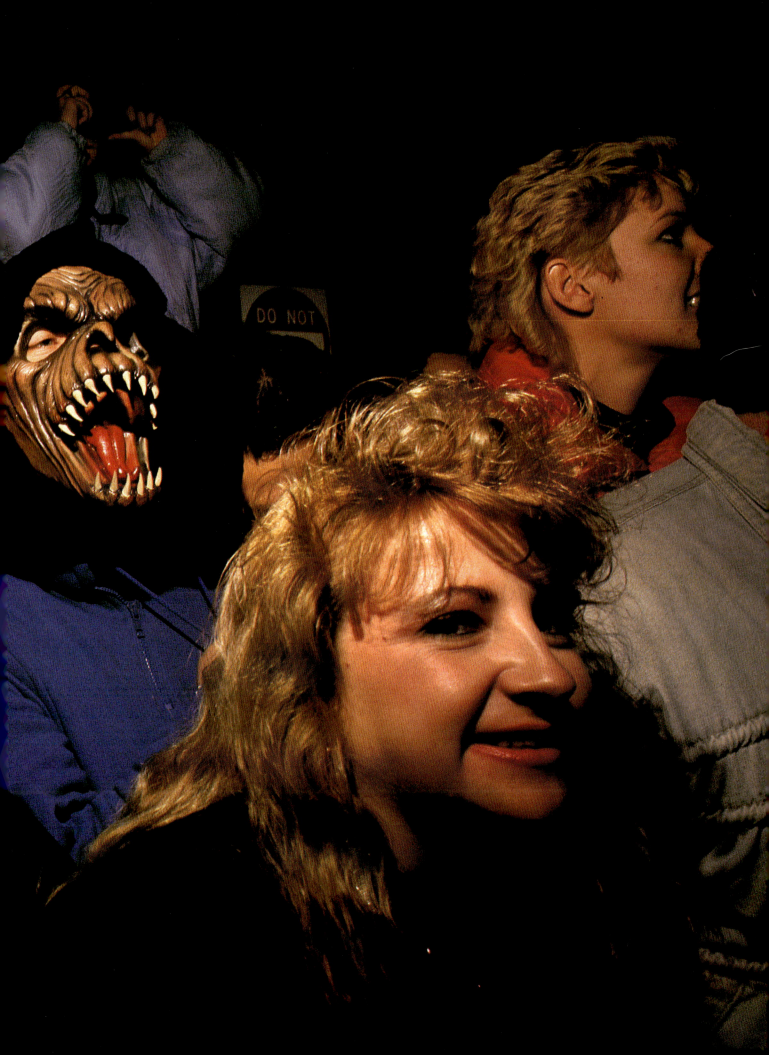

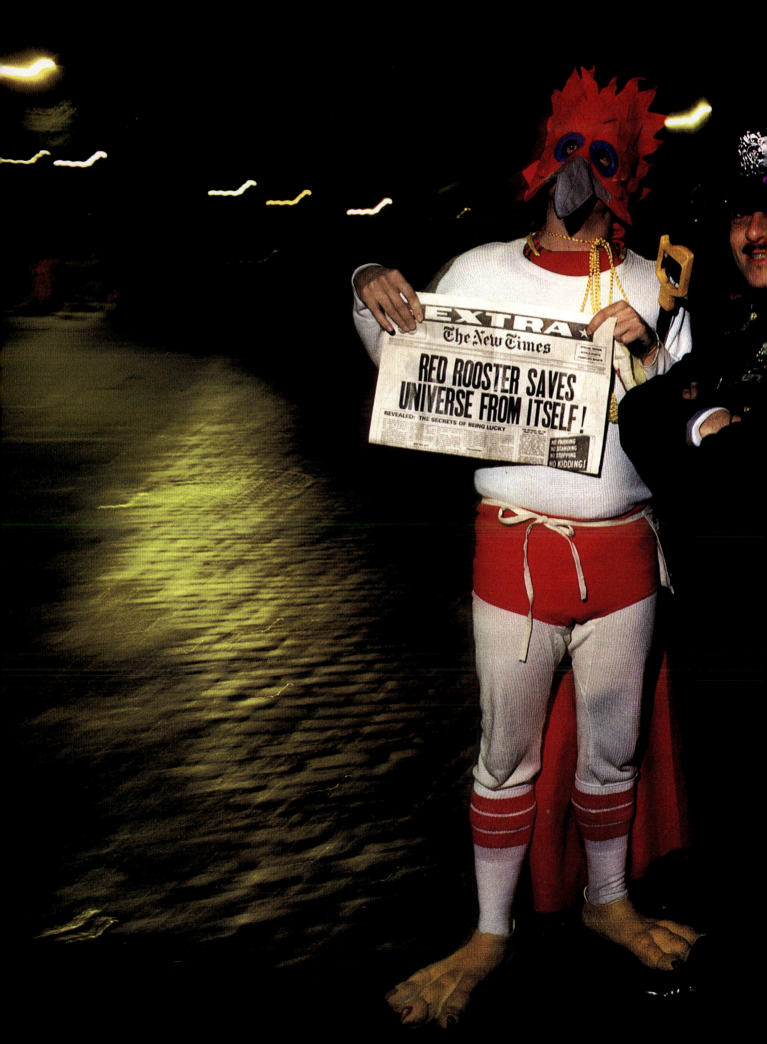

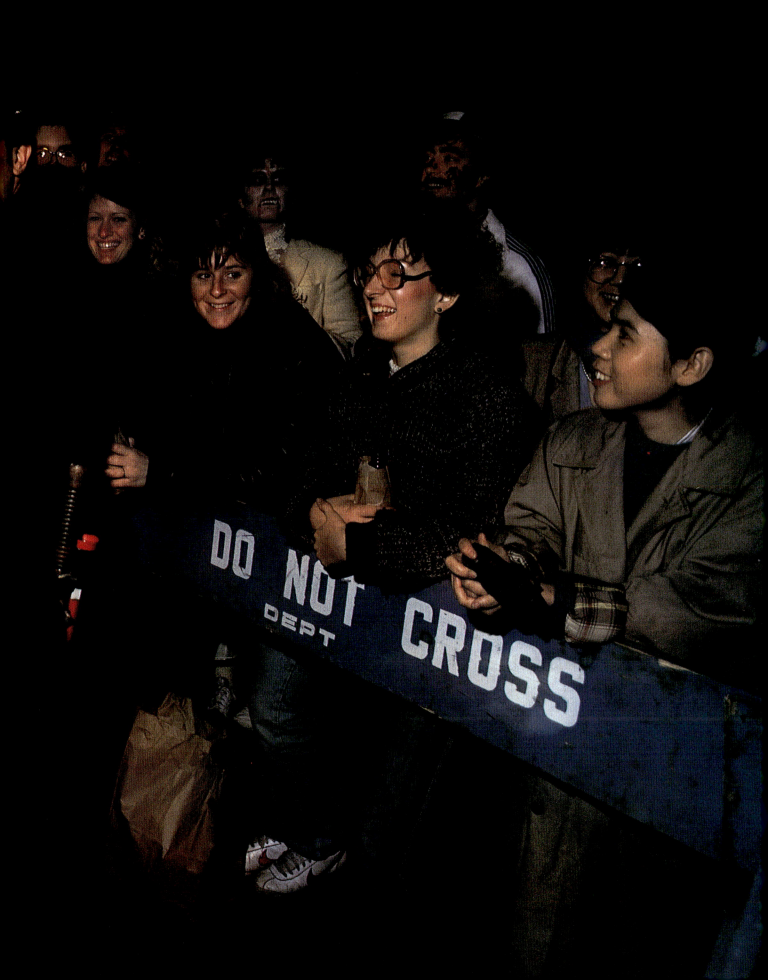

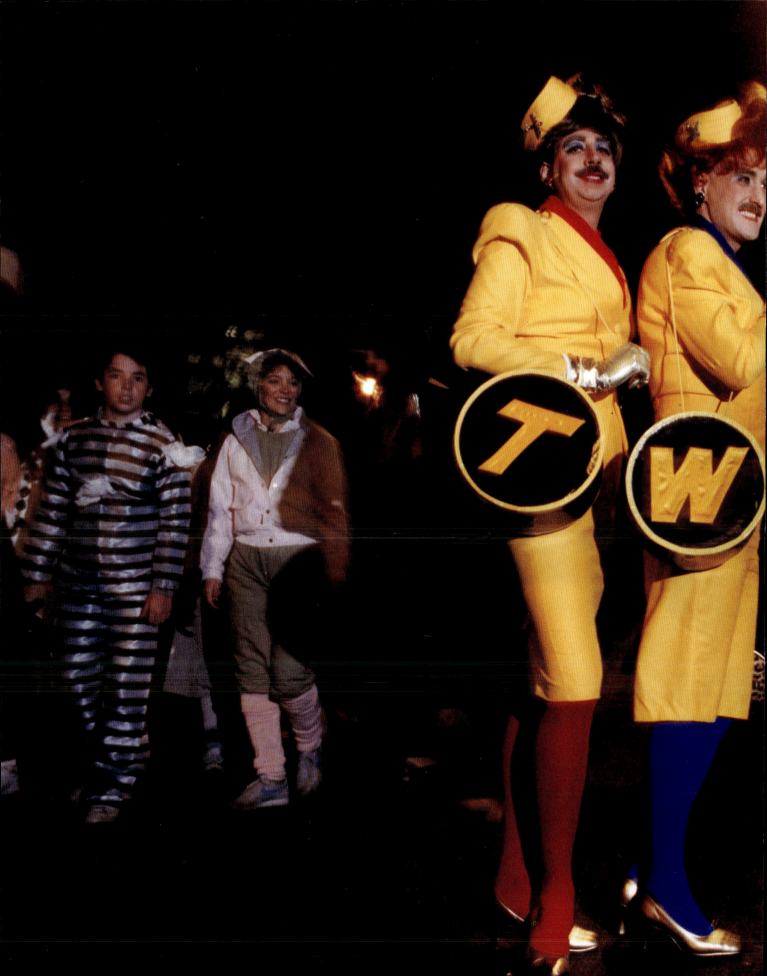

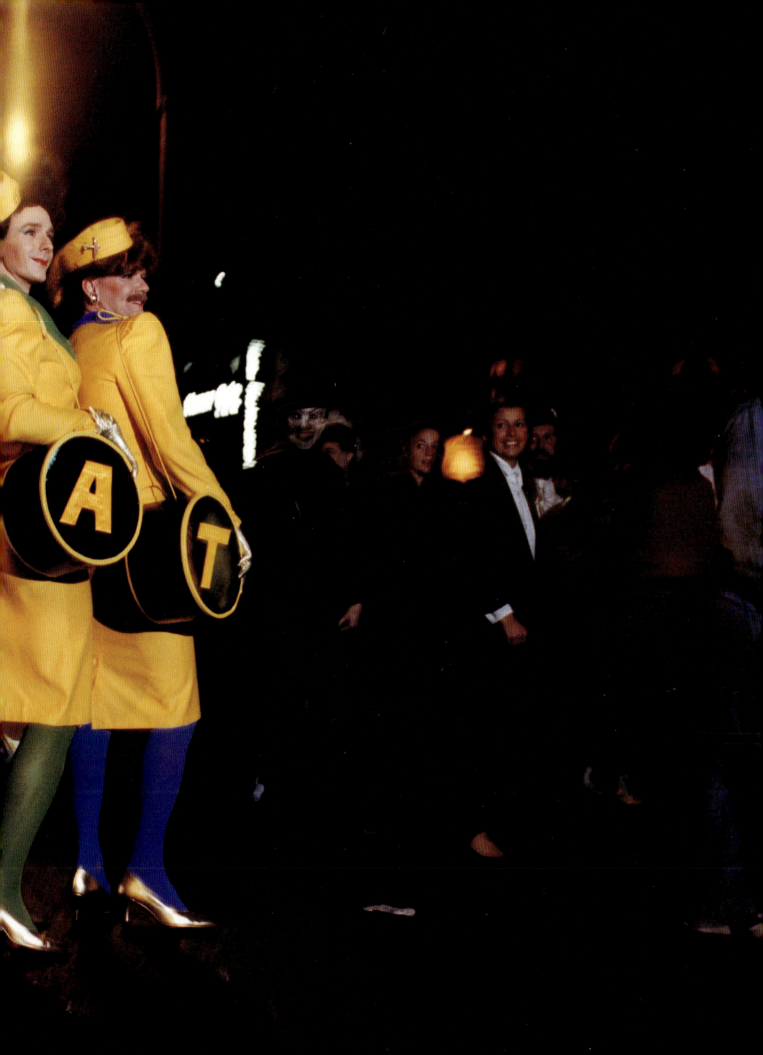

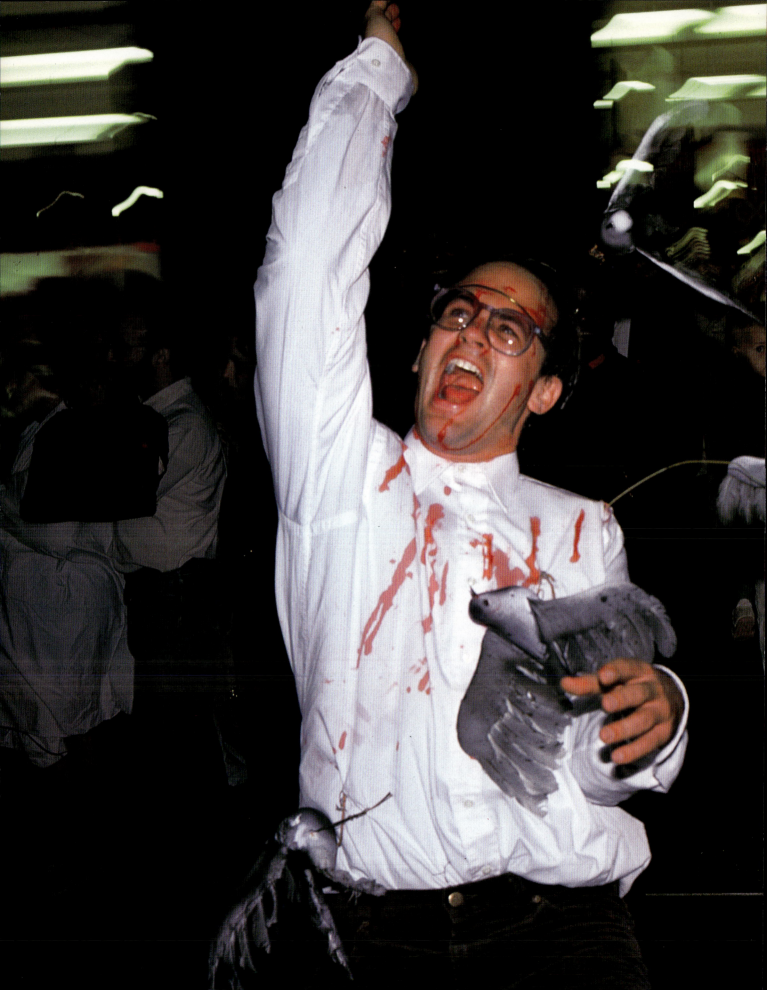

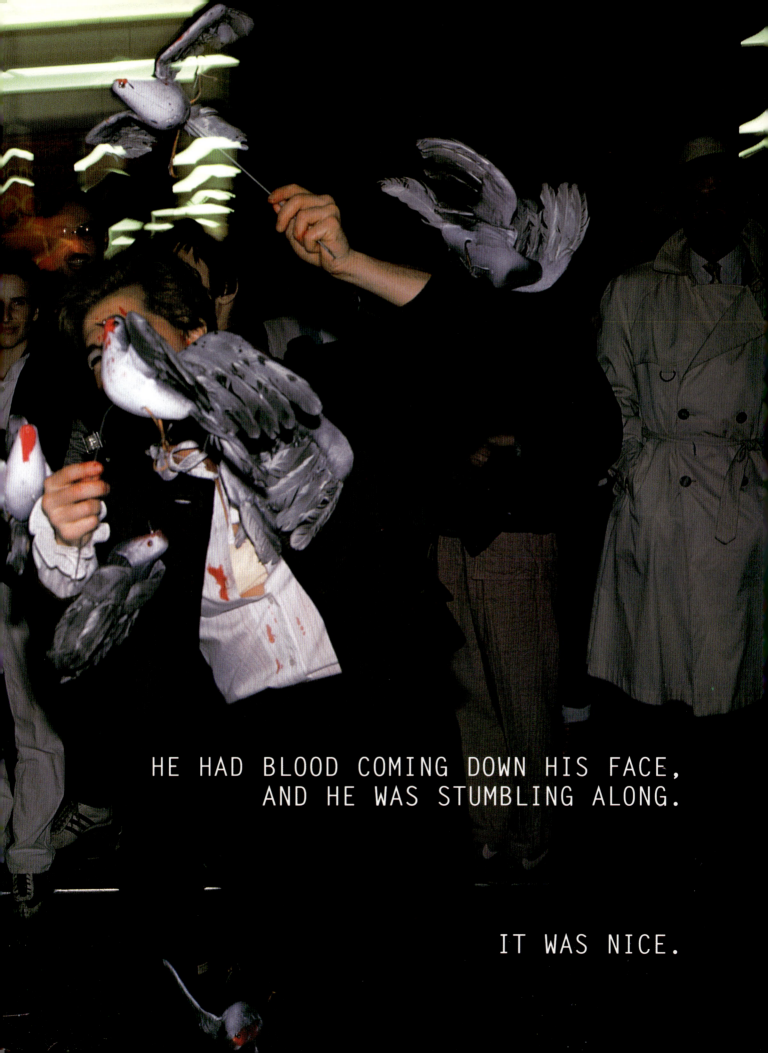

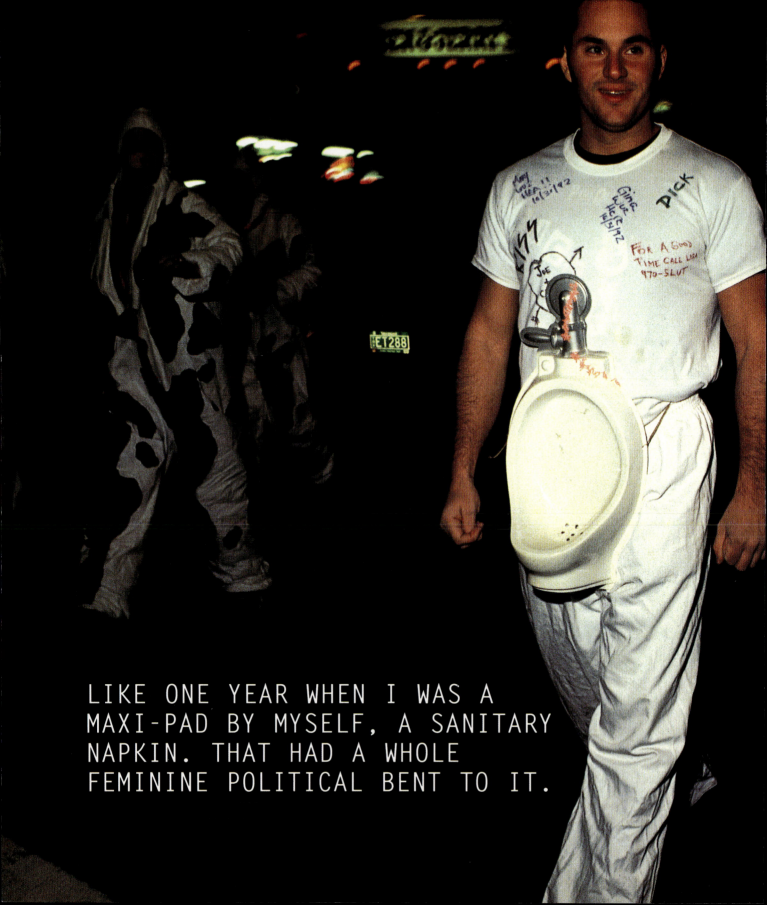

Making Art

Seen through the eyes of drag queens, the parade is in decline, and the most talented performers have either died or are seeking alternative venues for their routines. But for the majority of those who participate, the parade still offers a chance to have fun, to perform on the streets of the city wearing simple masks, store-bought or even laboriously created costumes, to bask in the glory of a great public spectacle, and to capture public acclaim even for a short time. Still, others are less interested in having fun but are determined through their costumes to have an impact on the city, to rally others for their cause. Given the economic ills faced by New York since the late 1980s, an increasing number of participants and spectators consider such a political turn appropriate.

Tasha Depp appeared in the 1992 parade as part of "The Tornadoes." A thirty-two-year-old graphics designer, she has participated with the same group of women for the past seven years. As an artist, Depp relishes the opportunity to perform for a broader public than she can by exhibiting her work in small New York galleries. The larger the audience, the more people there are who's sensibility she can challenge.

"It started when I was at Cooper Union as an art student and my roommate and I did costumes together. After I graduated it evolved into a larger and larger group of women friends. There were always wild Halloween parties to go to, and then I discovered the parade by accident. Making the costumes is really fun. As artists we just really like to do that. And it's fun also because we're all so busy now that this is a good way for us to catch up and socialize. It's like a quilting bee. We visualize something and then become it physically. It's just strange to envision how a person can become a thing. One year we were caryatids, and another year we were giant soda bottles filled with blood.

"Generally, the way we work is that somebody does the design or comes up with the idea, and we agonize over whether to do it or not. Usually that goes back and forth, and we change our mind a lot. Now it's gotten so that it's not until three or four days beforehand that we actually decide what we're going to do, which is awful. Then somebody designs it. We have this joke where one of my friends is really notorious for coming up with the greatest ideas at the very last minute, and so every year in September we start telling her that it's Halloween in a week. This year my friend Chris who's the architect went and bought the wire mesh and all the materials that we needed to do the tornadoes. She actually convinced us to do the costume because she had put so much work into it. We just felt that since we have to do something, this might as well be it. We each worked on our own costume in the shop but helped out if someone fell too

far behind. It depends what the idea is, but it usually takes maybe three- or four-hour sessions to make the costume.

"Chris liked the tornado idea because she was interested in the structural problems involved with turning a human body into a tornado. But I just felt like it didn't have enough either political or social or even just humorous content. It was too simply a structural idea. So I kept on trying to find a way to connect it to the recent hurricane in Florida because that might have made me happy. But that really didn't get through to people.

"The Tornadoes were each about twelve or fifteen feet tall, and we wore them on our bodies. They were made out of wire and two or three metal structural rods. The metal rings got bigger and bigger as they got higher. They were covered with cotton batting, which we pulled out and stretched diagonally around the wire rings, because tornadoes go in rings like that. Then we spray-painted the batting dark gray on gray. At the last minute we stuck some little things into the costumes. I had a man's hand coming out of mine to look like the tornado had sucked someone up. And we had a few victims walking with us who were friends of ours. One of them was really great. It was like his head had come through a trailer window and he was just wearing a portion of the trailer around his neck. He had blood coming down his face, and he was stumbling along. It was nice. The whole thing cost around $180. We split that up, and so it came to $30 or $40 a piece. That's pretty average.

"The audience reaction would vary depending on whether we had the energy and enough room to do our performance of rotating, sucking up, and trying to chase after the victims. And when we had a wide enough space and we weren't being swallowed up by other costumes, the crowd would actually scream, 'Oh, wow! Tornadoes!' And you'd hear this clapping. They'd be all excited. But then other times you had people saying, 'What are you?'—people who came up to you real close and they couldn't really see the other tornadoes or the victims. They just saw this big weird thing coming towards them and they didn't know what it was. So it varied. I always find that real disappointing. You go to all that work and people say, 'What are you?' That's just really awful. I never answer.

"It's sort of hard to explain what these costumes really mean to me. It depends what they are. Like one year when I was a maxi-pad by myself, a sanitary napkin. That had a whole feminine political bent to it. Two years ago we were men and that was really fun. Last year we were male lifeguards, and we had these big muscles. We looked like we were naked. It was done with stockings and stuffing material. The year before we were muscle-builders, and we had on big gold chains. We copied the idea the second year. But it was fun because people really couldn't decide whether we were men or women. And then when they realized what we were, they were so surprised and shocked. It was a really great costume, really fun.

"As an artist I like the fact that I have an audience. It's really hard when you're an artist in New York. You struggle and struggle to show your work. This way people lined up for blocks to see you in a costume or to see your artwork. There's something very gratifying about that. And serious about it, too, particularly when we've come up with the more conceptual types of ideas like impersonating men. One year we were flowers. There was something kind of feminist about doing these huge flowers that walked down the street. They were twelve or fifteen feet tall. That was kind of nice. And also there's something about just making art that visible and that important and that public and understandable that seems really important, too. Because a lot of people don't walk into art galleries. They don't want to deal with art that way.

"The significance of dressing as men, of course, is making fun of men. And I hesitate to say that it's not vicious. It's making fun of the power that men take on with muscle-building and things like that. And we're sort of saying we can look this way, too. At least for a night. Or we can try to embody this kind of power. I think when you're wearing a costume you do take on the qualities of whatever it is you're dressed up as and that's really strange. It takes a little while to fall into the pattern.

When we were the men we all started to walk differently

and carry ourselves differently. And that's pretty exciting. Another fun thing about being men is that we could flirt with all the gay men who were embodying women. That was hilarious. That's a nice thing to do in the parade—to have a costume that interacts well with other people. It forces people to communicate with each other just because they're dressed up as something. It breaks down all these barriers.

"If you ask me what the parade does for the city, one of my immediate answers would be that a lot of people who aren't from the city now come to this parade, and that makes it both fun and unfun. I remember when the parade had a lot more to do with the West Village and the gay community. I think maybe the costumes were a little bit more individual and a little bit weirder, and now it's becoming a little bit less interesting. But I think it still is a real focus for the city on the night that it occurs. This year after I left the parade, it seemed as if nobody else was even dressed up. The whole city was focused on the parade. And if you weren't at the parade then you weren't interested in Halloween. Generally, though, I think people in New York make a big deal about Halloween. I'm not sure why that is. Maybe because it's sort of a slightly satanic offbeat holiday and people in New York kind of really jazz it up. I can't imagine this parade in another city.

"My parents live outside Richmond, and I just can't imagine this level of commitment to Halloween. I can just imagine a whole Southern fundamentalist idea operating where they don't want to celebrate Halloween. I think one reason why I like it so much is that it is not a Christian holiday. And that's important to me personally, because I'm not a Christian, and that's partly because I have a lot of born-again Christians in my family, and I find that a lot of things about Christianity are really repressive. And there's something about Halloween—it's kind of like Mardi Gras. I remember being in that parade where it was just one amazing visual thing after the next. I can think of things like someone who was Mona Lisa with a gold frame around themselves. And there were all kinds of amazing ideas and some of them are really political, some of them are sexual, and some of them are just visual. It's such a barrage of amazing expressions of people's ideas. And that kind of creativity does not come out in any other holiday. I mean people just do not do that. It's not about repression at all. And it's not about carrying around an image of someone on a cross and feeling sorrowful. It's totally wild, unpredictable, and chaotic. It's much more like life is. So for me, it's more important than any of the other holidays."

Theresa Demas is in her late twenties. She is a politically active singer who plays keyboard and synthesizer in a rock band. The first year she was in the parade, Demas appeared as a wicked witch from Oz wearing gothic black clothing.

"After that I came as Mr. Bubble. I had a couple of hundred balloons, and I was blowing bubbles at the crowd. And then I was Tammy Faye—I had a big bucket that said 'Tammy Faye's Mascara Fund' and people would give me money. I was Leona Helmsley. I was in a jail suit with an enormous royal purple robe and a crown. Another year I was Marla Maples, and I went with two other people—a Donald and an Ivana. One year I was this very strange ethereal thing like something from a fairy tale, and I was throwing fairy dust at people. Then I was a mummy one year."

Although she considers current events in designing her costumes, Demas insists on interweaving the serious and the light-hearted. Laughter, after all, is subversive. In 1992 she appeared as "A Thousand Points of Light" together with her husband Craig, who came as the Easter Bunny. I asked her about the combination.

"If you believe in one, you're just as likely to believe in the other.

I wore very large pink glasses because when you look through them

everything looks rosy.

I had a small little safety net with me and a big sign that said 'Thousand Points of Light' with a big yellow smiley face on it. I carried a magic wand and a bag of fake money with Alfred E. Neuman's head instead of George Washington's. My husband came as the Easter Bunny. He carried a basket of carrots and Easter eggs. He's also currently unemployed and will be so until spring (ha, ha). And he's a good spokesperson for family values because he came from a very large family. So the costume connects to modern-day American mythology. I was a superhero who most people have never seen but they've all heard of so it was the first opportunity for people to see me in the flesh.

"My husband and I have been married for a year, and this was his first time in the parade. He didn't know a lot about it. He does sculpture and jewelry, and I told him that this is right up his alley. At first he needed encouragement. We live now in New Jersey, and when we left home it was like we were the only ones dressed up. But as soon as we got off the train in New York, there were people walking around in costume. New Yorkers are so used to eccentricity and diversity that people didn't take any notice of us. I used to live in the Village, and on Halloween I would wear my outfit all day. I would go to the bank, do errands, and even be at work in costume. Most of the time I worked in a record store. People would come in, see a witch, and they'd think it was a hoot.

"I pick my costumes by which ones interact well with the crowds and with other performers in the parade. When I was Mr. Bubbles, there was a medieval lanceman who was bursting all the bubbles I was blowing. When I was Tammy Faye there were all kinds of other preachers, and we would totally cut it up or people would say, 'Tammy Faye, I gave you enough money!' and I would start crying in an exaggerated way. This year when I was 'Thousand Points' people would tell me that I was the scariest costume in the parade. And I would give them the fake money with Alfred E. Neuman's face instead of George Washington, and they would burst out laughing. There were a lot of Barbara Bushes in the parade, and I would pose with them and we would cut it up a bit. Next year I'm definitely going to do the parade, and I'm already thinking of what to do. But it depends on what's in the headlines and what people are talking about because I like to interact with the crowds.

"There's a lot of political stuff in the parade, but I don't really see the parade itself as a political event. It's apolitical and political—both. The satisfaction to me is when you get lots of people to laugh and to play along with you. Most of the time New York is not like this. It's a harsh kind of place, and this is the time when everyone in New York just comes together and laughs together and fools around together. Like two days before the parade this guy was acquitted of stabbing some guy in Crown Heights, and all the papers were trying to make it into a racial thing and stir up race riots. But in the parade everyone just got together and had a good time. You saw every nationality in the parade and every nationality on the sidelines. People went there to have a good time, and that's what they did."

Nobody Else Is Fidel

Given how many approach Halloween intending to articulate particular political and cultural agendas, it is somewhat surprising that a number of participants even think about the religious implications of the holiday, designing their costumes and performances as a meditation on the struggle between Life and Death, Good and Evil, God and the Devil. Some do it tangentially; as part of their interpretation of a persona, the meditation is almost an afterthought. Others do it intentionally; for them it constitutes the reason for participating in the parade, the very meaning of the holiday. Even such seemingly political costumes as Richard Nixon or Saddam Hussein may be less "political" than a part of the larger license the holiday provides to play at being evil, or in the words of one informant, "to do a little business with the Devil." Such costumes constitute the overwhelming majority of those worn at the parade, although the intentions of their wearers are seemingly quite secular. Their meanings, however, can be rather complex: they appear to celebrate evil, but in doing so, the intentions may be simultaneously to exalt as well as to dispel.

Ray Nunez is a thirty-one-year-old doorman who has appeared in the parade as Fidel Castro for the past several years.

"The biggest fun for me was the debate between Bill Clinton and Mr. Bush at the parade, because having Mr. Fidel Castro in the middle to separate them is really quite funny. I found that to be pretty exciting. The parade was moving along, they would stop and I would get in the middle and that would be the end of that.

"Why do I do Fidel? Well, number one, nobody does Fidel Castro, and being from a Caribbean island—I'm from Puerto Rico, it's right next to Cuba—I like to do Fidel Castro. It's something unusual. It's really a lot of fun, and I get very good vibes from people, good reaction. There are a lot of people who are happy to see Fidel Castro at the parade, and I actually looked pretty good out there.

"The fact is that it really doesn't make any difference what costume you get dressed up in, the whole point is that you're going to go out and people are going to appreciate you getting dressed and having the guts to go out and march in the parade. And people look at you and say 'Man, you did it!' That's the thrill I get when people come up to me, shake my hand, and say, 'You really look like Fidel. Hey, you look good! You look good! You really do. Nobody else is Fidel but you!' I go,

'Hey, somebody's got to do the dirty work.'

[Laughs] That's my kick."

Norbert Lopez is a professional wrestler who earns his living by driving a truck. He is in his twenties, lives in the Bronx, and for the past few years he's been attending the parade dressed as "The Road Warrior." The costume resembles a skimpy coat of mail with metallic-looking spikes and a large silver sword. In 1992 he participated with two other people: a woman friend was his "so-called manager" and held onto him with a chain; a male friend came as "The Terminator." Lopez has never been to Christopher Street and knows nothing about the promenade. When the 1992 parade reached Union Square, Lopez headed to the Palladium to compete in a costume contest sponsored by a local radio station. He was eliminated after making the semifinals.

"I thought it was really wild, a really outrageous type of thing. I didn't think the parade was a gay thing. Just people having a good time, having fun. I've been in it three times. The first time in black and silver, then red and black, now black and silver. I changed the outfit just by changing the color.

"I first heard about the parade from 'Hot 97 FM.' I was a spectator at it once, and I said to myself, 'If I could just be part of it, marching in the parade, showing off my costume!' The fun is having people say, 'Man, look at that costume! Look how unique it is!' It's like an original because I made it all. Nobody helped me, I put it all together myself. It's based on two professional wrestlers known as 'The Legion of Doom.' They have the shoulder pads and the leg gear. And another team known as 'The Demolition' had the face mask, and what I did was I combined them both together into one outfit.

"Next Halloween I'll probably play somebody else. Maybe a professional wrestler known as 'The Undertaker.' Or perhaps someone other than a wrestler. I like to be very unique in my designs. It may be time to try something new for next Halloween, something unique and outrageous that will make people look twice or three times. Just to outdo other people. This time I scared a lot of people. I even scared dogs. A lot of people wanted to know where I got the outfit. It's fun because you get interviewed by TV. Being in the newspapers is just like the ultimate high because you can say 'I was part of it. I've been in it.' It's a nice thing.

"None of my friends participates in the parade that I know of. I tried to get them to go to some clubs afterwards, but most of my friends would rather go out throwing eggs and bombing people with flour and shaving cream. To me it's not my type of having fun—running around and causing trouble like that. It's not my way. I was brought up by good parents not to start trouble like that."

Dmitry Lontsman is a twenty-two-year-old Soviet Jew originally from Turkistan who is currently a theater student at New York University. He appeared in the 1992 parade as Data, a character from television's *Star Trek: The Next Generation*. Lontsman's costume stood out partly because of the meticulously detailed replication of Data, but also because he combined it with a robotlike performance and remained in character throughout the parade. He says he spent a year developing the costume.

"The reason that I do the parade is because it's interesting for me as an actor. When you act on stage, you feel free but it's complicated. There's you, there's the audience. You act, they watch. But on Halloween everyone can be an actor. The people in the audience were getting into the act with me. And at the Halloween parade you feel free because on stage if you make a mistake you blame yourself. But on Halloween you can do anything. It was fun when people were smiling and saying, 'Oh Data, Data!' And I said, 'I'm not Data. I'm Lore his twin brother!'

"It's fun also because I meet people. It's a carnival, and people like carnival. You can see people dressed like Madonna or the Beatles, and you can't see these people everyday. I saw the Beatles and I knew they were not the Beatles, but the audience and me acted like they were the Beatles. The same was for me. Many women like Data, and they would scream, 'I love you, Data.' And I would say, 'I'm sorry. I'm not capable of emotions.'

"New Year in Turkistan was a little like this. We would dance around a Christmas tree and put costumes on.

But this is different because on Halloween we try something forbidden. On this day we can do a little business with the Devil, and we won't be punished by God. For me I just like to walk around and scare people. I remember how I scared an old woman. She wanted to ask me something, and so she said 'Young man, young man.' I said, 'Hahhhhhhhh' and showed her my long fangs. She got scared.

"My first year in the United States I worked as a paperboy in Staten Island and on Halloween I saw all these pumpkins and skeletons, and I had no idea what they were about. Actually, the first information I had on Halloween was from the movie *E.T.*, but I had no idea what it was. The first time I wanted to put on a costume was when I came to class and saw that some of my friends had black faces and strange-looking eyes. I had no money, but I'm creative so I put some chalk on my face, I found an ink pen and I painted my lips black, and I put black around my eyes. I had a rehearsal on that day and later when I came out, I saw the people walking around. I wanted to be a part of it, and I promised myself that next Halloween I'll do something.

"Last Halloween I got the idea of making fun of a policeman. I was just mimicking him when he wasn't looking. I was doing his pose and the public was laughing, and when he turned towards me I stopped. I also loved the part when I saw a guy who was dressed like the Pope and kept saying 'God bless you' to the people. I got in front of him and said, 'God damn you!' I was dressed like a devil. He put his cross in front of me and I said, 'I'm a Jewish vampire. I'm not afraid of you.'

"The idea for Lt. Commander Data I got last Halloween, but I didn't know where to find the shirt. Before I came here I used to work in the theater, and I knew I could make the pants and everything, but I couldn't make the shirt. So last year I had to go as something else. When I left my country I took with me a top hat, tails, and a vest. I just thought that I'd make some kind of costume. I didn't like Dracula because it was too classical. I thought that I would make myself as a Diakon, a Russian vampire. So I bought this big bat on a chain to put on my chest. I put spiders all over me. I put on frightening makeup. I bought rubber teeth. I worked one whole week making it. It was beautiful. At the parade I didn't know what I had to do. I thought I would just walk. Suddenly, I felt that I had to dance. I shouldn't have done it because once I started I couldn't stop. I danced all twenty-three blocks.

"Very often I feel like Data because it's hard for me to fit in. I'm an alien. I can understand that people get bored with me. I don't have the interests they have. Also, most of the guys here in school are eighteen years old. Three years' difference sounds like nothing, but it isn't. They have different interests. Mostly, the problem I have is because of language. I can't express what I feel. My teacher told me that a person who thinks clearly explains clearly. But when you have mashed potatoes in your mouth you can't. But even before I came here I felt that. I'm a little bit different. And sometimes I feel like I have a robot ability. I'm so logical. I can't find contact even though I'm a social person. When I talk, people listen to me like Data, but actually my point of view is different. It's close to human but it's different."

For many participants the satisfaction they derive from the parade has a good deal to do with the license their costumes give to explore an otherwise inhibited aspect of the self. Most take considerable satisfaction in expressing such aspects humorously—appropriately so, given the close tie between the politics of this event and the subversiveness of laughter. Those committed to a more serious form of expression devoid of satire may find the parade a disappointment, the response of participants and spectators much too shallow. The following interview suggests the degree to which some participants may misinterpret this event by seeing it as a genuine dialogue with the pagan world of spirits rather than what it is, namely a collective celebration of self and community.

Michael Broderick is a twenty-three-year-old graphic designer who works in a toy store in Manhattan. At the 1992 parade he wore a red wig spiraled into points to look like horns with a ponytail in back. Black eye shadow created an image that he describes as "clownlike, but with thin black lips, it was more harlequin than circus clown." He wore a short jacket that was diamond-quilted in various shades of red covering a medal-filled red shirt. He also wore red pantaloons, red tights, and black slippers. His friend Rory Tyler, a window dresser, accompanied him. Tyler, whose dark black costume contrasted sharply with Broderick's red outfit, was dressed as a personification of evil with large feathered wings, pale makeup, a long black robe, talonlike fingernails, pointed ears, and bright violet eyes. Together they made quite an impression, gathering a coterie of admirers greedy for the perfect photograph wherever they walked.

Broderick:

"I was supposed to be an evil clown, as if the Marquis de Sade had a court jester.

I go every year as some sort of clown. This year I wanted to do something that had a macabre edge to it. All of my costumes ever since I was little had been good or benevolent in some sort of way. I wanted to do something evil because Halloween is not about good and kind but about the scary things that come out and go bump in the night.

Tyler: "I'm attracted to dark beauty. Evil. I think our general idea of beauty as shiny and perfect is boring. I like the darker side, the cemetery or crypt. It's all about embracing the dark side. If you find these things beautiful, it dispels a lot of fear. I was brought up in a home that you would call paganistic. A lot of people in the family are into witchcraft, Tarot cards, things like that. So the pagan and psychic world are natural to me. I'd rather be a dark angel than a light angel—it just seems to me that the dark angel would be much more interesting.

"Halloween to me is supposed to be when the two worlds are closest—this world and the spirit world. It should be a time when you celebrate that, when you recognize that there are other realms that you can't see. The Halloween parade should be more like a grand procession celebrating death and the spirit world. Instead, it's become kind of juvenile to me. Halloween is not really a religious holiday because you don't need to observe anything. But it's just a time to consider death and not do this high school sort of howie wowie. It's like the Mexican Day of the Dead. You should also have fun.

"Halloween is significant for me because it's a release. The barriers come down between the world of the real—the sane and logical—and the fourth dimension. The result is a kind of controlled chaos. Like an orgy of the spiritual and the occult. Art has a lot to do with that. But people who don't wear costumes can still celebrate Halloween. But the part of Halloween where people are scared has been replaced by people drinking and having a good time. It's more like New Year's than Halloween. I increasingly see people with beer cans and tee-shirts. To them it's New Year's Eve in October.

"I spent a week and $400 on my wings, and people would run right into me without regard for my work. After the parade, I went to a party uptown at the Jacob Javits Center sponsored by Z100 FM. There was a cash prize, and I was hoping to win that. The cash was $1,500. Judging was an audience thing, and according to the audience response, I should have gotten second prize. But a Frankenstein family and not me was asked to go back up. First prize went to a big pair of pants with a penis hanging out. Yes, I was mildly upset.

"Of course, in New York it's more of a drag festival than anything else, which I view as sad. Someone can get in drag any night of the week. Drag has nothing to do with the link between this world and the spirit world. Halloween is about spirituality and the unseen. I tried to get others to go to the parade, but most people I know have abandoned it. A lot of it is that people don't have the time to do it. They're growing older and thinking that Halloween is childish. It also has to do with the growing right-wing Christian influence that wants to dispel Halloween because of its association with the occult. There are not as many Halloween specials on TV. It's like everyone is trying to forget about Halloween. They've just turned it over to the gay community and said, 'OK. Here's a holiday for drag queens.'"

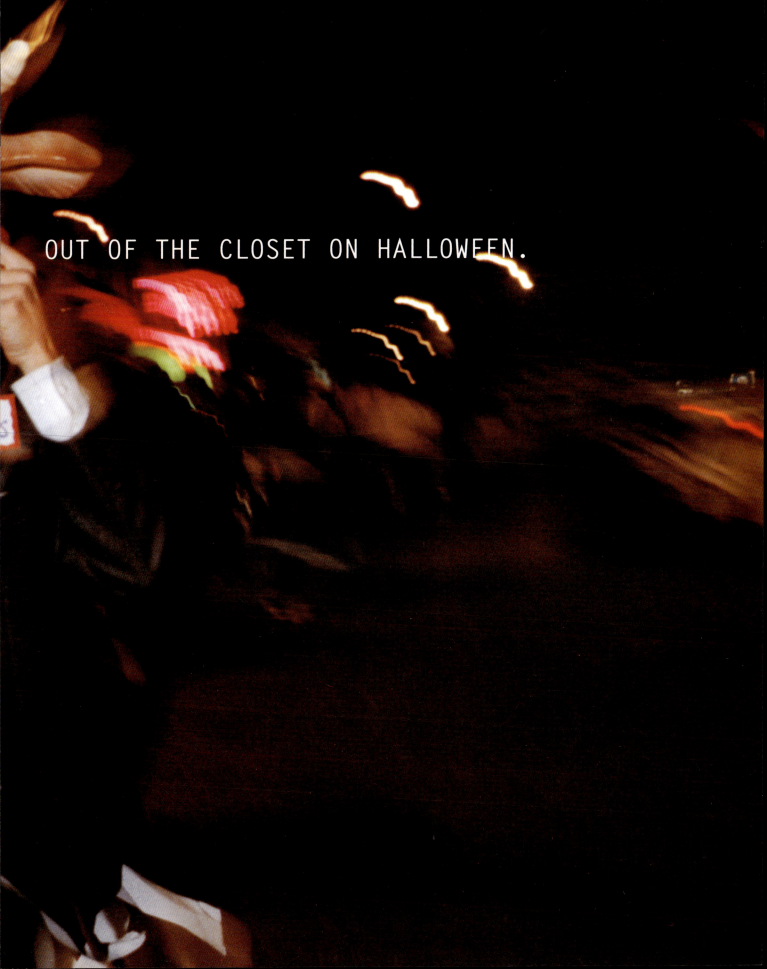

It's My Time to Shine

New York City's Halloween celebration does more than provide a public venue for ridiculing authorities and the conventions they prescribe. The parade also legitimates alternate visions of authority, or perhaps what might be better termed as counterauthority. The previous chapters examined the meanings Halloween has to various groups and individuals; these last two chapters consider the ways in which the parade reconfigures the city and particularly its inhabitants as an "imagined community." Such collective imaginings, as Benedict Anderson has noted, are critical for the formation of national identities among peoples far more attached to their local cultures.[1] It has considerable significance, too, for a city many of whose residents have been born elsewhere or have chosen to attach themselves to communities that are not based on ethnicity or other bonds of kinship but rather on common interest or lifestyle. Because of the problem of housing availability in the city, few of these communities can establish themselves in one residential neighborhood. For communities as ephemeral or dispersed as those of designers, artists, performers, and gay people, the need to dramatize their existence is always present. But the need becomes increasingly urgent when their way of life is threatened or the turf they've long felt to be their own is occupied by others.

Unlike most civic celebrations, the Greenwich Village Halloween Parade makes no claim to respectability. Rather than challenging the city's elite by marching along Fifth Avenue—the typical route of ethnic events—the Halloween parade consecrates its own terrain. Particularly in its early years, as it wound its way through the streets of Greenwich Village, the parade both outlined the parameters of the neighborhood and dramatized its uniqueness. Indeed, unlike other parades, this dramatization of *place*—Greenwich Village—defined, initially at least, a way of life, a bohemian, artistic, and frequently gay way of life. Although the gay relationship to Greenwich Village is not in dispute (aside from the threat to its size and vitality posed by the AIDS epidemic), Greenwich Village as a bohemian artist colony is a thing of the past. New York neighborhoods have undergone transformations in recent years that are leaving whole sections of the city unrecognizable to their long-standing working-class or ethnic residents, and neighborhoods such as Greenwich Village are no exception. Given the high cost of housing in the city in general, including Greenwich Village, this charming neighborhood of early nineteenth-century row houses maintains a link to its celebrated past as an artist and writer's colony largely through Westbeth, a subsidized residence for artists. The fact that the parade was organized by artists living there, that in its early years it originated there and fanned outward through the neigh-

borhood and in more recent years has sought to link its route with its downscale counterpart, the East Village, New York's contemporary Bohemia, suggests the contentious aspect of the parade, its attempt to incorporate and consecrate space that in real life is no longer its own. Outside the framework of a one-day public celebration, Greenwich Village has become part of the ordinary work-a-day world and not the artists' world of "work as play."

Although this event draws much of its authority as a licentious "tradition" from Greenwich Village, its significance is increasingly associated with the city more generally. Perhaps this has something to do with the search for coherent images of place. Throughout history, public squares, monumental buildings, and processional avenues have served to generate a sense of cosmic and social order. But the decades of the sixties and seventies have not been kind to the symbolic ordering of city spaces. Rockefeller Center, for example, one of the great corporate contributions to city planning, has seen its thirties' utopian vision undermined through an expansion of utterly banal buildings that overwhelm rather than complement the complex's original layout. The Empire State Building, once the midtown symbol of New York City, stands now in the shadow of two lower Manhattan competitors—the twin towers of the World Trade Center—which have earned their place on the skyline by dint of brute force rather than style or grace. Moreover, the plaza in which they sit is forbidding not only because of its scale, but because it is windblown, ugly, and devoid of shops and cafes that have traditionally humanized such baroque urban spaces. The corporate city of the 1960s and 1970s was a significant retrenchment from the attempts at social engineering through design of earlier decades.

Still, even when city design is overwhelmed by utilitarian concerns, urban cultures have their own way of generating sense of place.[2] According to the urbanologist Lewis Mumford, "The key to the visible city lies in the moving pageant or procession."[3] Indeed, there are often many physical representations of New York City within the Halloween parade—roach motels, Statues of Liberty, the World Trade Center, Greenwich Village surrounded by encroaching high rises, and even stockbrokers jumping from skyscrapers—each underlining, albeit satirically, the uniqueness of the city and its sense of place.

Eric Mueller, a graphic designer, describes the "subway" costume he designed for the 1989 Halloween parade:

"It was a representation of New York and what New Yorkers are familiar with—a parody on what's good and bad about New York. The subway was the H line—the Hell line—with destinations instead of going from, like, Dyre Avenue, we spelled it 'Dire' Avenue. Instead of going to Bedford Stuyvesant, it went to Deadford Stuyvesant. Slurs and slants on all the stuff. It was kind of cynical, and we wanted to throw a kind of gruesome or grotesque thing in a very Halloween-type costume as well as just this New York thing. One thing that worked out really well with it that we hadn't planned on, was we had sliding doors on the costume and of course the parade got held up many times so the subway car would stop frequently. We'd slide open the doors and a lot of other people that were just in the parade in various other costumes went in and 'rode' the subway with us.

"I think a lot of people liked it because they could associate themselves with it. It's something that's part of their lives here, the subway—all it's faults and things like that which we made fun of. It seemed to draw a lot of attention. It was mentioned on local news and I think on national news. When they wrapped up their coverage, they said, 'The hit of the parade was a working subway complete with malfunctioning lights.' We had rigged up the lights with flashlight batteries. The batteries would die, and we would replace them. The lights were flickering. So basically it did come off like a malfunctioning subway car that was always being held up, and the lights would go off. We even re-created the effects of sparking tracks with a flash bulb, a little handheld flash bulb which popped off every once in a while. We had someone in there with a ghetto blaster. We really did try to recreate the ambiance, as it were, of being inside a New York City subway car."

Proportionately, such representations of New York City are only a minor part of the parade. So it is less the actual representation of place that makes a parade "the key to the visible city," than it is the very act of parading.[4] And it may partly be the ephemerality of a parade that makes it such an efficacious way to represent the city. "There is a special poignancy," writes Kevin Lynch, "in the moment of transition."[5] Ephemerality may explain why we take notice of such events, but their impact and the reasons for their emergence has much to do with their appeal to the imagination and the increasing role it plays in the modern world of vast population movement and continual economic, social, and cultural change.[6] Given the out-migration of the working class and

ethnics within the postindustrial city, and wrenching dislocations as neighborhoods become ghettos or undergo gentrification, public celebration constitutes one means of generating a sense of place and community among the city's transient population. Indeed, it is striking how many of those interviewed for this book were born elsewhere and moved to New York as adults to pursue a career in the arts or the design industry. Little wonder, then, that the parade moved so quickly from the margins of New York City's arts and gay subcultures to become "an East Coast version of Mardi Gras."

Over time, of course, an event can become a totemic representation of place. The process by which this happens is generally not accidental since state agencies and private developers are ever eager to market local color. Not so this event whose funding, indeed its continued existence, comes about entirely through the efforts of its organizers to secure new grants each year from private and public foundations. Also, unlike civic or corporate events (most of which are scoffed at if not entirely ignored by New Yorkers not otherwise directly involved), the Halloween parade is largely improvisational and requires no membership to participate. The parade's appeal is therefore partly its openness. Although such openness makes the parade vulnerable to appropriation, competition for public attention underlines in a positive sense the very multivocality of urban culture that the parade seeks to celebrate.

Moreover, the processional nature of a parade generates an illusion of coherence, despite a vast array of contradictory images. Ultimately, people accept the parade as a faithful representation of their city and its culture, less because they carefully examine and agree with all its content than because they can see enough of themselves and their sense of the city within it. This is why straight middle-class New Yorkers participate in a parade that many have long seen as closely tied to the gay community. Indeed, this is why they continue to enjoy an event that some long-term gay parade goers no longer do. Take, for example, the following interview with Henry and Rebecca Packer. The couple struck me as quintessential New Yorkers—an arts background, eternal students, sympathetic to the city's and the Village's bohemian traditions, prosperous yet contemptuous of the price paid for financial success. Rebecca is a doctoral candidate in English Education. Henry is a Wall Street systems analyst. The couple, in their late thirties and early forties, reside in Greenwich Village. They have been in the parade six times—Rebecca most recently as a witch, Henry as "Death Yuppie" complete with skull mask, a three-piece suit, and an attaché case.

Henry: "I remember hearing about the parade more than seeing it. And then seeing it on TV, and then I decided I wanted to be in it. They said anyone could join so in the mid-1980s I just decided one day to put on a costume and go down. It was great. I was an actor once many years ago. I never quite got over the thrill of being in front of an audience. The parade has a lot of energy. The other thing I enjoyed about the parade is that it wasn't preprogrammed. It's sort of a spontaneous combustion."

Rebecca: "Can I make a suggestion about your motives? I think there's a connection between the work you do and the roles you play in the Halloween Parade."

Henry: "Yeah, playing 'Death Yuppie'—an inverse of what I am in real life. There's something great about having that skull mask on because no one can recognize me. It's very anonymous."

Rebecca: "The reason I like to come is kind of similar. I like to play. And I love to dress up and I think of myself a little bit in the way I dress, so this gives me the perfect excuse to go maybe five steps further in the way that I present myself. I just love the fact that I can dress up and that I don't have to feel self-conscious. It's not an act of vanity. It's an act of creativity. I can be a peacock, and everybody else is acting like that, too."

Henry: "I always think the drag queens are the best."

Rebecca: "Yeah. I think they're also the best because they really invest so much. Well, because between life and art for them there's a very thin margin there, because they're always putting on a costume anyway to be something they're not quite. Maybe they are on the inside but not quite on the outside. So they're endowing themselves. In past years I've asked myself about the costumes I wear, and I often go as sort of an aspiring generic movie-star prostitute type. I'm always wearing too much makeup, and lots of hair, and glitter. But it's also a part of me that wants to be sort of a fairy princess too. It's sort of all merged.

"When I was a child, Halloween was my absolute favorite holiday. Even though I'm a New Yorker, as a child I lived for five years on Nantucket Island. And for reasons that I won't go into, I was called 'witchy' by a lot of students. I was sort of ostracized. I was a bookworm. My parents

were sort of arty—my mother was an actress and I was in a very conservative community in the 1950s. So I was called witchy all the time, and I was beaten up. On Halloween I would never be a witch. I would be a princess. It was my time to shine and nobody could make fun of me because everybody was dressing weird, so I didn't stick out.

"I really think I can trace back my love for Halloween into my early love of atmosphere. The moon I remember in this seacoast town used to be very orange, and it really appealed to my sense of aesthetics and beauty. And I got a chance to be part of that beauty instead of being the witch."

Henry: "I honestly don't know what the parade does for New York City as a whole. It's a big tourist thing, I imagine. It looks like that. It's kind of well known, and I have noticed that some people will come up and say, 'Excuse me, sir, do you mind if I take a picture of you?' That means they're not from New York. A New Yorker will just come up and take a picture of you. I have a certain sense of solidarity with this neighborhood when I do it. I honestly wonder if that's a common feeling. A lot of people are coming down from other neighborhoods to be in it, but to me it is a Greenwich Village thing.

"It's also a kind of mini-Mardi Gras. One of the things that we did this year was we ate at a Japanese restaurant after the parade, and I took off my skull mask and I was in this three-piece suit so I was the straight one and everyone else in the Japanese restaurant was dressed up, including the waiters and all the sushi chefs. One guy was Spider Man. He was in a thong and his whole body was painted."

Rebecca: "It was very risqué."

Henry: "A lot of people are very out of the closet on Halloween, which I think is great."

Rebecca: "Two years ago I was in it with some friends of mine and Henry. My women friends and I went as a group pillow fight. We had met at Oxford, and one night we all had a huge pillow fight. All the people in Oxford were just saying, 'Will you pipe down there!' But we had a blast. So we went as the Oxford Champion Pillow Fighting Team. And we bashed each other on the head with pillows and ran around in pajamas."

Henry: "They attacked Freddy Kruger, too."

Rebecca: "Yeah. We attacked Freddy Kruger and all the bad guys. And we went up to a few policemen who looked friendly, and we bopped them on the head with pillows and they cracked up. We were very childishly dressed in curlers and bows. It was the first time I had gone as a team effort. I loved it. I thought it was great, but I was exhausted."

Henry: "And you were on TV."

Rebecca: "I think they liked Henry's 'Death Yuppie'—that's what they were attracted to. It seemed sort of timely."

Henry: "It was more timely in 1990. More people applauded."

Rebecca: "I have a sense of what it might do for the city. I think that aside from being a chance to act out in a safe way because there are children there and people from all walks of life and persuasions and ages, I think that it creates something that a city like New York needs and that's a sense of community. You know there's a sense of unified purpose, and there's no particular ideological reason behind it. So when people come to play there's going to be less strife, less opportunity for conflict. Just the chance to express oneself creatively. I think that cities like New York are in sore need of a sense of community, and I really don't think it's an accident that this developed not that long ago..."

Henry: "Nineteen years ago, which I think is very revealing. Most people when they refer to the 1960s, the mythical decade, they're really talking about the period of time that began with Kennedy's assassination and ended with Watergate. And I think it's a very interesting coincidence about when it is that this parade began. Well, there is always a cultural need. Art can be safe if it's in a museum or if it's on a stage. When it's in your face and it's on the street, it can be dangerous."

Rebecca: "In fact there's always been a slight sense of risk about this Halloween parade. I mean a little bit of intellectual or cultural shock value. In fact, I think people from other boroughs come for precisely that reason, because it's a little bit chancy."

Henry: "When I mention at my office that I go to the Halloween parade, a lot of people said, 'You actually go to that homosexual thing? You actually go there?' And I said, 'Yes, I've been in it for the last ten years.'"

Rebecca: "Playing one of you!"

Henry: "In fact, I once put on my costume in the office."

Rebecca: "They loved it."

Henry: "Yeah. Everybody applauded me, so I guess the hostility wasn't so great. What does 'Death Yuppie' mean? I wonder. I don't know.

I figure that if I could survive the 1980s I can survive anything."

Rebecca: "Your job isn't something you love."

Henry: "No. It isn't. I'm not a Yuppie by temperament. I'm a Yuppie pragmatically. I don't feel I have much other choice. You know you need a job. I've gone up the corporate ladder a little bit. If I really tried, I'd be chairman of the board by now I'm sure."

Rebecca: "But your interests have always been artistic."

Henry: "Yes. But the fact is I would be an abject failure as a starving artist. I couldn't afford to live in this neighborhood. Starving artists could live in this neighborhood in the 1940s. In fact, that's what made this neighborhood. But if you ever read anything by Max Bodenheim—*My Life and Loves in Greenwich Village*—it all took place before the 1950s. Before there were beatniks when they didn't even have a word for it. They just referred to it as a vaguely bohemian term. This city does attract workaholics like you wouldn't believe. I just saw a TV show on the news about people who have no time for sex. And it was fascinating because they talked about their careers taking up all of their time. And my only reaction to these people was, why let your career take up so much of your time? This city is full of that kind of super professional. I mean that's the problem we had at the Halloween party we used to go to. Everyone wanted to talk to us about their careers. We wanted to dance."

Rebecca: "And play. I think we're both pretty serious. I don't think it's a matter that we're not grave individuals. In fact, I think that one of the reasons I love the parade is that I am so serious, and I often feel burdened by worries and anxieties, or interests that I have. So this parade really is a release. I don't drink, I don't do drugs, and I really never did, so I don't think I really fit in with some of the colleagues. I've always gotten my high from playing, from dancing. And one thing I do during the parade is that I always position myself next to the band. And Henry works the crowd."

Henry: "Yeah, I shake people's hands."

Rebecca (teasing): "Kiss the ladies hands."

Henry: "There's nothing quite like having a skull mask kiss your hand."

Rebecca (laughing): "Yeah. All the women scream, 'Come on! Come on!' They love it. And I always just dance. I love to dance and to be able to dance without dancing with anyone in particular. I really love it. You know, I wish I could do it more often. And you asked a question earlier, you asked, 'What do you think it does for the city?' And I said, 'A sense of community.' Also I think that when people are in costume it's an exaggeration of their inner selves, and so I think all these people come together as the sort of multicultural, sort of almost an aberrant exaggeration of what New York City is anyway. It's made up of all these different types of people, and this is sort of an acknowledgment of it."

Henry: "You know something that is very common in this city is to talk about how much better things used to be. So everyone will tell you that the parade isn't what it used to be. People will say that about Greenwich Village, too. In fact, they were saying that in Max Bodenheim's day. They were probably saying that when Edgar Allan Poe lived in this neighborhood."

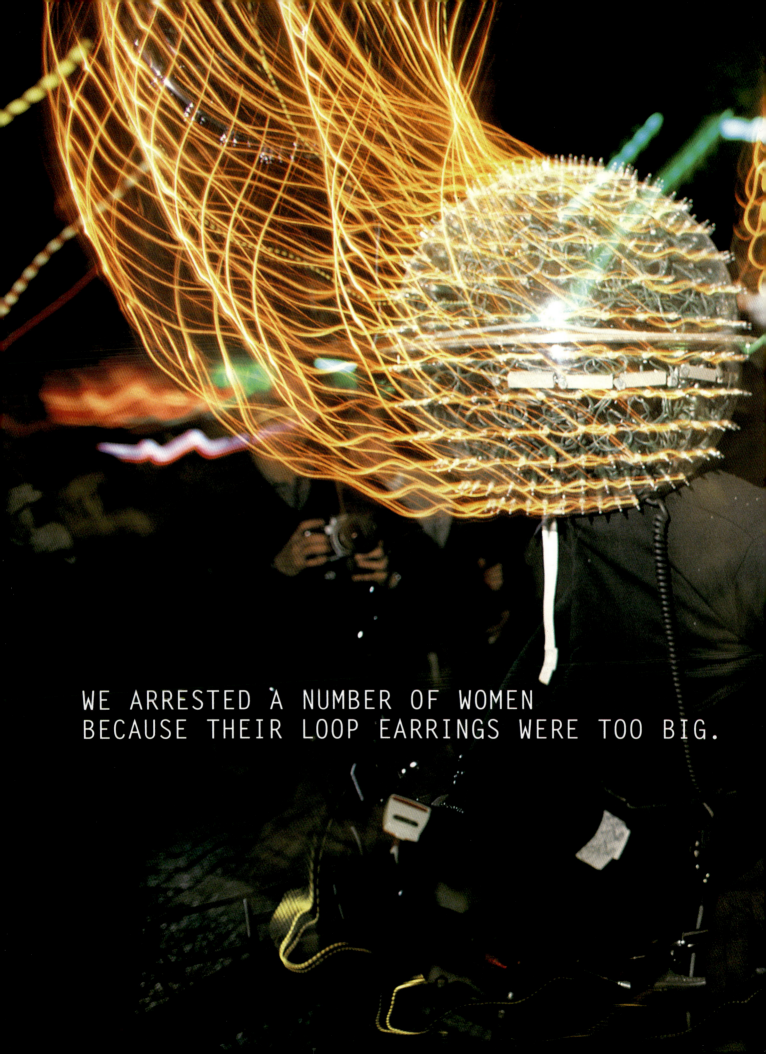

WE ARRESTED A NUMBER OF WOMEN
BECAUSE THEIR LOOP EARRINGS WERE TOO BIG.

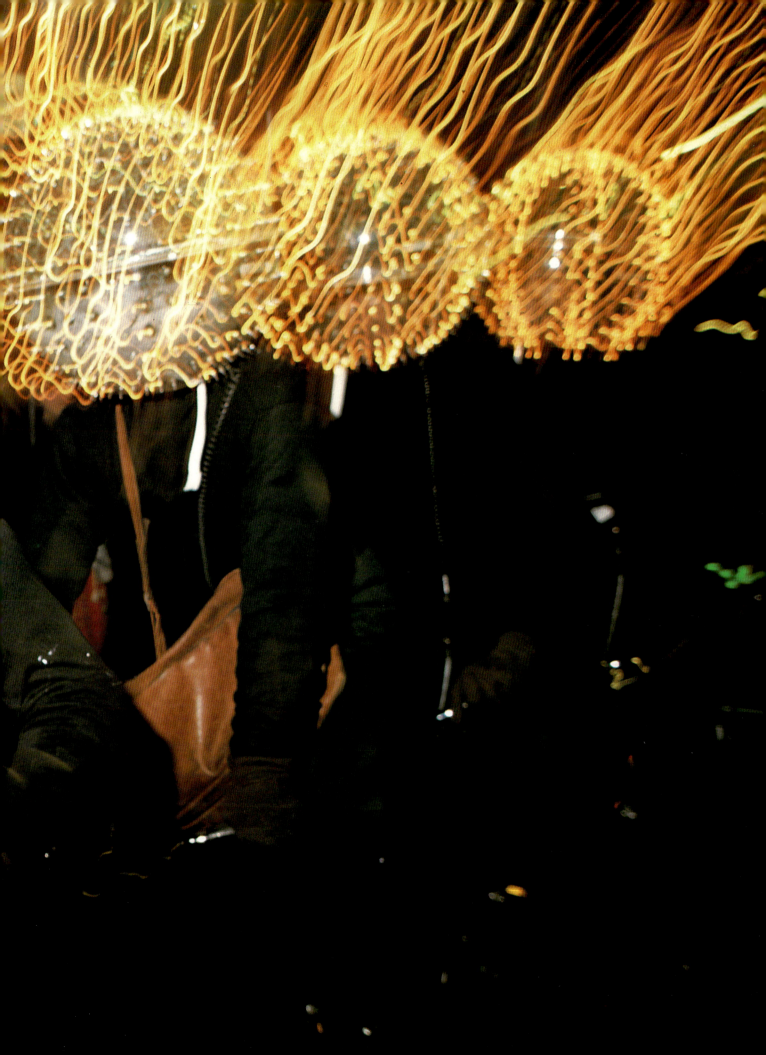

To Be a Part of It

As the entry point for millions of immigrants, New York City's historic role in American society has long been that of a great borderland—the site of an intense intermingling of cultures. Borderlands are frequently sites of intergroup conflict, but they also foster hybrid cultures that typically lack discrete boundaries.[1] Constant contact with strangers creates excitement as well as danger, and the Halloween parade puts a distinctly positive spin on such encounters, presenting New York's diversity in dreamlike rather than nightmarish terms. Indeed, *dream* is a particularly suitable metaphor here: the event takes place at night, an unusual time for a parade, but an appropriate time for fantasy and seduction; it makes a dreamlike journey by violating the most logical and sought-after venue for New York City (processions marching up or down Fifth Avenue), meandering instead chaotically crosstown through various streets of Greenwich Village; and it envisions the city as a place of pleasurable transgression, where identities are unmoored and otherness can be tried on like a costume, rehearsed, experimented with—thus enabling, if only temporarily, an expansion of the threshold of the self.[2] The idea of rehearsal permits us to see this event as street theater, albeit on a grand scale, where both actors and audience are continually playing at the border between self and other. For the actors in this event, the process is quite intentional. The great attraction of the cosmopolitan city, its very claim to legitimacy as a world center, is partly the fact that it permits a wide range of possible lifestyles for its inhabitants, and it does so increasingly as traditional class and ethnic communities give way to new neighborhoods of choice. The Halloween parade legitimizes that claim.[3] But it also allows the city's population to reclaim streets and neighborhoods albeit symbolically, and in so doing to experience themselves as active agents in the creation of their "imagined community."

The Greenwich Village Halloween Parade may have lost its former intimacy as a local neighborhood celebration, but in expanding beyond the borders of its own community it has managed to do what no other public celebration in the city does—provide a public space for large numbers of people to experience a sense of relatedness to the social and the physical fabric of the whole city. The sociality of meeting and interacting with, and even assuming the identity of, the other transforms the city into a place

of pleasure and exchange across broad disjunctures of class, ethnicity, race, and gender.[4] In doing so, the parade eroticizes the city. It reclaims urban life from its corporate owners and reasserts the diversity of the city, its streets and its people.[5]

Of course, to limit this analysis of the meaning of the Greenwich Village Halloween Parade to New York City would be to overlook a phenomenon that is national in character. The 1970s saw the widespread development of what one observer has referred to as "counterfestivals,"[6] and their emergence points to much broader national, if not global, social and cultural transformations. This phenomenon, and the increasing significance of Halloween within the pantheon of American holidays, suggest a cultural transformation with substantial impact on the individual sense of self. If the 1950s enshrined the nuclear family as the hedge against world apocalypse,[7] and the 1960s gave rise to oppositional youth culture, the 1970s witnessed the increasing severance of the self from conventional social obligations. As a result, marital ties have become increasingly brittle, while sexuality has become a matter of choice and lifestyle. At the same time, the politics of gender has contributed to a degree of tension between the sexes, generating a certain tendency to explore identities outside of culturally prescribed roles. Religious beliefs and practices have been affected in a similar way with a marked expansion of various cults and practices. Perhaps, then, the recent popularity of Halloween celebrations has something to do with the increasing emergence of a self free from social and cultural restrictions of an earlier time. Its neopagan quality offers, if not a world without limits, then at least a cultural "border zone" in constant motion, one that can be explored and developed according to personally chosen rather than socially prescribed interests and needs. Little wonder that parallel to the upsurge in Halloween celebrations has been a fluorescence of "New Age" beliefs and practices which, like Halloween, are highly focused on the self and the search for individual and group-of-choice validation. Indeed, it may very well be the case that we will need to place Halloween within the framework of an emerging "New Age" culture to fully understand the position it is assuming nationally and perhaps internationally as well. If this is so, one can easily predict the increasing significance of this holiday as New Age sensibilities make their way into mainstream American, European, and perhaps global culture, reflecting a widespread disenchantment with civil religion and the observances connected to it.[8] Clearly, then, the success of this festival is only partly a result of its ability to affirm local identity through public performance. It competes successfully with more established celebrations because unlike them it addresses through popular idiom rather than state ritual or church dictum, universal concerns about social and cultural continuity, and for at least some of its most devoted participants about life in the face of death.

David Sinkler is a member of the Fashion Police. I met him in 1987 after he ticketed me for wearing a "60s retro" buckskin fringe jacket. He wore a white paper costume and fireman's helmet topped by a flashing siren. Unlike most participants, Sinkler appears sporadically in the parade—twice so far (in 1991 I had to ask to be ticketed)—and each time with a different partner.

"The idea of giving tickets in 1987 was to see how far we could go without getting killed. We gave bald-headed men fashion awards for their wig.

We arrested a number of women for LSD—'let the sixties die'

—or because their loop earrings were too big. We were ticketing things out of style or things that didn't go together. That year we gave out very few awards. This year we gave out maybe sixty. The awards are small 3-D stickers with a hologram of a pumpkin in the center."

Unlike his 1987 performance, Sinkler's decision to do the Fashion Police in 1991 was a response to the evidence of decline in Greenwich Village caused, in part, by a changing economy, but largely by the plague that is wasting so many of its inhabitants.

"The Village has changed. Christopher Street has changed. So many of the buildings' street-level stores are shut and for rent. Their original proprietors may have died of AIDS. Or they closed because of rising rent. There used to be people, people, people all the time. Now it's pretty dark and pretty forbidding. It's not pleasant to go there. I went there with some out-of-town friends and saw some guys who looked like they were from the suburbs smoking crack in their truck in broad daylight.

"In the 1970s the parade's politics was the politics of sex. It was to make the most alluring and arresting statement. The boys in the spider web [a group of nearly nude men wearing black webbing masks and G-strings] were the only ones like that this year. It was much more like that in the late 1970s. Other years there were very alluring and highly sexual things, but very little of that this year. It's conservatism. It takes a lot of guts and a lot of time. With so much death going on, that's a luxury in people's lives. Even with death going on in my life, I made it a real point to get somebody and be the Fashion Police. It's a very important thing for me that I do this. I equate this with feeding the homeless and giving enjoyment to other people.

Normally, I'm a pretty conservative guy

and going out into the community and physically doing something to create this persona and creating surprise on Halloween—it's so out of the ordinary for me. And it's fulfilling—it happens too rarely in my life. I usually go down to the Church of the Good Shepherd on Christmas and help feed the homeless. I feel that's a better use of my time than sitting home. On Halloween, to sit at home when something as great as this is happening in the city makes no sense. It makes no sense not to be a part of it."

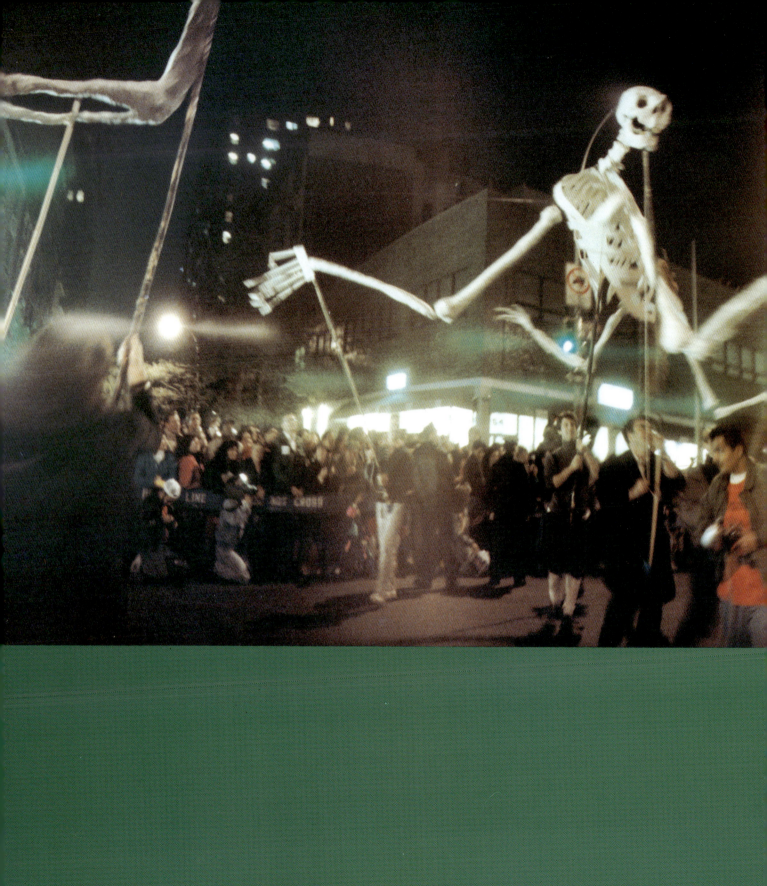

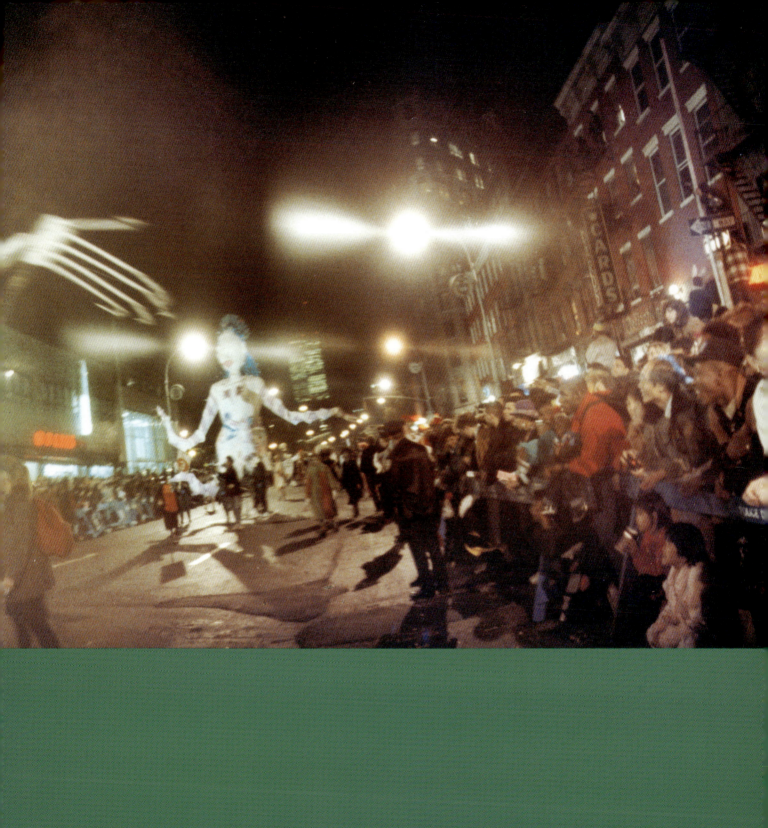

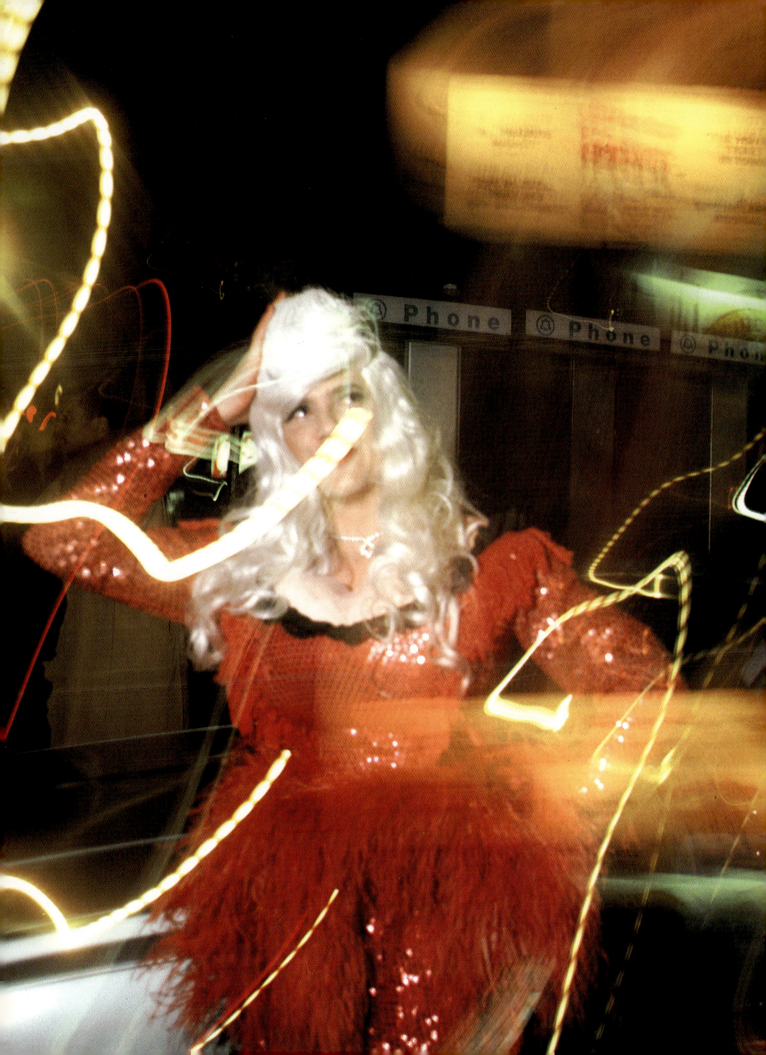

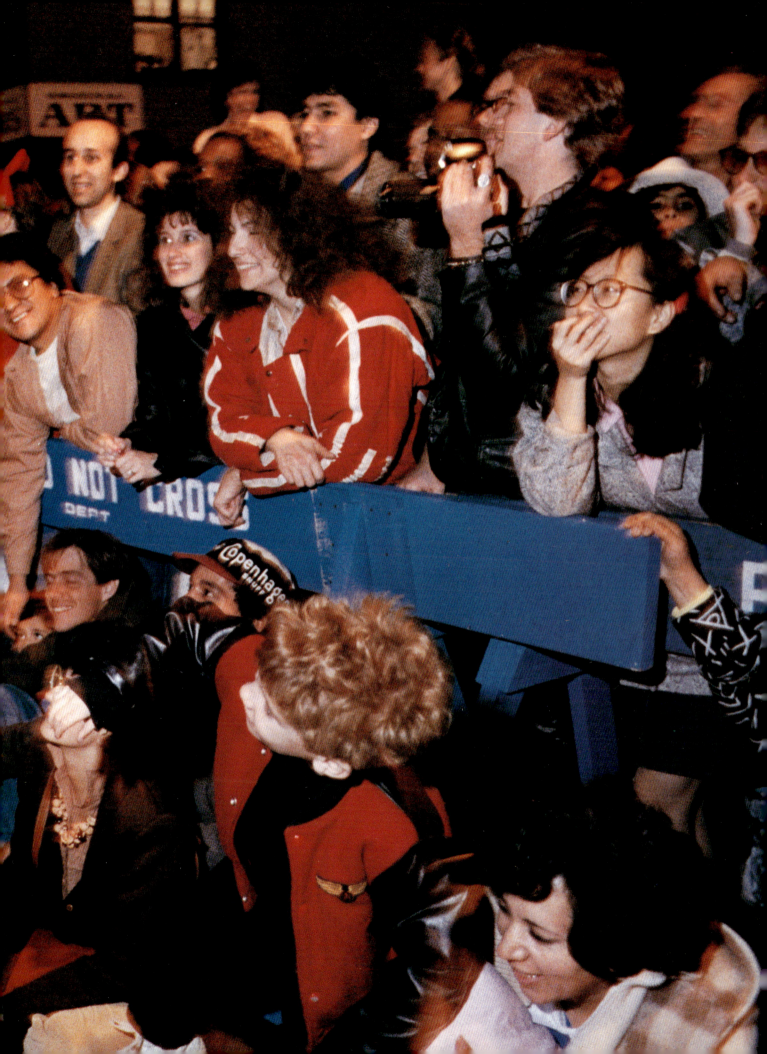

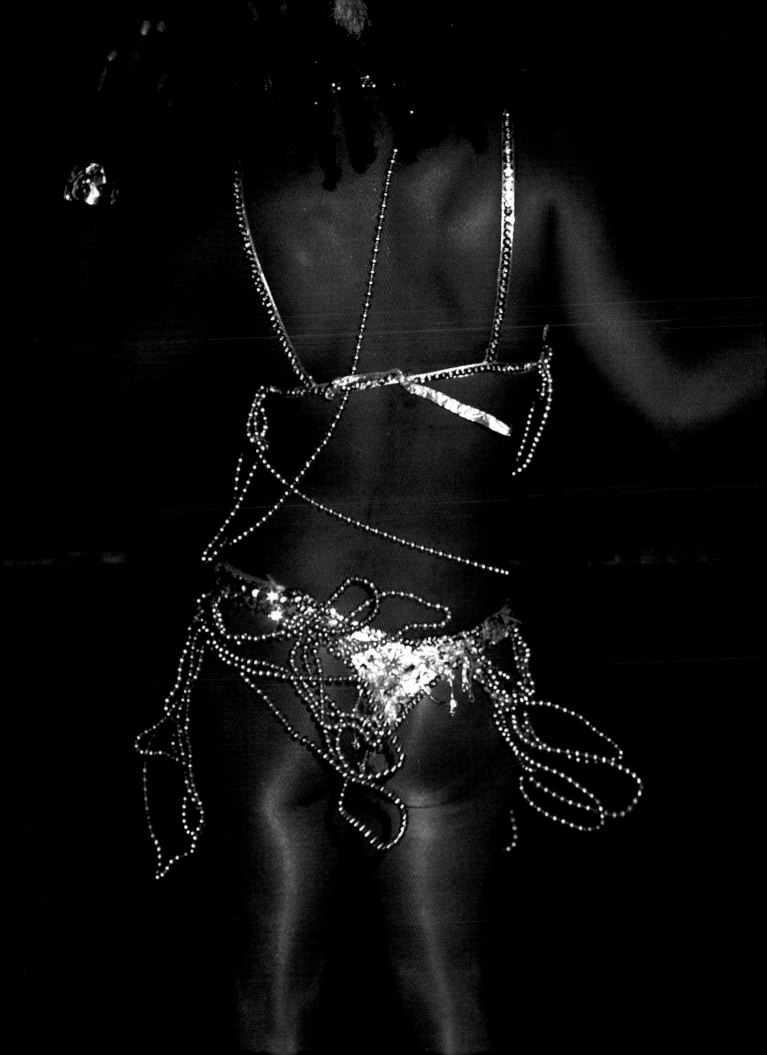

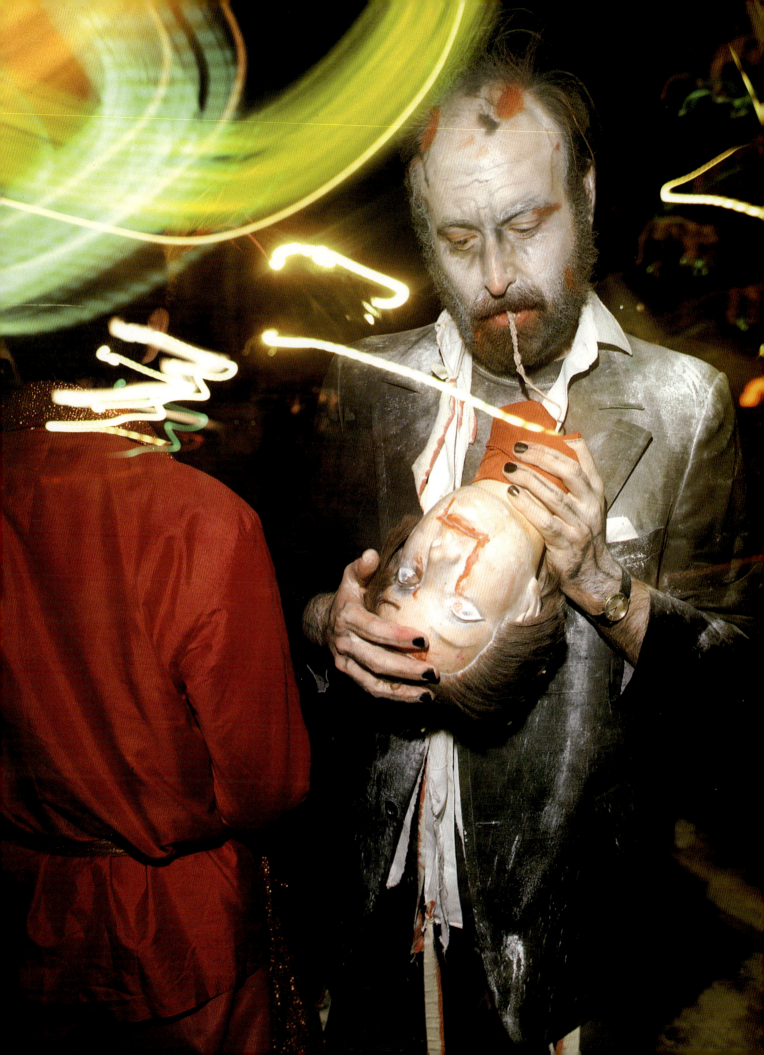

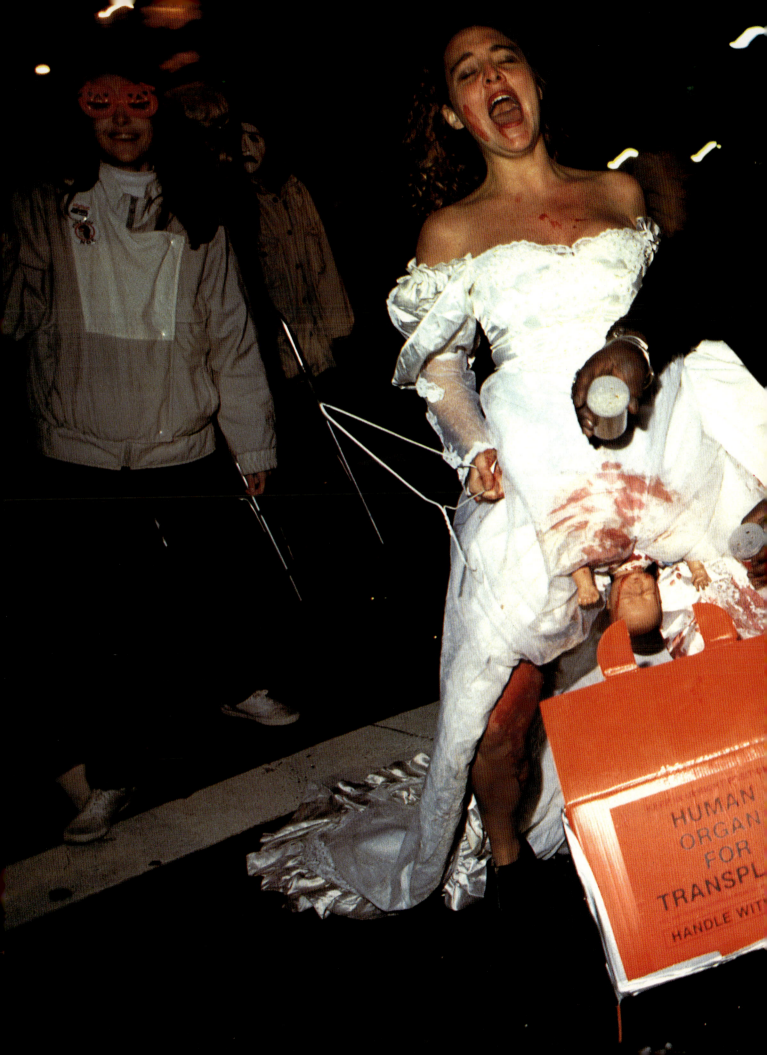

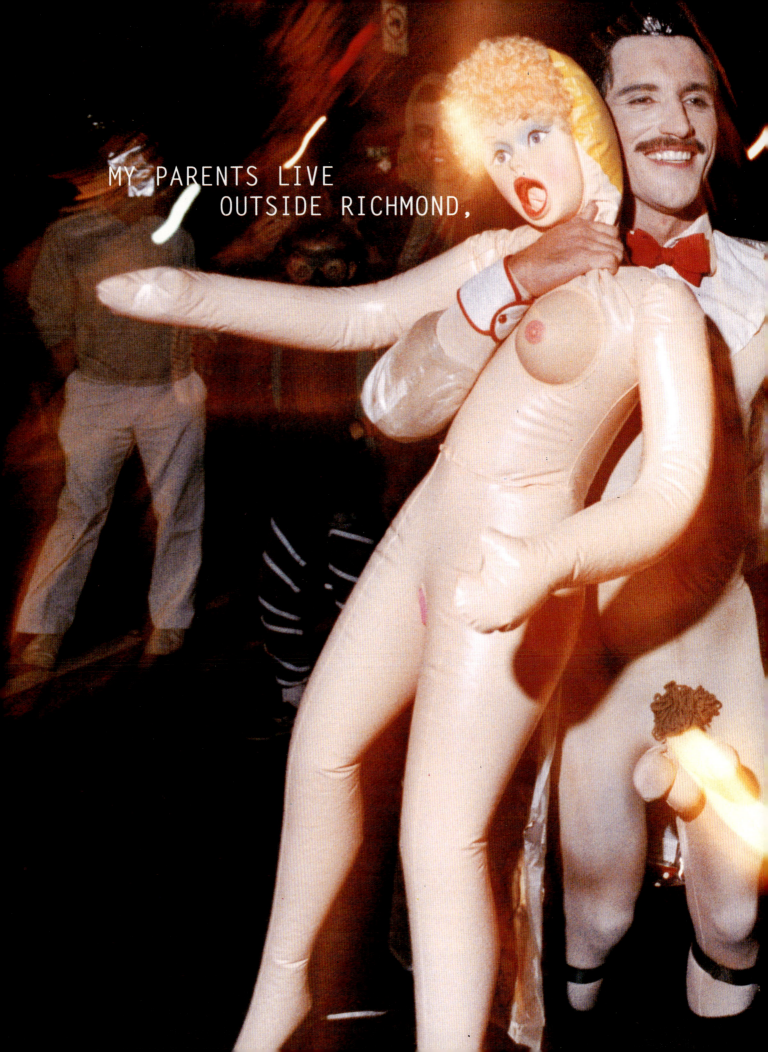

MY PARENTS LIVE OUTSIDE RICHMOND,

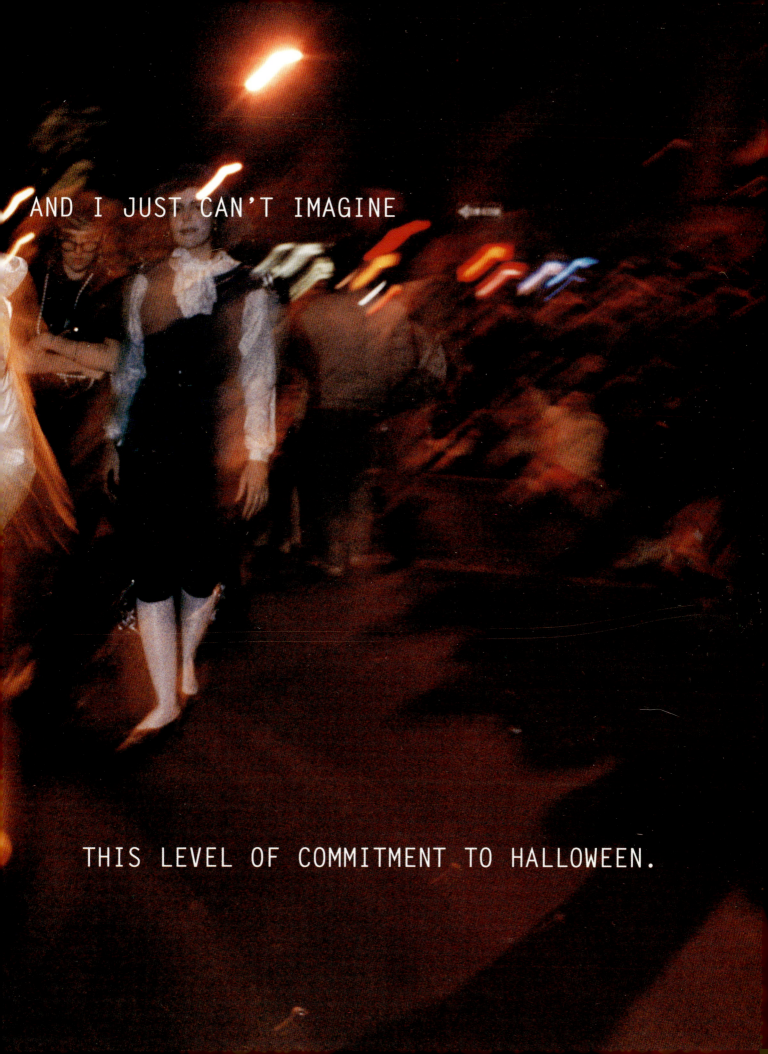

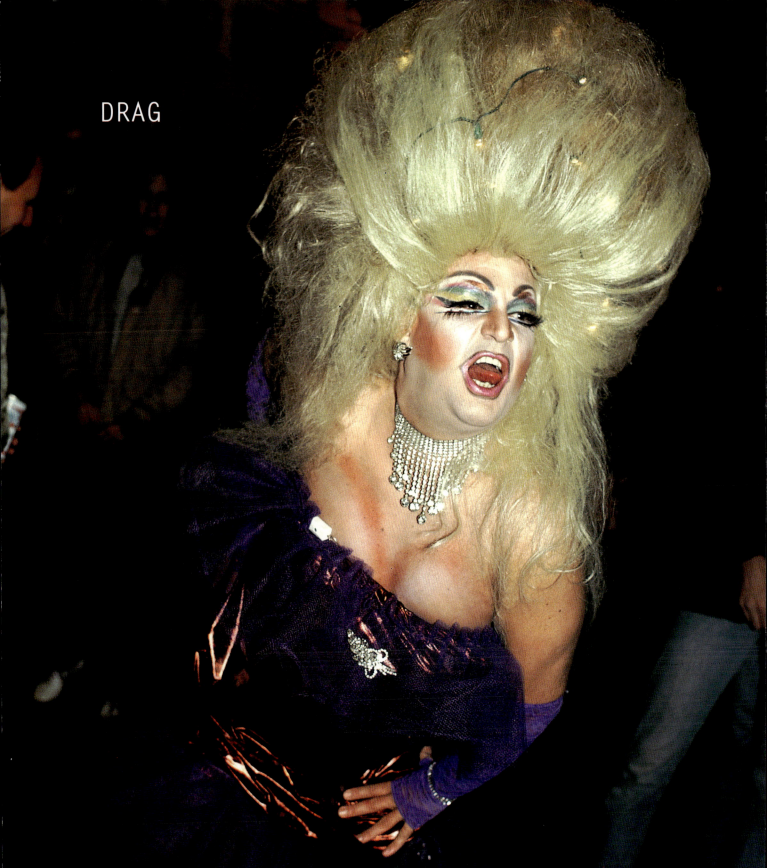

DRAG

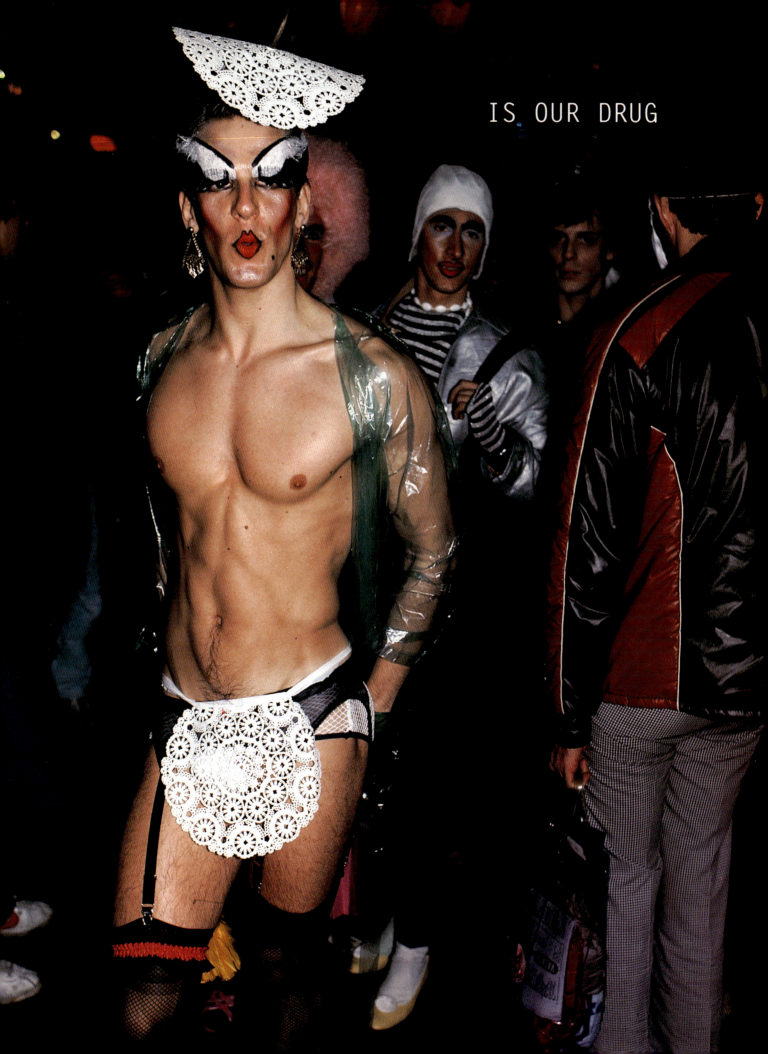

IS OUR DRUG

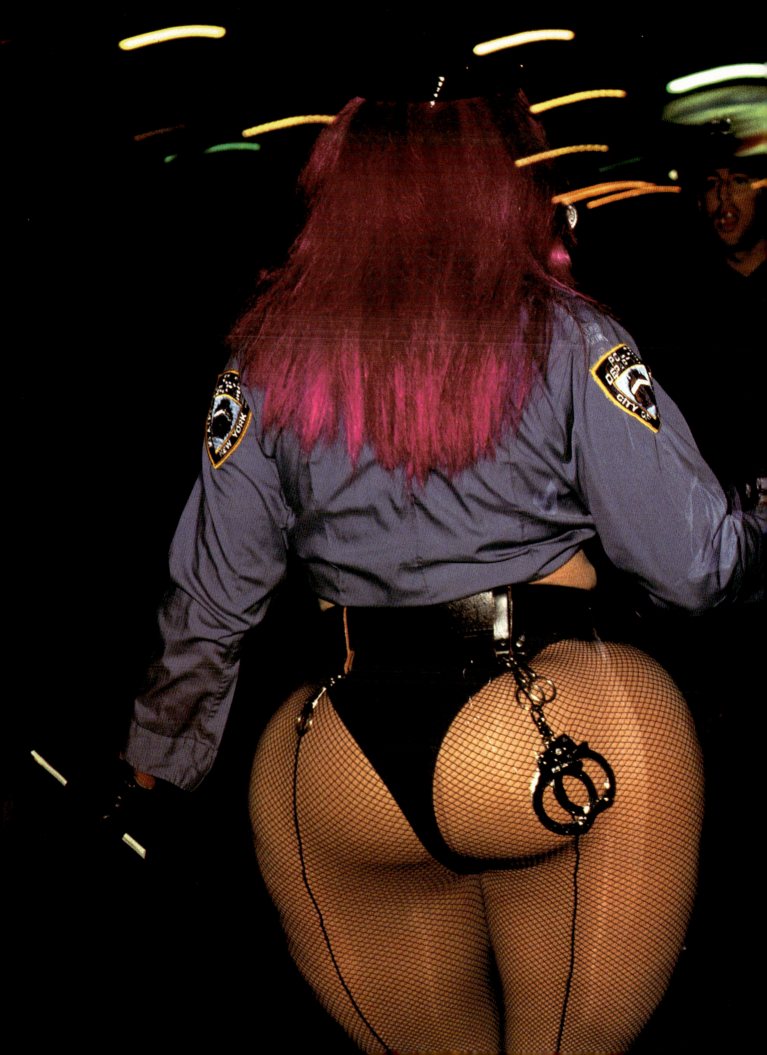

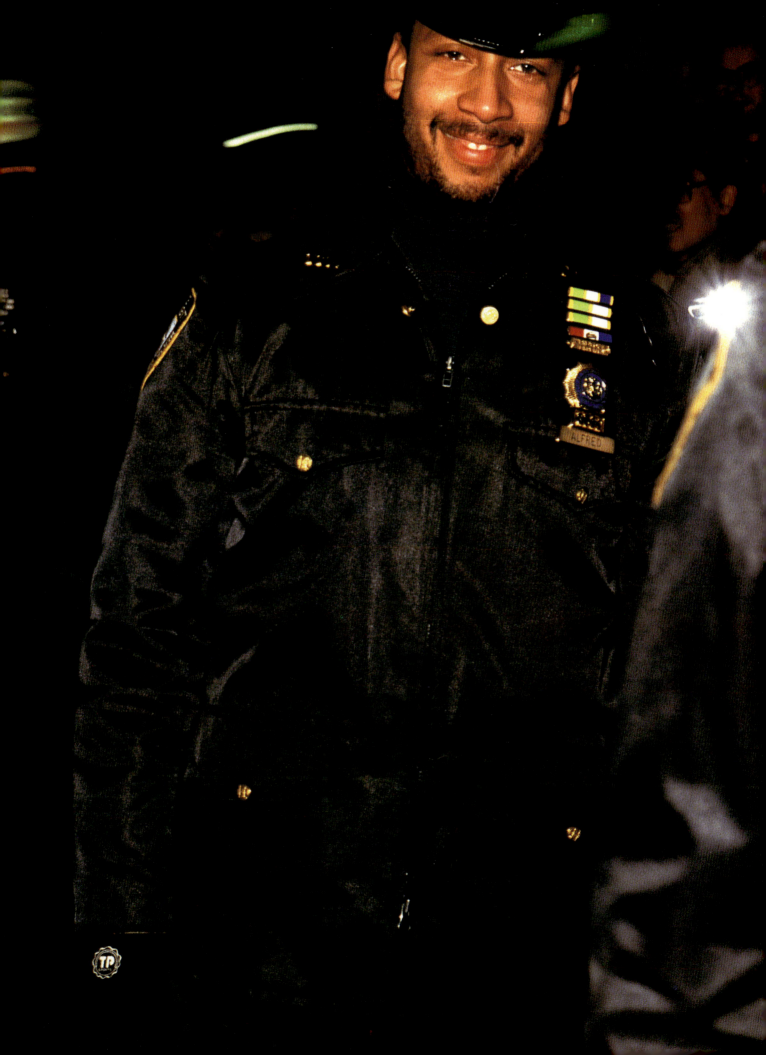

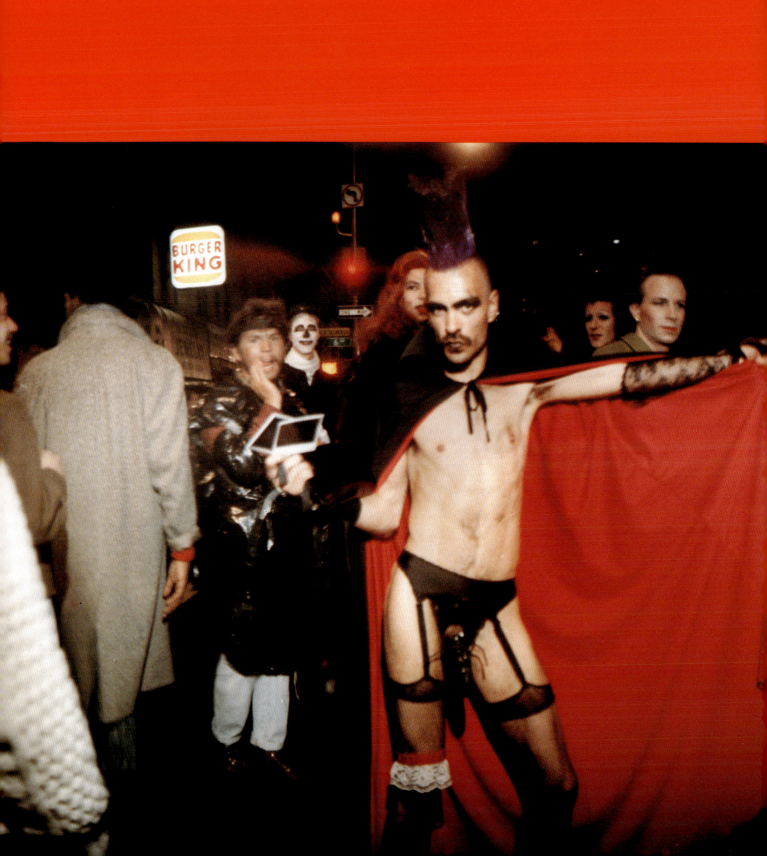

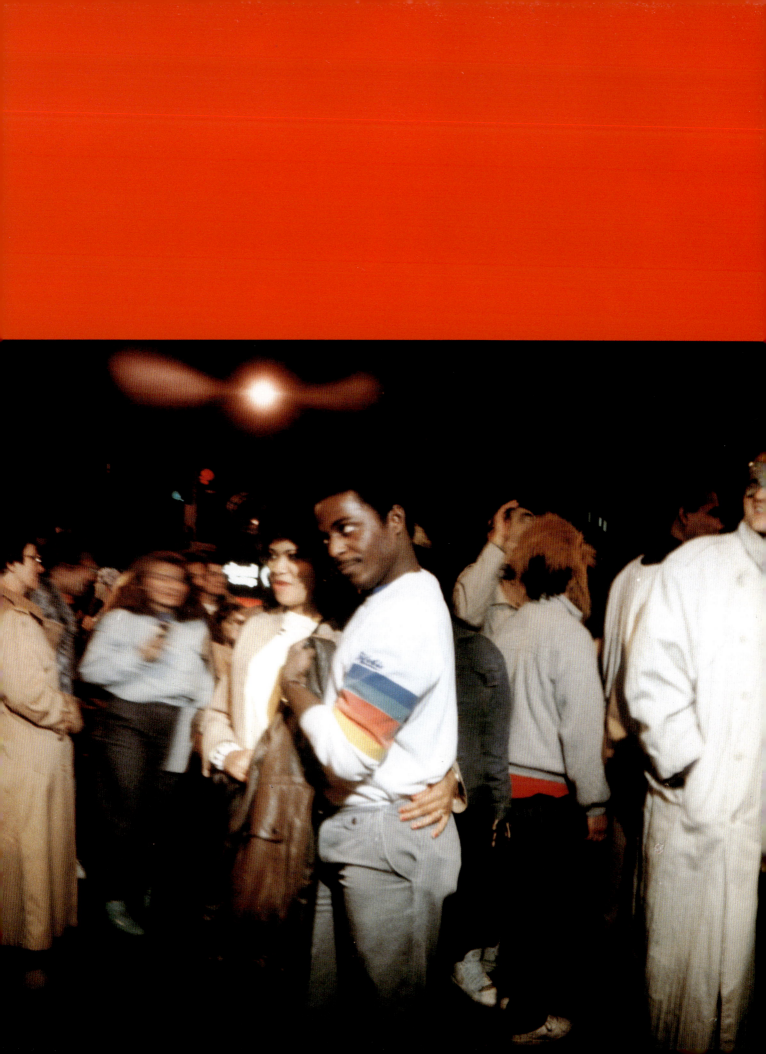

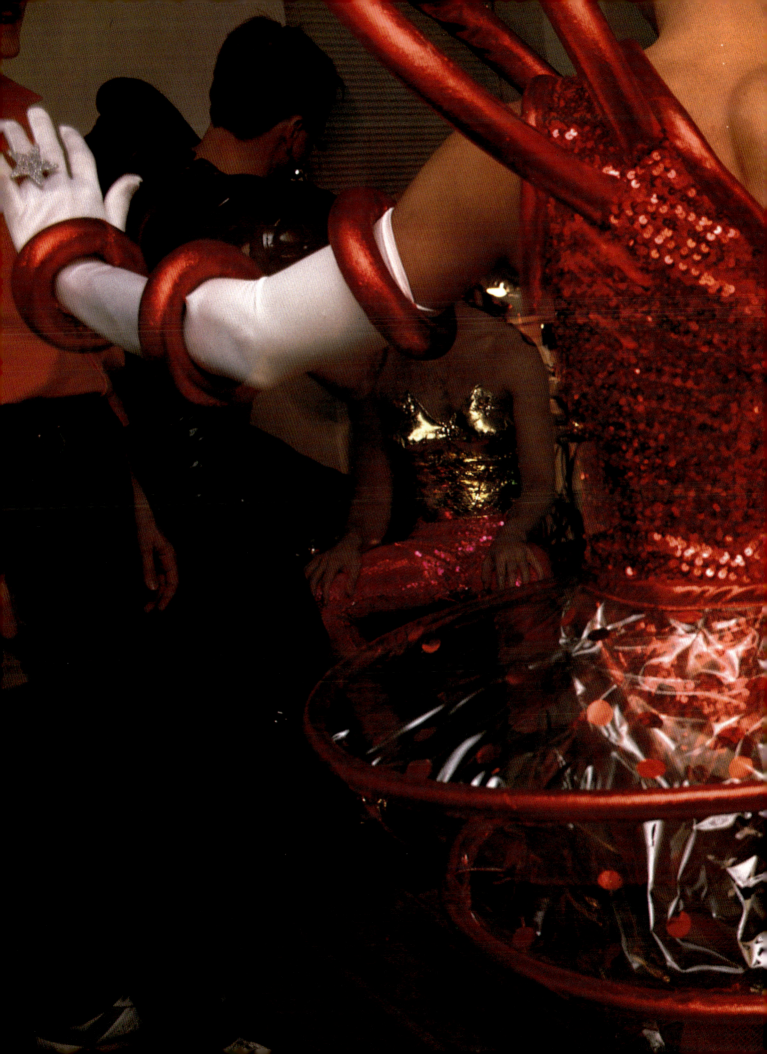

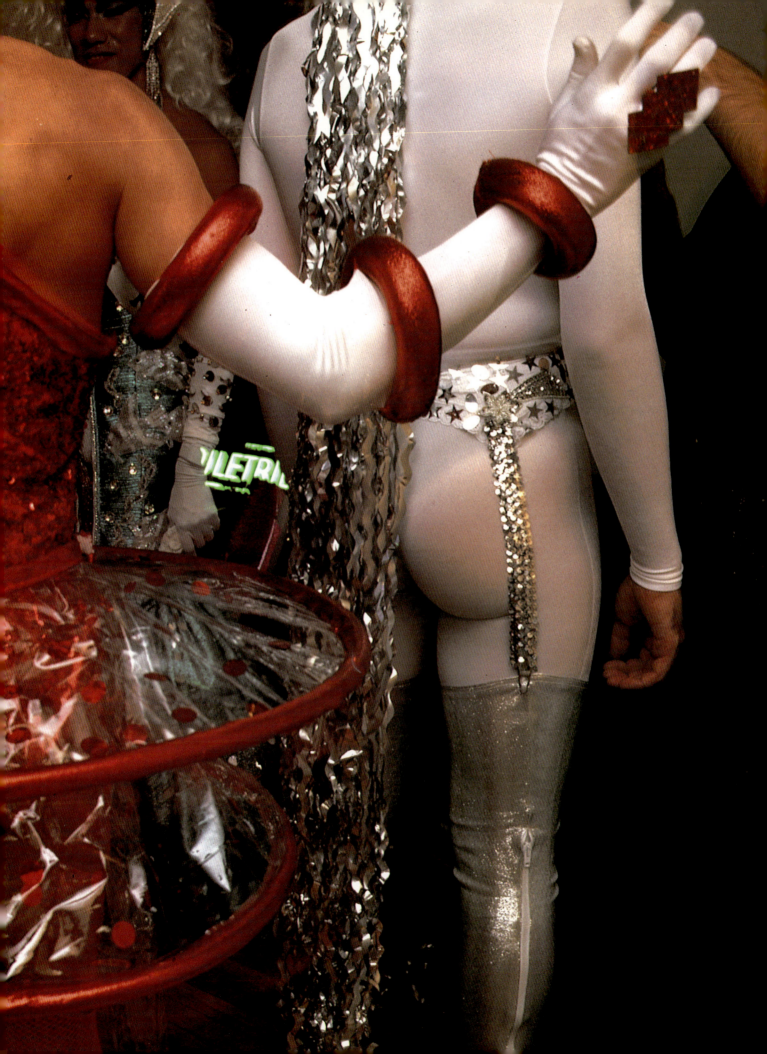

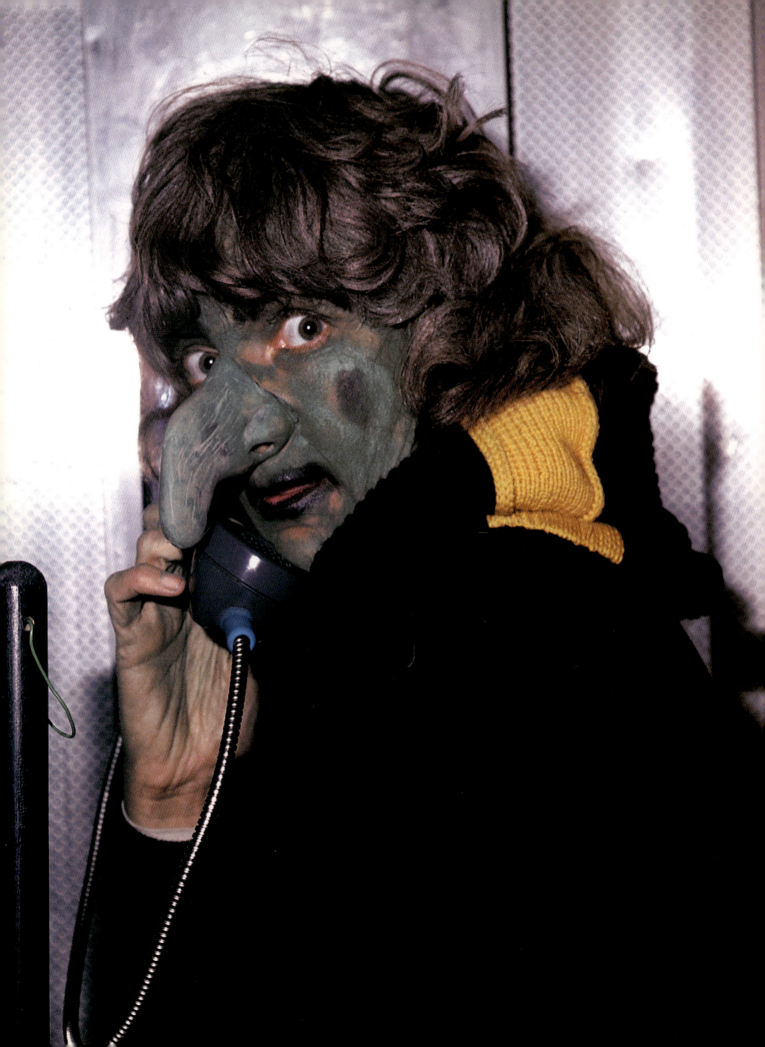

HALLOWEEN IS NOT ABOUT GOOD AND KIND

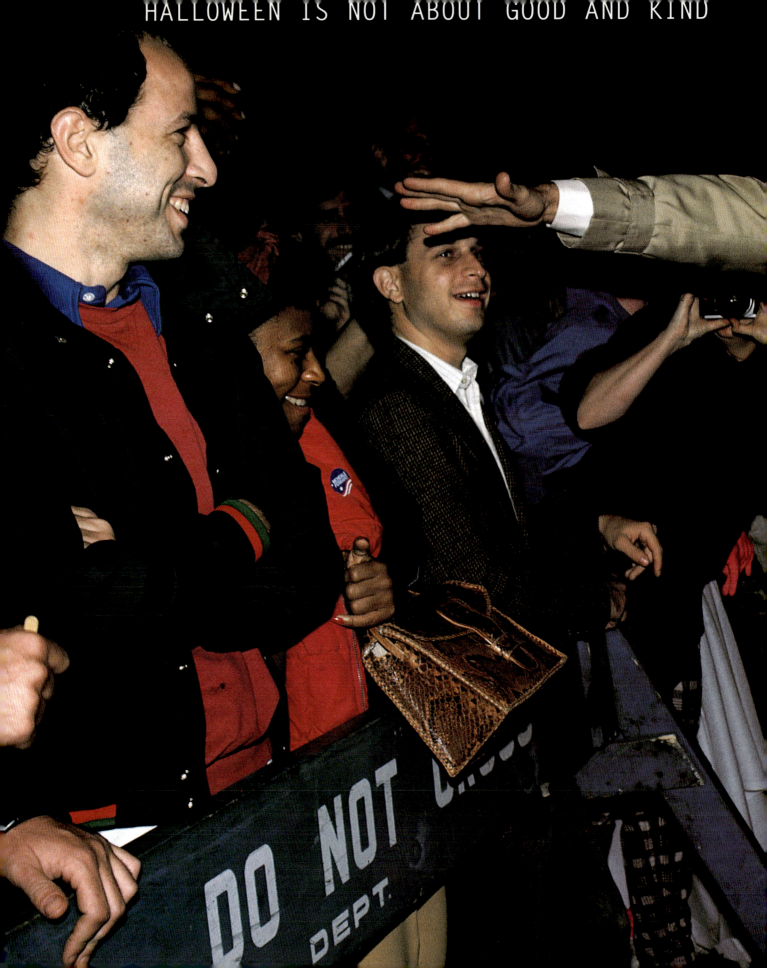

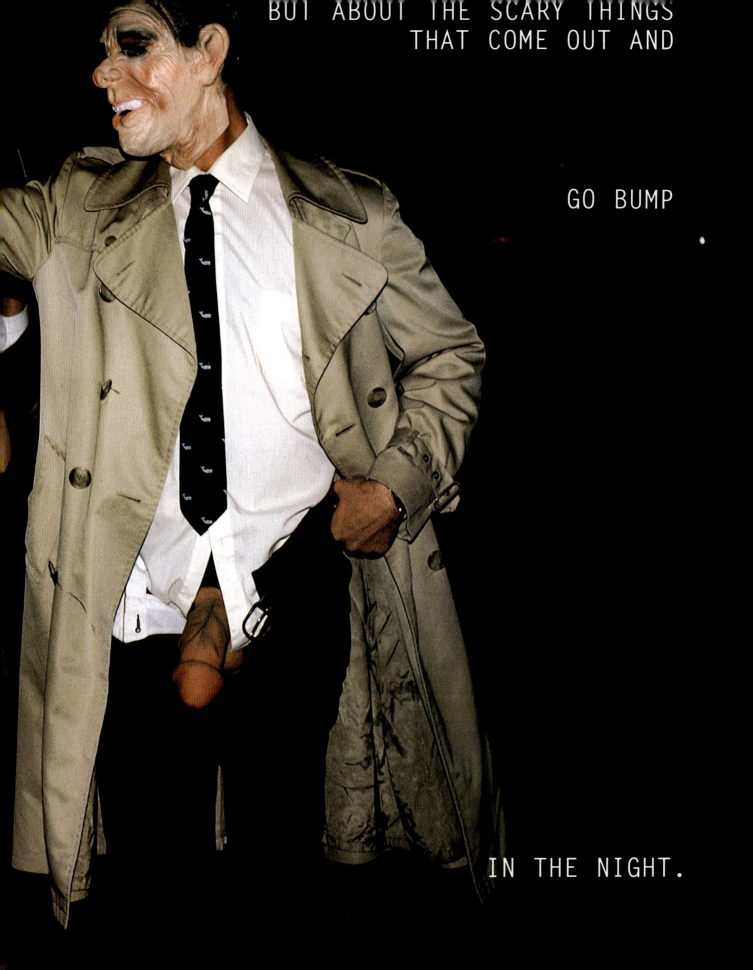

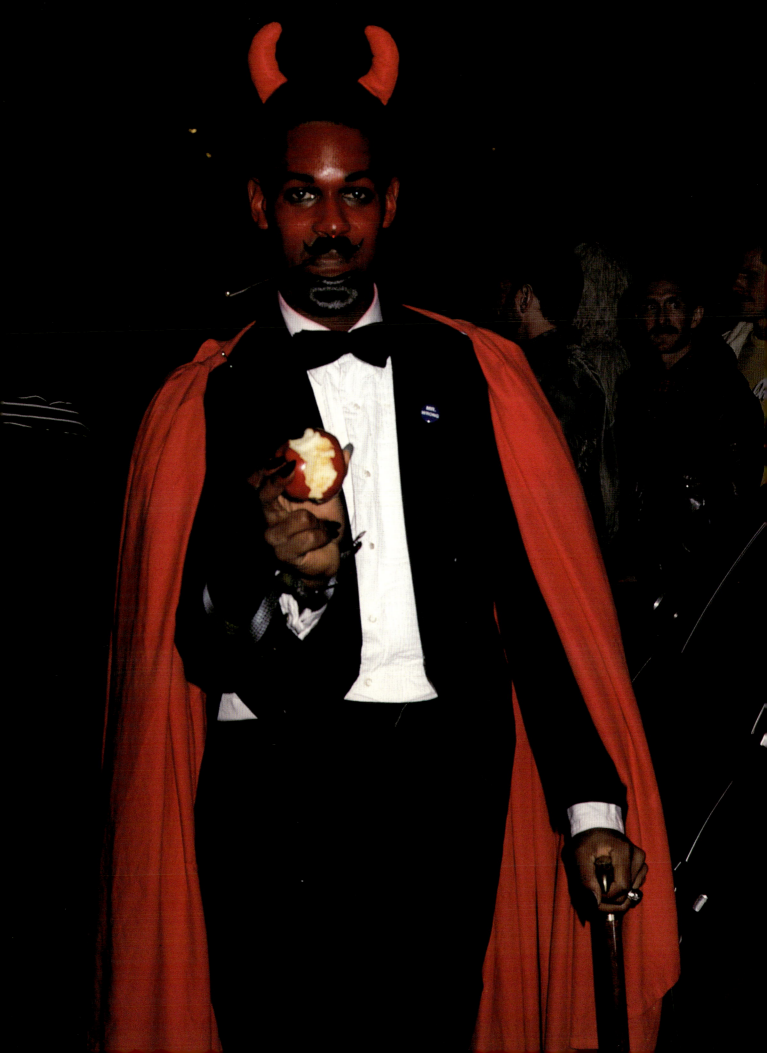

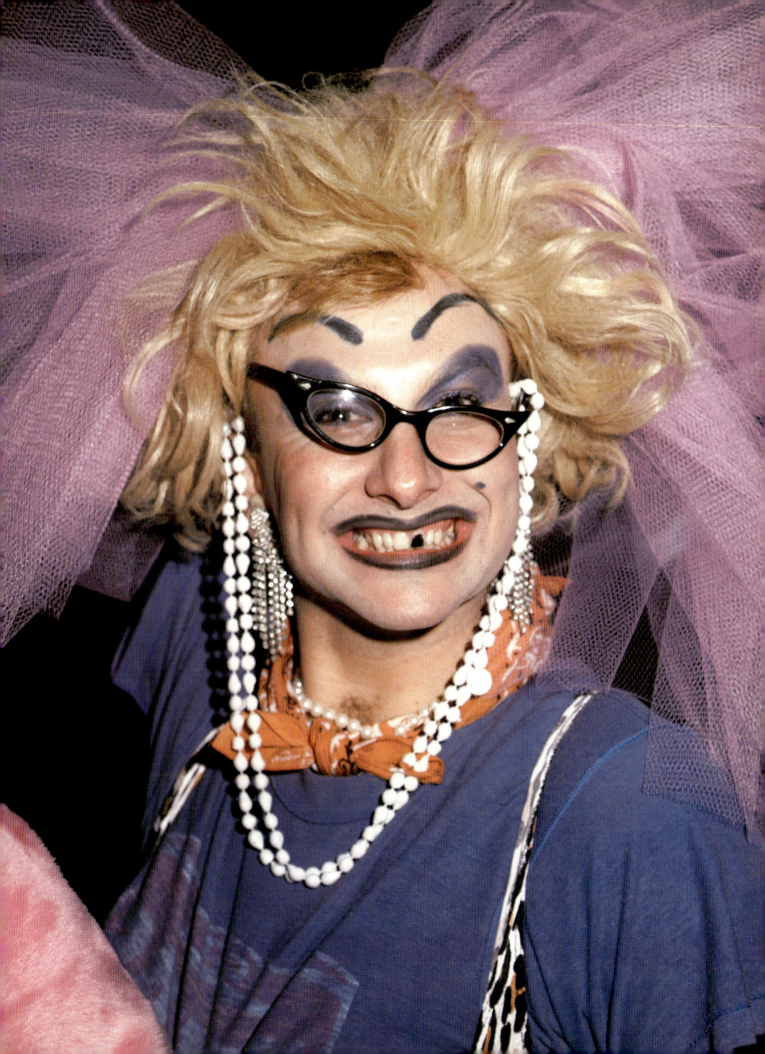

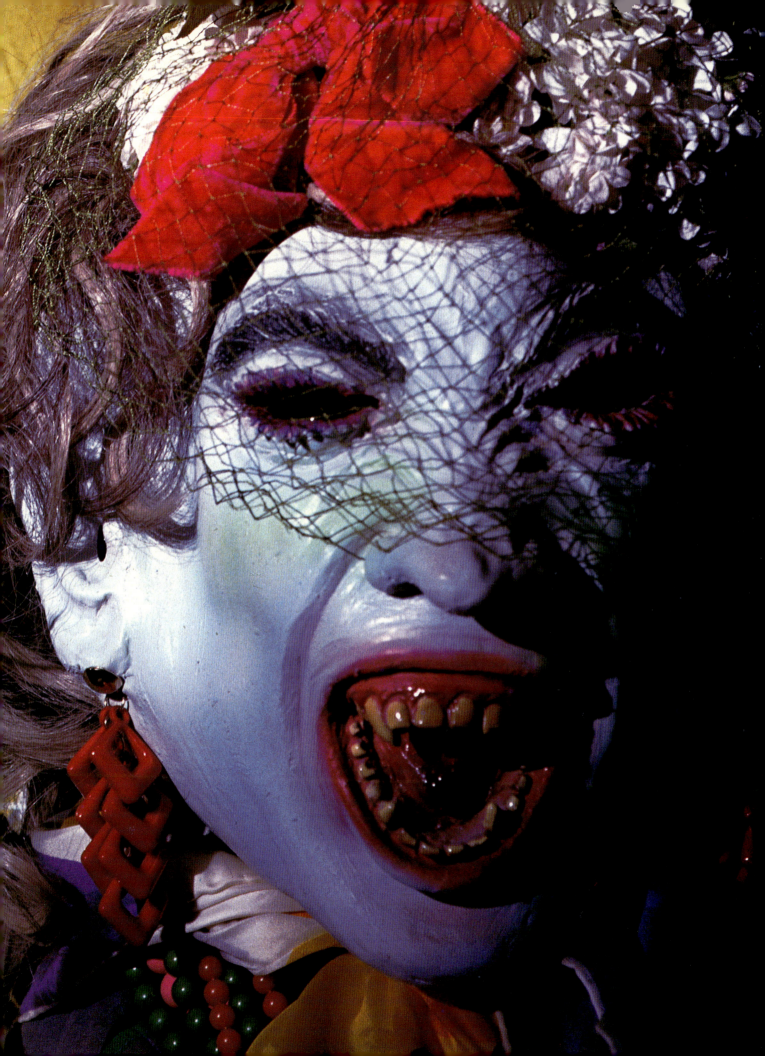

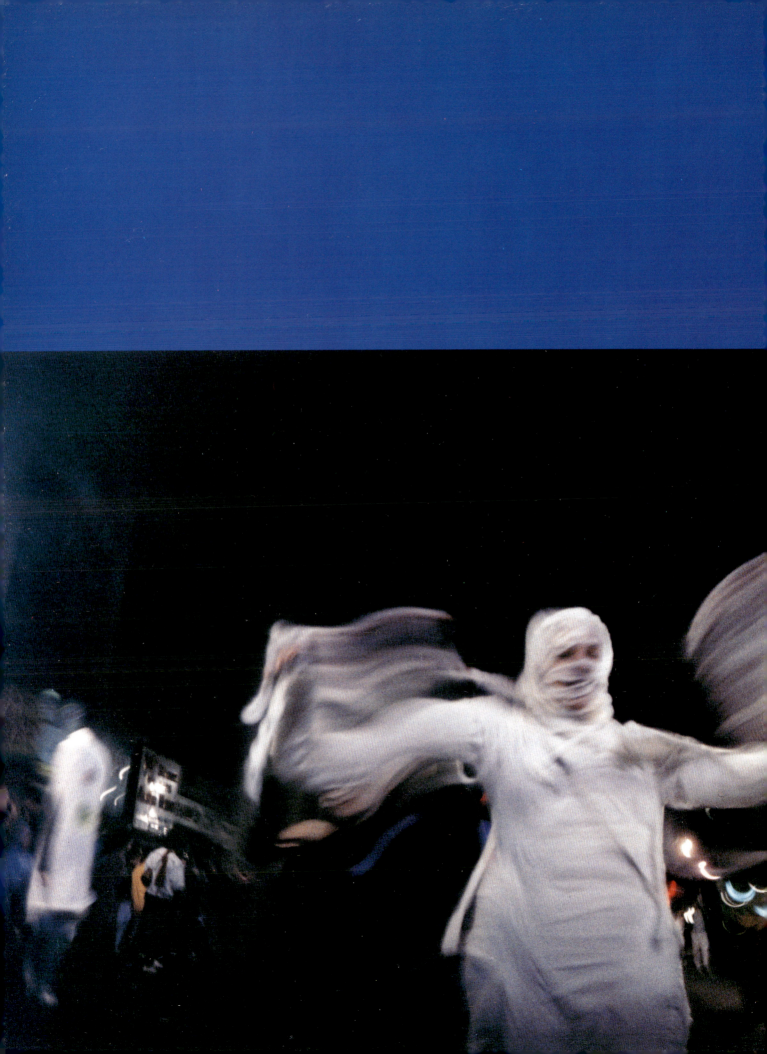

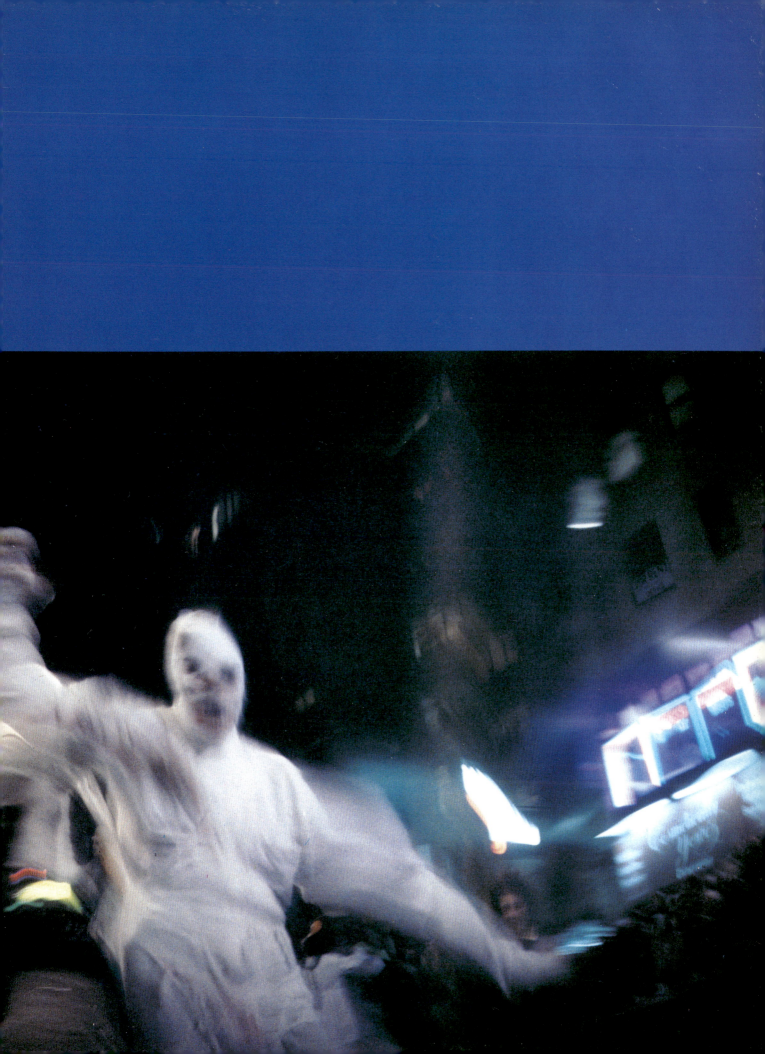

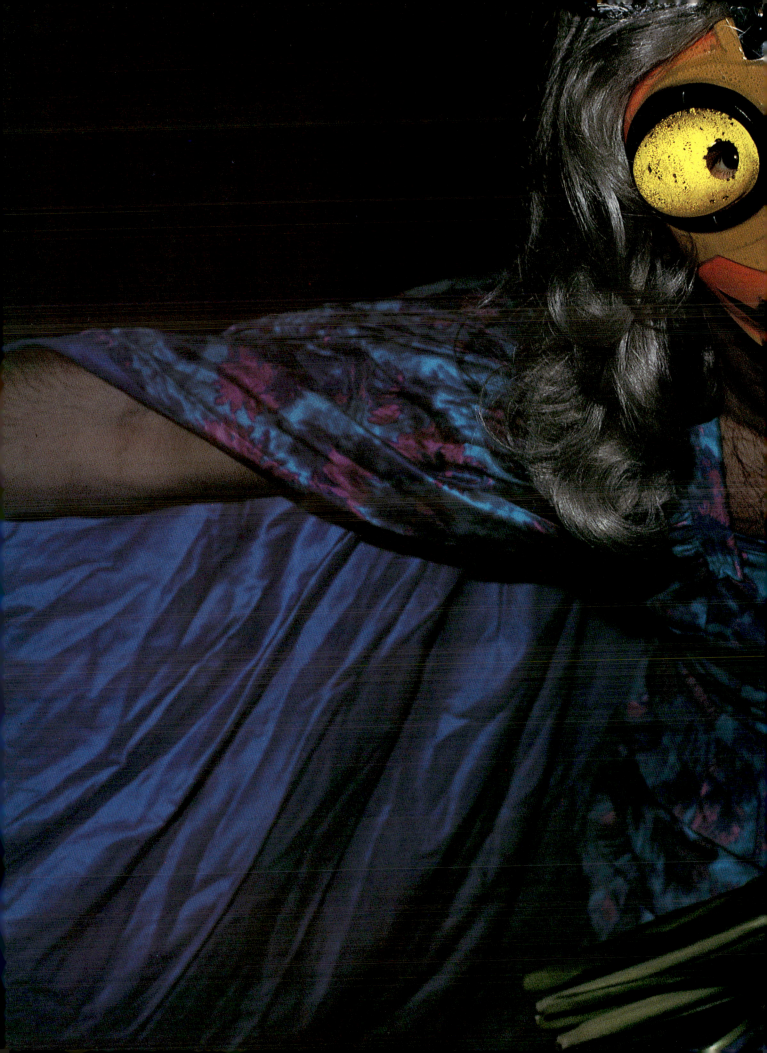

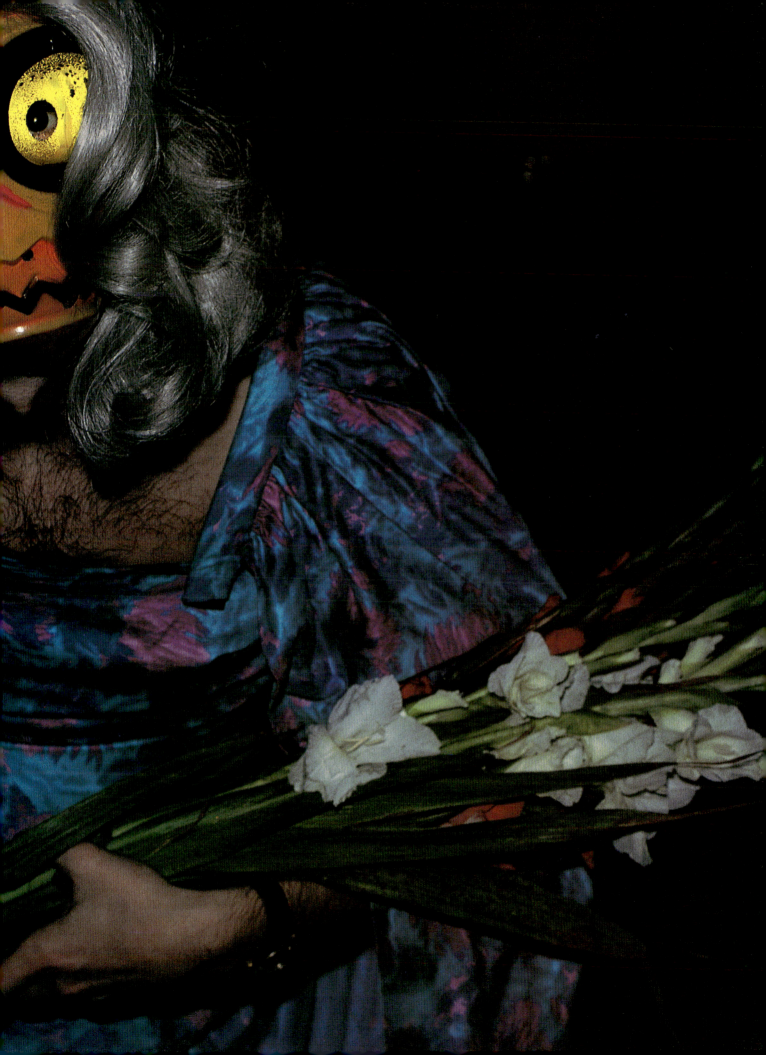

Halloween Parade

There's a downtown fairy singing out "Proud Mary"
As she cruises Christopher Street
And some Southern Queen is acting loud and mean
Where the docks and the Badlands meet

This Halloween is something to be sure
Especially to be here without you.

There's a Greta Garbo and an Alfred Hitchcock
And some black Jamaican stud
There's five Cinderellas and some leather drags
I almost fell into my mug

There's a Crawford, Davis and a tacky Cary Grant
And some Homeboys lookin' for trouble down here from the Bronx

But there ain't no Hairy and no Virgin Mary
You won't hear those voices again
And Johnny Rio and Rotten Rita
You'll never see those faces again

This Halloween is something to be sure
Especially to be here without you

There's the Born Again Losers and the Lavender Boozers
And some crack team from Washington Heights
The boys from Avenue B and the girls from Avenue D
A Tinkerbell in tights

This celebration somehow gets me down
Especially when I see you're not around

There's no Peter Pedantic saying things romantic
In Latin, Greek or Spic
There's no Three Bananas or Brandy Alexander
Dishing all their tricks

It's a different feeling that I have today
Especially when I know you've gone away

There's a girl from Soho with a teeshirt saying "I Blow"
She's with the "jive five 2 plus 3"
And the girls for pay dates are giving cut rates
Or else doing it for free

The past keeps knock knock knocking on my door
And I don't want to hear it anymore

No consolations please for feelin' funky
I got to get my head above my knees
But it makes me mad and mad makes me sad
And then I start to freeze

In the back of my mind I was afraid it might be true
In the back of my mind I was afraid that they meant you

The Halloween parade
See you next year
At the Halloween parade—

—**Lou Reed**

"Halloween Parade" by Lou Reed © 1988 Metal Machine Music
All rights controlled and administered by Screen Gems-EMI Music Inc. (BMI)
All Rights Reserved. International copyright secured. Used by permission.

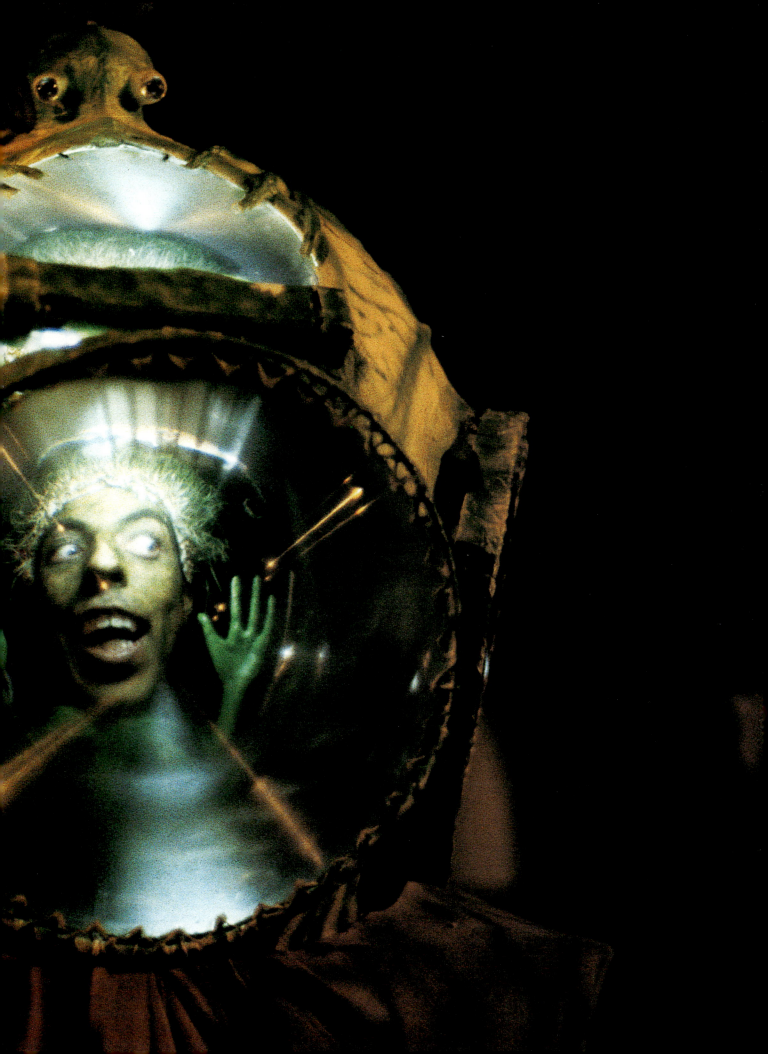

Notes

1: "You'd Make a Great Vampire"

1. Frances Fitzgerald uses this concept in describing the Halloween celebration in San Francisco's Castro district. Fitzgerald, *Cities on a Hill: A Journey Through Contemporary American Cultures* (New York: Simon and Schuster, 1986), p. 12.

2. Jack Santino, "Halloween in America: Contemporary Customs and Performances," *Western Folklore* 42 (1983): 1–20.

3. For an anecdotal history of this holiday, see Lesley Pratt Bannatyne, *Halloween: An American Holiday, an American History* (New York: Facts on File, 1990).

9: "It's My Time to Shine"

1. Benedict Anderson, *Imagined Communities: Reflections on the Origin and Spread of Nationalism* (New York: Verso, 1983).

2. For a discussion of recent research on the relationship between "imageability" and the sense of urban coherence, see Gloria Levitas, "Anthropology and Sociology of Streets," in Stanford Anderson, ed., *On Streets* (Cambridge: MIT Press, 1986), p. 236; William Sharpe and Leonard Wallock, eds., *Visions of the Modern City: Essays in History, Art, and Literature* (Baltimore: Johns Hopkins University Press, 1987); and Kevin Lynch, *The Image of the City* (Cambridge: MIT Press, 1960).

3. Lewis Mumford, *The City in History: Its Origins, Its Transformations, and Its Prospects* (New York: Harcourt Brace Jovanovich, 1961), p. 277.

4. Indeed, this is precisely what Mumford meant by his statement. See also Barbara Kirshenblatt-Gimblett, "The Future of Folklore Studies in America: The Urban Frontier," *Folklore Forum* 16, no. 2 (1983): "A sense of the city is something accomplished, rather than discovered, something constituted rather than uncovered. Expressive behavior is a powerful way of constituting a sense of the whole city" (p. 185).

5. Kevin Lynch, *What Time Is This Place?* (Cambridge: MIT Press, 1990), p. 86.

6. Arjun Appadurai, "Disjuncture and Difference in the Global Cultural Economy," *Public Culture* 2, no. 2 (Spring 1990): 5.

10: To Be a Part of It

1. For the concept of borderland, see Renato Rosaldo, *Culture and Truth: The Remaking of Social Analysis* (Boston: Beacon Press, 1989), pp. 196–217.

2. For a discussion of the concept of cultural rehearsal, see Steven Mullaney, *The Place of the Stage: License, Play, and Power in Renaissance England* (Chicago: University of Chicago Press, 1988), pp. 60–87.

3. This dream borderland is a counterpoint to the borderland as nightmare—the dark spaces of the city or what Tuan refers to as "landscapes of fear" (both outer borough and even local parks), where gangs of ghetto and working-class youths prey upon the more affluent and relatively tolerant middle-class population, at least in this part of NewYork. Elsewhere and at other times the unknown may represent danger, but at the Halloween parade it beckons unthreateningly. Yi-Fu Tuan, *Landscapes of Fear* (New York: Pantheon, 1979), pp. 145–74.

The parade, then, is a conscious effort to create a counterpoint to personal experience and popular lore, including such films as *Fort Apache, the Bronx* (1981), *After Hours* (1985), and *Bonfire of the Vanities* (1990), which envision the city in nightmare terms. In that sense, the event is less about resistance than it is about integration, less about gay people satirizing straight constructions of gender than about urban people feeling that the streets of the city belong to its citizens.

4. Roland Barthes, "Semiology and the Urban," in M. Gottdiener and Alexander Ph. Lagopoulus, eds., *The City and the Sign: An Introduction to Urban Semiotics* (New York: Columbia University Press, 1986), p. 96.

5. Michel Foucault refers to this reimagining as "heterotopia." Included in Foucault's characterization of heterotopias "are privileged or sacred or forbidden places, reserved for individuals who are, in relation to society and to the human environment in which they live, in a state of crisis" and the capability "of juxtaposing in a single real place several spaces, several sites that are in themselves incompatible." Foucault further distinguishes between heterotopias or perhaps better-termed heterochronies (such as museums and libraries, whose task is to accumulate time indefinitely) and the opposite, " time in its most fleeting, transitory, precarious aspect, ...time in the mode of the festival." Michel Foucault, "Of Other Spaces," *Diacritics* 16 (Spring 1986): 22–27.

Foucault's heterotopias of crisis are ways that society traditionally channeled transformations in the lives of groups and individuals. In the contemporary world, heterotopias of crisis are increasingly replaced by those of discipline—rest homes, psychiatric hospitals, and prisons. Foucault is perhaps too pessimistic here. Indeed, the emergence of the Halloween festival suggests the continued existence of the heterotopia of crisis. Its purpose is to establish a public space for the city undergoing transformation to assimilate change, to reintegrate the new within an older form of the city—that is, to make a place for intense social interaction within and outside of particular social groups, a neighborhood.

6. See Denise L. Lawrence, "Parades, Politics, and Competing Urban Images: Doo Dah and Roses," *Urban Anthropology* 11 (1982): 155–76; and Lawrence, "Rules of Misrule: Notes on the Doo Dah Parade in Pasadena," in Alessandro Falassi, ed., *Time Out of Time: Essays on the Festival* (Albuquerque: University of New Mexico Press, 1987), pp. 123–36.

7. See Elaine May, *Homeward Bound: American Families in the Cold War Era* (New York: Basic Books, 1988).

8. William M. Johnston. Celebrations: *The Cult of Anniversaries in Europe and the United States Today* (New Brunswick, N.J.: Transaction Books, 1991), p. 119.

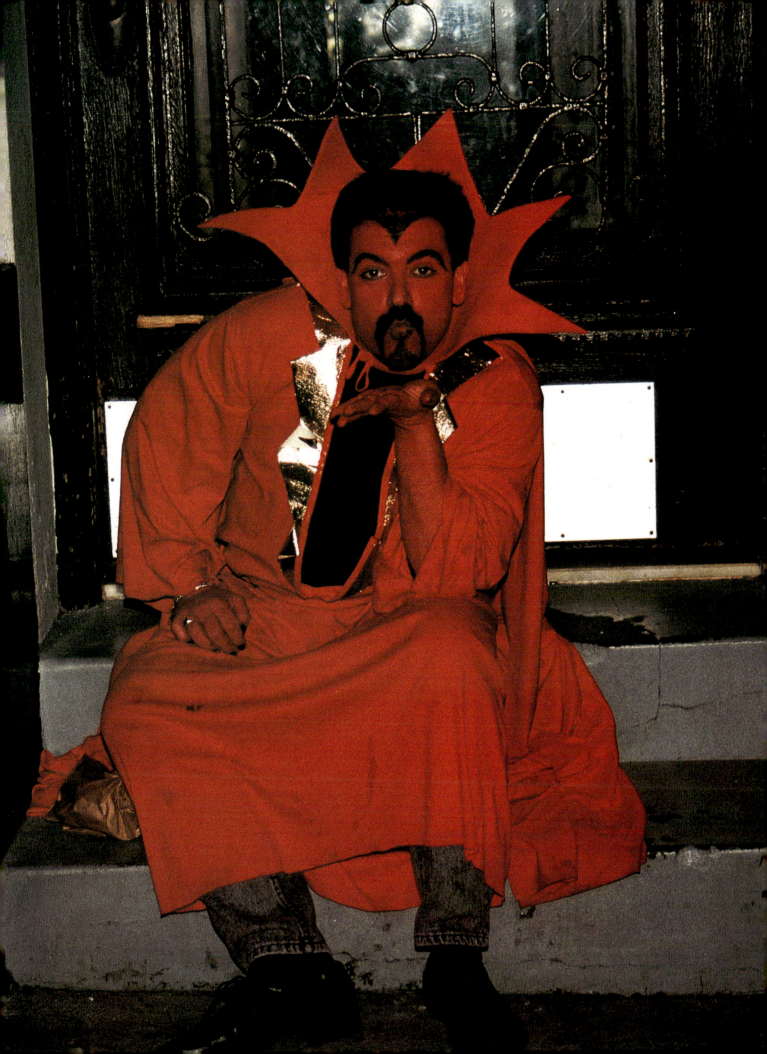

Photography Credits

[p. 1] Flying mummies (*photo*: Elijah Cobb)
[p. 2] Red Demon (*photo*: Harold Davis)
[p. 4] Danny Wintrode and Luis Goitia (*photo*: Marilyn Stern)
[p. 6] Punk Dog with cigarette (*photo*: Harold Davis)
[p. 8] Plastic ass with lipstick kiss (*photo*: Harold Davis)
[p. 10] Mona Lisa on Sixth Avenue (*photo*: Mariette Pathy Allen)
[p. 11] Shirley Temple by Michael Miles (*photo*: Lauren Piperno)
[p. 12] Twirling figure from "Coral Reef" by Cohen, Kindschi, and Kanazawa (*photo*: Lauren Piperno)
[p. 13] Drag queen with pursed lips (*photo*: Mariette Pathy Allen)
[p. 14] Matron on Christopher Street (*photo*: Marilyn Stern)
[p. 16] Unicorn putting on makeup, Edwin M. Viconte, Jr. (*photo*: Marilyn Stern)
[p. 18] Gory man carrying severed head (*photo*: Marilyn Stern)
[p. 26] "The Ghost of Tom" hanging in the Washington Square Arch by Ralph Lee (*photo*: Elijah Cobb)
[p. 32] Overview of the parade on Sixth Avenue (*photo*: Elijah Cobb)
[p. 38] Unicorn with mirror, by Edwin M. Viconte, Jr. (*photo*: Marilyn Stern)
[p. 39] "The God Pan" (*photo*: Harold Davis)
[p. 40] Devil by Ralph Lee (*photo*: Mariette Pathy Allen)
[p. 42] Crucifixion (*photo*: Marilyn Stern)
[p. 44] Masked parents with baby (*photo*: Mariette Pathy Allen)
[p. 46] Calypso dancer (*photo*: Marilyn Stern)
[p. 48] Man at sewing machine (*photo*: Lauren Piperno)
[p. 50] The Cocktail Party by Robert Tabor (*photo*: Lauren Piperno)
[p. 52] "Mask of the Plague" (*photo*: Harold Davis)
[p. 54] Death walking past police officers (*photo*: Lauren Piperno)
[p. 56] Boob Tube with children (*photo*: Mariette Pathy Allen)
[p. 58] View from inside Emperor Hadrian's chariot by Ralph Lee (*photo*: Elijah Cobb)
[p. 60] Emperor Hadrian's chariot being pulled by the Devil (*photo*: Elijah Cobb)
[p. 62] Three sweepers purifying the parade route by Ralph Lee (*photo*: Mariette Pathy Allen)
[p. 64] Sweeper in front of Jefferson Market Library (*photo*: Lauren Piperno)
[p. 66] Inflated spirit balloon (*photo*: Lauren Piperno)
[p. 68] Woman with a birdcage on her head (*photo*: Mariette Pathy Allen)
[p. 70] "Coral Reef" by Cohen, Kindschi, and Kanazawa (*photo*: Elijah Cobb)
[p. 72] Lipstick group by Robert Tabor (*photo*: Lauren Piperno)
[p. 74] Wicked witch with broom (*photo*: Lauren Piperno)
[p. 75] Black Death (*photo*: Harold Davis)
[p. 76] Aztec god boarding the bus by Ken Allen (*photo*: Mariette Pathy Allen)
[p. 78] Woman roller-skating past police officer (*photo*: Lauren Piperno)
[p. 86] The Good Fairy being interviewed as Uncle Sam looks on (*photo*: Mariette Pathy Allen)
[p. 94] Desirée Storm and friends by Danny Wintrode (*photo*: Mariette Pathy Allen)
[p. 102] John Humpstone as can-can "girl" reclining on a bed of dresses (*photo*: Mariette Pathy Allen)
[p. 104] "Machismo" (*photo*: Harold Davis)
[p. 106] Nixon in drag (*photo*: Elijah Cobb)
[p. 107] The French Court on Christopher Street (*photo*: Mariette Pathy Allen)
[p. 108] Imelda Marcos's shoes (*photo*: Lauren Piperno)
[p. 110] Drag queen in front of nuns with mustaches (*photo*: Lauren Piperno)
[p. 112] Buxom derriere by Danny Wintrode (*photo*: Marilyn Stern)
[p. 114] Two poodles in their limousine (*photo*: Elijah Cobb)
[p. 116] Royal Fairies of Winter (*photo*: Lauren Piperno)
[p. 118] Blue and silver tropical bird (*photo*: Harold Davis)
[p. 119] Aztec god by Ken Allen (*photo*: Mariette Pathy Allen)
[p. 120] Ballerina with spectator (*photo*: Marilyn Stern)
[p. 122] Bare-chested beauty with cross earrings (*photo*: Lauren Piperno)
[p. 124] The Devil and the Hulk (*photo*: Lauren Piperno)
[p. 126] Women as muscle men (*photo*: Elijah Cobb)
[p. 128] Police officer in patrol car (*photo*: Lauren Piperno)
[p. 130] Little Monster in red (*photo*: Lauren Piperno)
[p. 132] Monster in the crowd (*photo*: Marilyn Stern)
[p. 134] "Red Rooster Saves Universe from Itself" (*photo*: Lauren Piperno)
[p. 136] Piano Man (*photo*: Marilyn Stern)
[p. 138] "TWAT" airline stewardesses (*photo*: Lauren Piperno)
[p. 140] Re-creation of *The Birds* (*photo*: Lauren Piperno)
[p. 142] Men as urinals (*photo*: Marilyn Stern)
[p. 148] Shriners in mini-cars (*photo*: Marilyn Stern)
[p. 154] Wall Street bull on phone (*photo*: Lauren Piperno)
[p. 162] Electrified heads on a bicycle built for four by Eric Staller (*photo*: Elijah Cobb)
[p. 168] Spider monkey skeleton by Cohen, Kindschi, and Kanazawa (*photo*: Elijah Cobb)
[p. 170] Drag queen and vampire (*photo*: Elijah Cobb)
[p. 172] Man with bloody face (*photo*: Lauren Piperno)
[p. 173] Baby Doll with cigarette (*photo*: Harold Davis)
[p. 174] Monster man carrying bloody body (*photo*: Lauren Piperno)
[p. 176] Dancing the samba (*photo*: Harold Davis)
[p. 177] Zombie sucking blood out of a head (*photo*: Elijah Cobb)
[p. 178] Couple with a monster baby (*photo*: Mariette Pathy Allen)
[p. 180] Abortion (*photo*: Marilyn Stern)
[p. 182] Shower Man (*photo*: Harold Davis)
[p. 183] Naked man with swan (*photo*: Marilyn Stern)
[p. 184] Man holding blow-up doll (*photo*: Lauren Piperno)
[p. 186] Blond vamp on Christopher Street (*photo*: Mariette Pathy Allen)
[p. 187] Man with giant doily (*photo*: Mariette Pathy Allen)
[p. 188] "Policewoman" (*photo*: Marilyn Stern)
[p. 190] "Home of the Whopper" (*photo*: Elijah Cobb)
[p. 192] "The Fitting of Miss Mars" for the Miss Solar System Pageant by Robert Legere (*photo*: Lauren Piperno)
[p. 194] Witch in a phone booth (*photo*: Harold Davis)
[p. 195] Pee Wee Herman at the movies (*photo*: Marilyn Stern)
[p. 196] Ronald Reagan flashing the crowd (*photo*: Marilyn Stern)
[p. 198] The devil holding an apple (*photo*: Harold Davis)
[p. 199] Blond woman with pink lace and glasses (*photo*: Harold Davis)
[p. 200] Gruesome face with umbrella (*photo*: Marilyn Stern)
[p. 202] Flying mummies (*photo*: Elijah Cobb)
[p. 204] "Bright Eyes and Gladiolas" (*photo*: Mariette Pathy Allen)
[p. 207] Monster in deep-sea helmet (*photo*: Mariette Pathy Allen)
[p. 209] Jack-o'-lanterns on a stoop (*photo*: Harold Davis)
[p. 211] Devil blowing a kiss (*photo*: Mariette Pathy Allen)
[p. 213] "Goldie Lox" (*photo*: Mariette Pathy Allen)
[p. 214] Three skeletons waiting for the parade (*photo*: Elijah Cobb)
[p. 216] View of the parade from Washington Square Arch (*photo*: Harold Davis)

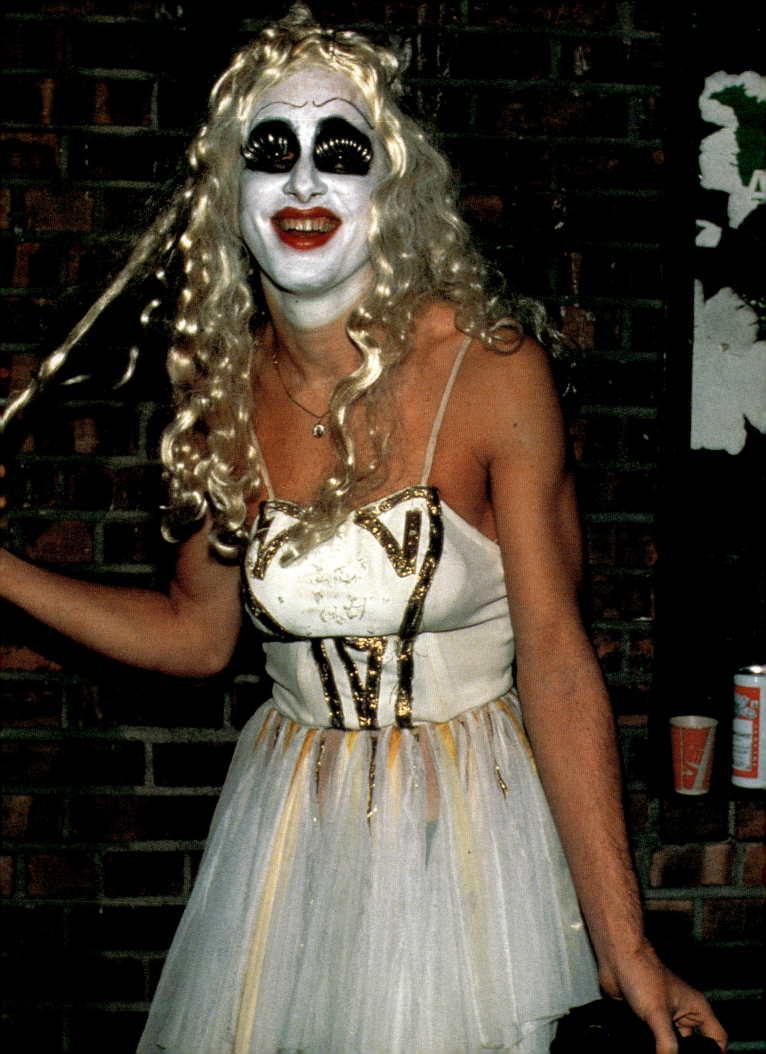

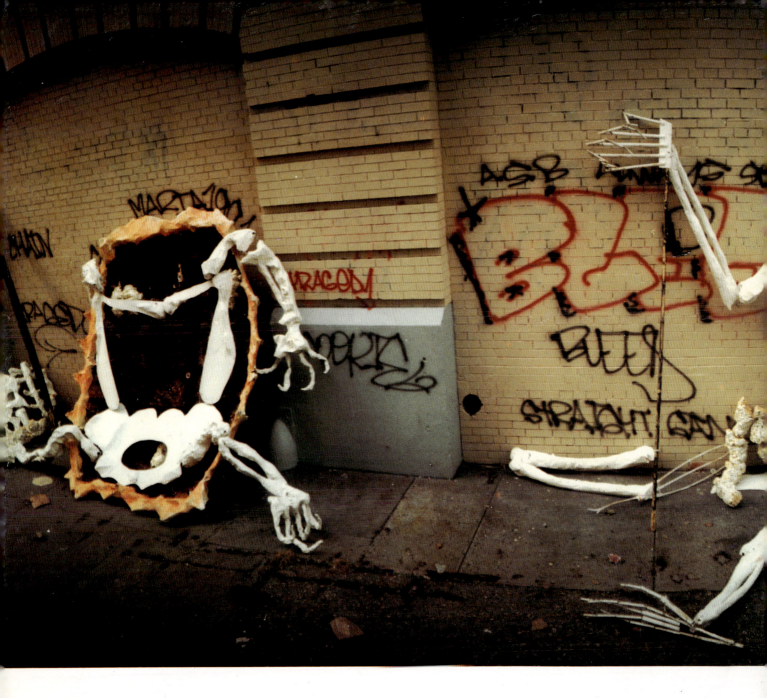

Photographers' Acknowledgments

The photographers would like to thank several people who helped bring this book to fruition: The New York Photographers' Salon for bringing us together; Rebecca Busselle for her astute vision and masterful picture editing; Roger Gorman and Rick Patrick for their inspirational ideas and design; our original agent, Edy Selman, for her long-standing faith in the project; William Nabers for his generous picture editing and creation of our first dummy; Fritz Lyon, Maggie Steber, and Carol Kismaric for their invaluable expert advice; the wonderful Rokeby family of volunteers; and all the parade participants who shared their creative preparations with us. We especially thank Columbia University Press, including editor Gioia Stevens and design manager Teresa Bonner, for their daring and dedication. Most of all, we are indebted to Ralph Lee and Jeanne Fleming, without whom there would be no Halloween Parade. It is to their creative genius and generosity of spirit that this book is dedicated.

Mariette Pathy Allen: "I would like to thank the New York City Department of Cultural Affairs for referring me to Ralph Lee in 1975. I would also like to acknowledge my husband, Ken Allen, who has marched in the parade in many incarnations, from a praying mantis to an Aztec god." **Elijah Cobb:** "Thanks to the Rokeby crowd for welcoming me to the pre-parade madness and for your encouragement and understanding of this project. Halloween just wouldn't be Halloween without your gargantuan efforts." **Harold Davis:** "I would like to acknowledge Barbara Bush and her bouquet of broccoli, Richard M. Nixon, the smoking punk dog, assorted witches, walking breasts, and herds of sheep... and everyone who participated in the parade and made it the glorious act of human imagination it is." **Lauren Piperno:** "Thanks to my husband, Paul Zinman, whose support and encouragement lovingly shines through this work." **Marilyn Stern:** Thank you, Randy Penttila, and, in memory, Mike Belt, for first bringing me to the parade in 1977.

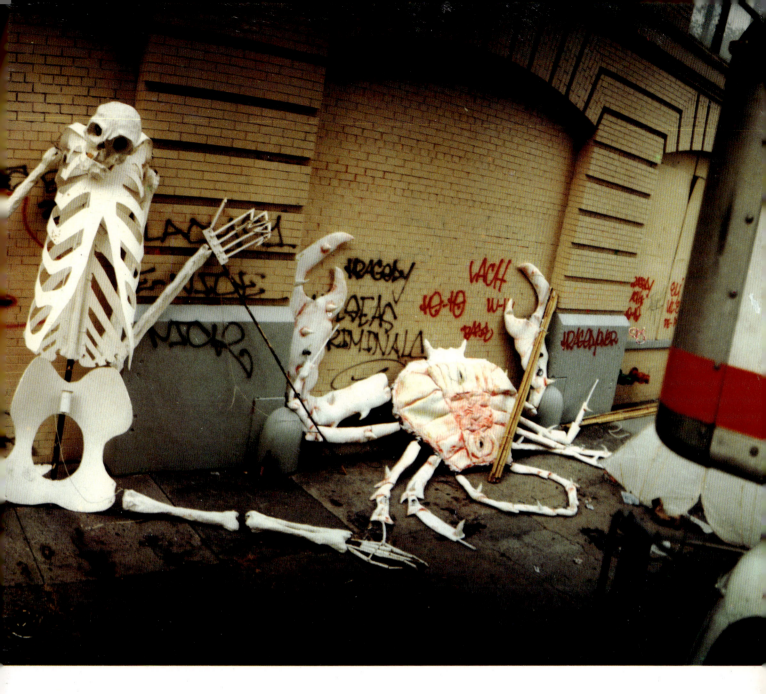

Author's Acknowledgments

Parts of this book appeared in the following articles: ``Wishes Come True: Designing the Greenwich Village Halloween Parade,'' *Journal of American Folklore* 104 (1991): 443–65; ``The Fun Is in the Dressing Up,'' *Social Text* 36 (1993): 135–49.

Research on this project was made possible in part by grants from the Wenner-Gren Foundation for Anthropological Research, Inc., and the Wisconsin Alumni Research Foundation of the University of Wisconsin–Madison. I would like to thank the many people who agreed to be interviewed for this book, both participants and organizers—and particularly Ralph Lee and Jeanne Fleming—without whom this book and the event it describes would not now exist. My thanks also to Gina Grumke and Erica Caswell, who helped conduct the research on the 1992 parade, and to Marc Kaminsky and Judith Summerfield for advice and hospitality. I owe a special debt of gratitude to Esther Romeyn, with whom I discussed many of the ideas in this book and who read through and commented on the manuscript at a very critical stage of its development; and to Gioia Stevens whose editorial guidance and generous commitment of time made it possible to bring this project to a timely completion.

Library of Congress Cataloging-in-Publication Data
Masked culture: the Greenwich Village Halloween parade/Jack Kugelmass...[et al.].
 p. cm.
 ISBN 0–231–08400–5
 1. Halloween—New York (State)—Greenwich Village (New York)
 2. Parades—New York (State)—Greenwich Village (New York)
 3. Greenwich Village (New York, N.Y.)–Social life and customs.
 I. Kugelmass, Jack.
GT4965.M27 1994
394.2'646'097471–dc20
 93-29821
 CIP

Columbia University Press
New York Chichester, West Sussex
Copyright ©1994 Columbia University Press
All rights reserved
∞
Casebound editions of Columbia University Press books are printed on permanent and durable acid-free paper.
Printed in Hong Kong. Design by Reiner Design Consultants
c 10 9 8 7 6 5 4 3 2 1

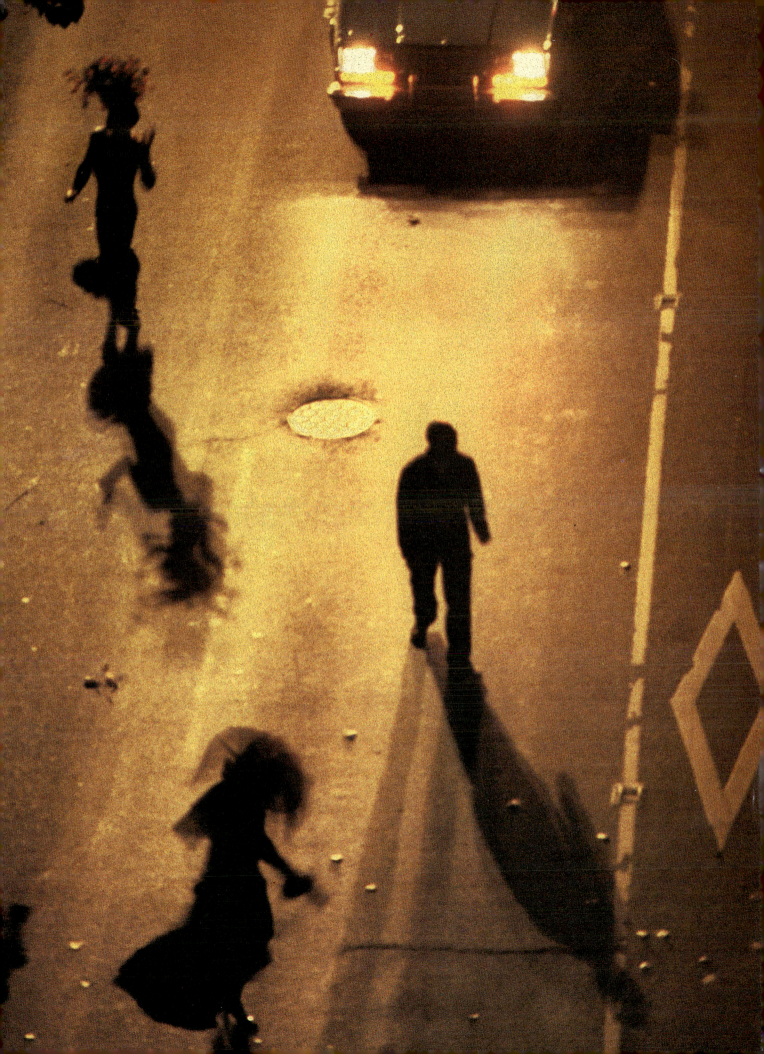